PHOTOGRAPHY 4.0
A TEACHING GUIDE FOR THE 21ST CENTURY

An invaluable resource for photography educators, this volume is a survey of photographic education in the first decade of the 21st Century. Drawing upon her 25 years of teaching experience and her professional network, Michelle Bogre spoke with 47 photo educators from all over the world to compile this diverse set of interviews. The themes of these conversations explore:

> *Why students should study photography*

> *The value of a formal photography degree*

> *Teaching philosophies*

> *Whether video and multimedia should be essential parts of photographic curricula*

> *The challenges of teaching photography today*

> *Changes in photographic education overall*

The second half of the book shares 70 photography assignments of varying levels of difficulty from these educators, some paired with examples of how students completed them. This book will inspire and invigorate any photography educator's curriculum.

MICHELLE BOGRE, an educator with more than 25 years of experience, is an Associate Professor of Photography at Parsons The New School for Design in New York City and a documentary photographer, writer, and intellectual property lawyer. She is the author of Photography as Activism: Images for Social Change, and she regularly writes about photography and law. Michelle authored the Copyright Corner (www.thecopyrightcorner.org), a website created to make copyright law accessible for photographers. She is actively involved with photography education, serving on the national board of the Society for Photographic Education (SPE) and on the advisory board of the Young Photographers Association (YPA). Her photographs have been featured in group shows, including at the Lawrence F. O'Brien Gallery at the National Archives in Washington, D.C. and at the Annenberg Space for Photography in Los Angeles.

www.photographyconfidential.com

PHOTOGRAPHY 4.0

A TEACHING GUIDE FOR THE 21ST CENTURY

Educators Share Thoughts and Assignments

Michelle Bogre

Focal Press
Taylor & Francis Group

NEW YORK AND LONDON

First published 2015
by Focal Press
70 Blanchard Road, Suite 402, Burlington, MA 01803
and by Focal Press
2 Park Square, Milton Park, Abingdon, Oxon OX14 4RN

Focal Press is an imprint of the Taylor & Francis Group, an informa business

Notices
Knowledge and best practice in this field are constantly changing. As new research
and experience broaden our understanding, changes in research methods,
professional practices, or medical treatment may become necessary.

Practitioners and researchers must always rely on their own experience and
knowledge in evaluating and using any information, methods, compounds, or
experiments described herein. In using such information or methods they should be
mindful of their own safety and the safety of others, including parties for whom they
have a professional responsibility.

Product or corporate names may be trademarks or registered trademarks, and are
used only for identification and explanation without intent to infringe.

Library of Congress Cataloging in Publication Data
Photography : a teaching guide for the 21st century : educators share thoughts and
assignments / [edited by] Michelle Bogre.
 pages cm
Includes bibliographical references and index.
ISBN 978-0-415-81521-5 (pbk.) — ISBN 978-1-315-77756-6 (ebk) 1.
Photography—Study and teaching. 2. Educators—Interviews. I. Bogre, Michelle.
 TR161.P57 2014
 770.71—dc23
 2013046495

ISBN: 978-0-415-81521-5 (pbk)
ISBN: 978-1-315-77756-6 (ebk)

Designed and typeset by Alex Lazarou

Printed and bound in India by Replika Press Pvt. Ltd.

This book is dedicated to all students worldwide who place their trust in us.

CONTENTS

Chapter 1
Photography Confidential: Educators Speak

Chapter 2
Assignments
Confidential:
Educators Share

Acknowledgments

This book owes its existence to many people. So in no particular order, I express my gratitude to all of my colleagues who generously shared their time, their thoughts, and their assignments; to my assistant, Jack Salazar, who miraculously created order out of my chaos; all the students who enthusiastically agreed to illustrate the book and "do" the assignments during their summer break; to Huang Taimei and Daniel Udell for their scholarly translations of Chinese and Catalan, respectively; to my colleague Bill Gaskins; to Jack Crager, the best editor I've ever worked with because he always improves my writing; to Kimberly Duncan-Mooney and Alison Duncan at Focal Press, for their unwavering support and enthusiasm; and finally to my husband, Peter Udell, who always cheered me on, but who will be happy not to hear me say, "Sorry I can't, I have to work on my book."

Image courtesy of Min Zheng

INTRODUCTION

The illiterate of the future will be the person ignorant of the use of the camera as well as the pen.

László Moholy-Nagy[1]

I LOVE PHOTOGRAPHY. And I love teaching. This book arises out of my love for both, and a desire to create a resource for my colleagues in photographic education. This book is a snapshot of photographic education in the first decade of the twenty-first century, based on interviews with 47 photo educators in six countries: China, South Africa, Finland, the United States, the United Kingdom, and Spain. I chose the educators from my personal network developed from more than 20 years teaching and 14 years as Chair of the Photography department at Parsons The New School for Design in New York. I sought to include a range of types of schools and programs, with an eye for diversity (although that, like photo education in general, is not as inclusive as I would prefer); to reflect my fierce interest in a global view; and finally, to include those faculty members who enthusiastically embraced this project. In interviews conducted either by Skype, phone or email, we talked about why students should study photography, the value of a four-year photography degree, teaching philosophies, whether video and multimedia should be an essential part of a photographic curricula, the challenges of teaching photography today, and changes in photographic education. In addition to sharing their time and ideas, my colleagues also shared assignments, which are as complex and multi-faceted as they are. These assignments can be adapted and altered as needed to invigorate our respective syllabi.

Based on these interviews—and my usual optimism—I have concluded that photography education is not in a crisis, and it is not facing a threshold of unprecedented change as some educators and critics have recently proclaimed. The photographic *profession* as we knew it may be struggling as it adapts to technology and social media. Education in general may be facing a crisis, particularly in the U.S., with top-heavy administration, the demand for "outcomes" and

"rubrics," the push for more part-time faculty, and the high debt load U.S. students acquire because we allow private lenders to set the loan terms, but photography education specifically is not. In spite of the dire predictions about the state of the profession, at least in the U.S., enrollments in photography programs are still increasing. Why? Because students know that photography is not dead. The photographic profession has changed for sure, but to fear the demise of photography is unfounded since each year we make more images than were made in the history of photography. In 2013, more than six billion images reside on Flickr; Facebook users have uploaded more than 240 billion images, and continue uploading 300 million daily; on average, users upload more than 27,000 images to Instagram each minute; and Snapchat users talk to each other by posting 80,630 ephemeral photos every minute. Photography is not dead. It is evolutionary and revolutionary.

These new concerns about photography education are criticism redux, it has been questioned and criticized almost as long as it has been a field. It first emerged in an institutional setting in 1929 when Walter Peterhans was appointed to teach photography at the Staatliches Bauhaus in Germany. Photography education came to the United States in the early 1940s when László Moholy-Nagy opened the New Bauhaus school at the Institute of Design (ID) at the Illinois Institute of Photography after the Nazi regime forced closure of the original Bauhaus. Coincidentally the ID was the same institution where Ludwig Mies van der Rohe hired Peterhans in 1938 to teach visual training to architecture students. Other photography programs appeared in the 1940s when prominent photographers championed the new field: Ansel Adams and Minor White at what is now the San Francisco Art Institute; Clarence White Jr. at Ohio University and Henry Holmes Smith at Indiana University. Moholy-Nagy also hired Harry Callahan, who

after a distinguished stint at the ID, joined the Rhode Island School of Design as the first head of the newly created BFA Photography degree program, which through its success sparked a proliferation of similar BFA photography programs in the U.S. and internationally in the last few decades.

Even as the study of photography thrived, it was criticized and interrogated. As early as 1971 articles appeared in important magazines questioning whether photography should be taught as a vocation or an art. Other debates swirled around whether a photo program should add color or only teach black and white (as an art form). We're having similar deliberations today, only now we parse whether we should teach technique or how much technique we should teach. We've replaced the color versus black and white debate with the analog versus digital or still versus moving image one.

In 1989, noted educator and critic A. D. Coleman, who stated he was pessimistic about the future of photographic education, declared that photographic education was suffering an "identity crisis" because photography programs existed in three distinctly different environments which he ranked qualitatively by value: the college or university, the art academy, and the polytechnic institute.[2] The disparity in programs, he noted, produced uncertainty in students, who couldn't be sure of their "destination" when they graduated. While his pessimism might have been premature, he astutely identified an underlying identity problem that still exists. Photography educators cannot agree on what should be taught or where photography should reside in an institution. Should it be a separate department or should it sit in design, fine art, or media and image? Where it resides fundamentally impacts how photography is taught—as a "fine art" or as a professional practice—but these differences are not always clear to the 17-year-old selecting colleges who might not realize that this choice will result in very different photographic educations. Essentially we are still debating how expansive the definition of photography should be. "Issues in photographic education definitely recycle and content changes but the questions always seem to be about how big the definition of photography is or should be," says Lorie Novak, Professor of Photography and Image from the NYU Tisch School of the Arts.

In the past few years, some educators have suggested that teaching students how to make and interpret photographs is obsolete. Given the ubiquitous nature of photography, it would seem that teaching students how to interpret images is increasingly important. As Jonathan Shaw, Associate Head, Media Department at Coventry University in the United Kingdom, notes, "[Photography] was more than a means of representation, it had become part of the conversation and a fluid form of communication." Barbara DeGenevieve, Professor of Photography at the School of the Art Institute of Chicago, adds: "Photography is one of the most important subjects that can be taught because aside from a skill base, it is a vehicle for understanding how the contemporary world has become what it is."

Other critics have posited that photography education and photography faces an "unprecedented technological, social and educational change" and even that it is at an "unprecedented historical threshold." Are photography and photo education really facing such an unprecedented change today? Photography, when it was invented, was as earthshattering to society as when writing was developed in the second century BCE. As a "mechanical" art, photography has always been informed and controlled by technological limitations, or advanced because of technological innovations. Are the changes imposed by digital technology really more unprecedented than when photography moved from the camera obscura to the fixed image? Or when cumbersome glass plates were replaced by film on flexible substrates? Or when the development of small cameras allowed photographers to be mobile? Critics worry that the malleability of the image in a digital world has "profoundly" changed the "truth" of a photograph. But as Picasso noted, art is a lie that reveals the truth. So is photography. Photography has always lied as it has told the truth. Although it is easier to manipulate a photograph using digital technology, photographic manipulation is not new. Photographers have always been manipulating images, just not in postproduction. Henry Peach Robinson glued, pasted, and rephotographed multiple images to create his Victorian melodramas believed to be true by his Victorian audiences. Roger Fenton moved cannonballs. Alexander Gardner dragged a dead soldier to the sniper's nest and added the wrong rifle for effect.

Photographic education is being transformed for sure, but more by the changes in education than by the development of digital technology. The new consumer approach to education and the focus on quantitative data impacts photographic education because creativity

is hard to quantify and photography educators cannot agree on a method, a definition of the medium, what essential skills should be taught, or even what a core curriculum is.

If photography education is so varied, and the type of education a student receives changes dramatically based on the choice of college or university, why should students study photography? The simple answer is that photography is the language of the twenty-first century and being able to think critically about and analyze photographs is an essential twenty-first century literacy. This is not a new or bold idea. In 1932 Moholy-Nagy asserted that, "The illiterate of the future will be the person ignorant of the use of the camera as well as the pen." It was prescient in 1932; it is reality today. Paul Hill, noted U.K. based author and educator, said it even more forcefully, "Photography is the most important art form of the last 200 years."

The photographic image has phenomenal power in our culture and more so now than ever when anyone with a smartphone has a camera and with that camera is a "photographer." According to Gartner, Inc., a leading information technology research and advisory company, more than 1.08 billion people own a smartphone, including half of all Americans, and global smartphone sales are projected to top one billion in 2013. The billions and billions of images taken with these smartphones are not the serious photography we teach, for sure, but they do communicate news of the everyday. "Put simply, photography constitutes the metaphysics of contemporary visual culture," says Catalan artist and educator, Joan Fontcuberta.

However, with the increase in the number of photographs produced comes a reactive decrease in understanding what a great photograph looks like. That understanding is the new required literacy and the core of a good photography education. As the language or the art form of the twenty-first century, students study photography to acquire fluency to fully engage in the present and be adaptable to whatever technological or communication changes the future holds. Email is virtually passé. Instagram now rivals Twitter as a microblog network, which some think will be replaced by the six-second video platform Vine.

Photography education is not in crisis because photography is not in a crisis. As photographic educators, we may be having a crisis of confidence—still struggling to justify our discipline, to shed our craft roots, to be allowed to sit at the adult art table. This is reflected in the debate that goes on in academia about whether we are artists or photographers and an academic culture that preferences a fine art photography program even when it sits alongside a practice-based program. By engaging in that debate we are devaluing our discipline. Or as noted photographer Catherine Opie, who with a 2008 retrospective at the Guggenheim Museum in New York qualifies as an "artist," says of the art versus photography debate: "The problem is that I don't really understand these categorizations. It just goes back to this older position of photography not being art. It's always been a quandary with me because although I am a photographer's photographer I was funneled into the art world as an artist, not as a photographer."

Photography education is not at a crisis point if we shift its goal from being the means to the end to being the beginning. The challenge for photographic education will be to toss off the shackles imposed by the "art" world and broaden the definition of photography. Photography is an art form, no doubt, but to teach it only as that is restrictive. It is reductive to justify photography only to the extent it is validated as fine art. Or as Jean-Claude Chamdoredon wrote, "The wish to cultivate photography as an art means condemning oneself to a practice that is uncertain of its legitimacy, preoccupied and insecure, perpetually in search of justifications."[3] We need an open and innovative educational approach to photography, to be more expansive in our definition, to embrace the moving image. We should be working to integrate photography into every discipline, or as Fontcuberta suggests, teach it in the political science department or the philosophy department. Maybe we should resist the urge to use adjectives to qualify photography and just teach it comprehensively.

We should stop justifying our value by how many of our students become "photographers" and focus on transforming them into educated, technologically savvy citizens. We should act like the English or History departments. No one expects a liberal arts program to defend its viability on the basis of how many of its English graduates become novelists or poets, nor how many who study history become historians.

However, to slightly contradict myself, even though anyone with a smartphone can take a picture, everyone with a smartphone is not a photographer. Let's defend a photographic education by explaining how difficult it is to become a good photographer, and explain that

learning to analyze photographs requires the same level of intensive study that learning to analyze literature does. Our discipline is far more complex than it seems and students (and the public at large) confuse the skill set that comes with a good DSLR with being visually literate. There is a profound difference between taking and making a photograph and an even greater difference between making a good or a great photograph. Or as my colleague Bill Gaskins at Cornell University notes: "Engineering students don't call themselves engineers and medical students don't call themselves doctors, but photography students call themselves photographers."

Almost none of the hundreds of billions of photographs on Facebook really matter to anyone other than the Facebook user who posted them and her Facebook "friends." They are not lasting images, or artifacts that invite the viewer to engage with the world. They do not contribute anything meaningful to cultural knowledge. They do not impact our consciousness or have a profound impact on us as a society. Great photographs do that. Of course studying photography doesn't guarantee that a student will ever make a photograph that matters, but it improves the odds. If we do our jobs well, then some of our students will produce photographs that matter and that will have a lasting impact on cultural knowledge.

Even if a photography student never quite makes a photograph that really matters, he or she is still acquiring transferable skills. Studying photography teaches the skills to think critically, independently, and creatively. It imparts the skills to solve problems, be resourceful and disciplined. Photography students acquire the ability to work on a complex project that has no imposed parameters, and the courage to hear criticism week after week. I realize these sound like platitudes to calm anxious parents, but Lorie Novak tells the story of one of her students who while applying to medical school was working as a researcher in a cancer research lab and thought the critique skills she learned in photography helped her critically question what she was doing and present and defend her research. Novak had another student working as an Emergency Medical Technician (EMT) before applying to medical school who believed that studying photography made him a better EMT because he was able to go into an emergency situation and very quickly make visual order out of the chaos.

In my conversations, the question of when and if to teach theory always arose, or more precisely how much critical theory to teach at the undergraduate level. While most faculty believed that critical theory must be taught, and by theory I am referring to the competing postmodern canons, a few didn't. Stephen Shore, for example, thinks that while undergraduate students should study photographic theory, most academic critical art theory belongs in graduate school. Undergraduate students need basic visual competencies before they confront postmodern theoretical concepts. So I would suggest that at an undergraduate level, before we introduce students to postmodern theory as a way to understand photography, we must first teach them how to make photographs. "While there is a place for theory, it is backwards thinking to teach it first," says Sian Bonell, Associate Professor, Photography at Falmouth University in the United Kingdom. "I teach my students that although theory is valuable, it must not lead the work."

We should consider introducing students to photography as a process of seduction rather than through theoretical concepts. We should ask students first: What do you love about photography? What was the first photograph that stopped you in your tracks with that fraction of a second moment of magic, the visual lyricism that just exploded your brain and made you want to be able to make that kind of photograph? We should help students understand what it is about a photograph that can make them feel something so intensely. Is it the unique way film or a sensor renders light? Is it how a piece of something at the edge of a frame suggests endless possibilities? Or is it, as with an Atget image, the suggestion that the quiet moments in life are critically important because there are more quite moments than decisive moments?

What surprised me most from my interviews was how conservative most programs seem to be. Almost without exception, everyone justified teaching black and white silver halide printing with some valid reasons, but also some reasons that were reductive or nostalgic. It seems to me that holding onto black and white processes is holding onto our one last bastion of technological specificity. Maybe we should consider whether there are more essential skills or concepts a student needs to learn. Is holding on to black and white printing holding us back because it locks us into the cult of the single image?

I was surprised that in 2013 video has been fully embraced by only a few photography departments even as digital convergence has blurred the boundaries between the still and moving image, text and image, and sound and image. We know that technology is leading us to the point where soon there will be no distinction between still and video cameras. Admittedly, technological advancements alone shouldn't drive curriculum, but photography educators could be more innovative and lead the charge to merge with film and media departments. We could embrace these new multilayered and interactive possibilities, so that students will be able to move seamlessly between photography, video and new media (and change the definition of photography and photographer). "It's just parochialism to protect the sanctity of a still photograph and not teach video," says Larry Fink, Professor of Photography at Bard College. "Why would you want to not teach something that is available and incorporated into associative life?"

Online education has almost no role in most photography departments. When I use the phrase online education I am not referring to Massive Open Online Courses (MOOCs), rather innovative thinking about how to implement technology to connect students globally and deliver information on more than one platform. The most interesting online work was being done at Coventry University, United Kingdom, in Picturing the Body (#picbod) and Photographic Narrative (#phonar) by Jonathan Worth, Jonathan Shaw, and Matt Johnston; and in the U.S., out of the computer science department by Jim Groom and his team at the University of Mary Washington in Virginia. They developed ds106 or Digital Storytelling, a psychedelic trip down an interactive rabbit hole, going strong in its third year.

So what are the challenges for photographic education in the twenty-first century? Photography education needs to shed restrictive ideas and language and be expansive in the definition of photography. It should stop describing new media in terms of old media, as Marshall McLuhan suggests. We need to think about the idea of the image as being active. Our main challenge is to redefine the medium and understand that we are going through the second paradigm shift for photography as the image breaks away from the artifact. (The first paradigm shift occurred when photography broke away from painting.) We must recognize that there is a difference between a printed photograph, which is an artifact, and a digital screen-based photograph, which is an image comprised of ones and zeros. "The artifact is fixed in time and it looks backwards; it has a provenance," says Worth. "The digital image is unhitched from time and space and it looks out. Artifacts and images are widely different and students need to understand why. If students aren't engaged in that dialogue, then they are ill-equipped to deal with the contemporary photography world."

The only thing certain about photography and photographic education is that it is changing, but it has always been changing. The changes today when seen 50 years from now will not appear more earthshaking than the moment when we figured out how to fix an image. It only seems to be more relevant or unprecedented because a new epoch has arrived and we are living through it. Most faculty are the transitional generation of image makers, unlike our students who are the new image makers.

If we can remain open to the fluidity of ideas about photography and images, the twenty-first century will be an exciting time for photographic education. If we succeed in becoming post-photography programs and departments, then the question of the future will not be what is the purpose of a photographic education, but what is the value of an education without photography?

NOTES

1 Bernd Stiegler, *Bilder der Photographie (-) Ein Album photographischer Metaphern* (Frankfurt am Main: Suhrkamp, 2006).

2 A. D. Coleman, "Identity Crisis: The State of Photography Education," *Photo Review* 12:2, Mar. 1989, pp. 17{-}19. Reprinted in A. D. Coleman, *Tarnished Silver: After the Photo Boom, Essays and Lectures 1979{-}1989* (New York: Midmarch Arts Press, 1996), pp. 49{-}60.

3 Jean-Claude Chamboredon, "Mechanical Art, Natural Art: Photographic Artists," in Pierre Bourdieu, *Photography a Middle-brow Art* (London: Stanford Press, 1996), p. 129.

CHAPTER ONE
PHOTOGRAPHY
CONFIDENTIAL:
EDUCATORS
SPEAK

THESE INTERVIEWS were conducted in late 2012 and the first half of 2013, either in person, via Skype, telephone, or email. The full conversations were all much longer than what appears in this chapter. I edited and condensed the transcripts but strived to maintain my colleagues' voices by presenting their ideas as thoughts about general topics. A few conversations appear in a traditional question and answer format because that format seemed most appropriate. Yet, as with a photograph, I bear sole responsibility for what was excluded and what was included. These interviews do not and cannot represent all the ideas these photographers, artists, and educators have developed from a lifetime of teaching photography and making photographs. They should not be read as formal academic essays. They are *conversations* about photography and teaching photography and they should be read in that spirit.

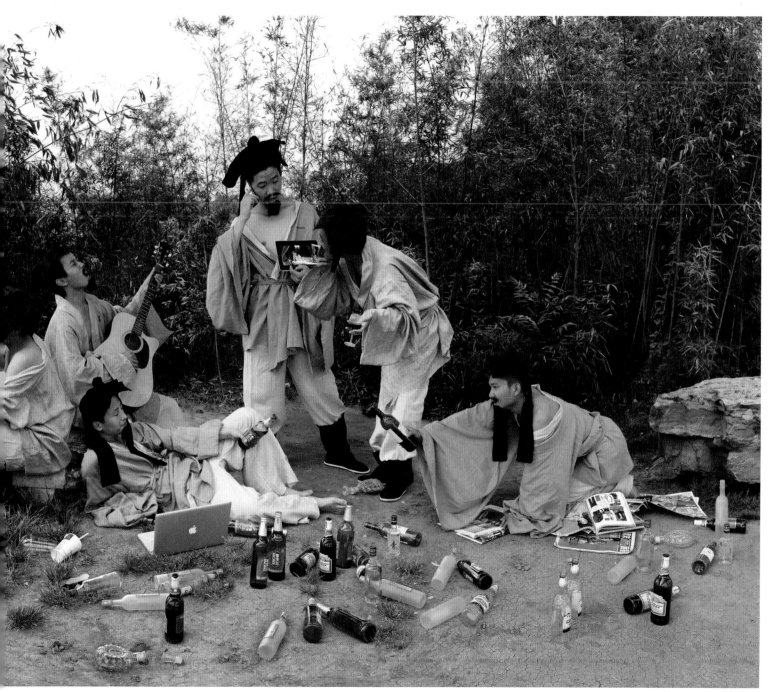

Sama Alshaibi

Associate Professor of Photography/Video Art
University of Arizona, Tucson, Arizona, United States

http://samaalshaibi.com

It is a difficult process being an artist. It is a very hard world. If you can't get yourself up in the morning to make work that matters, why are you in this field?

ON TEACHING PHOTOGRAPHY

I believe that art and photography can be taught. One of the problems I face here in America—I teach workshops in the Middle East—is that the average student has a lot of technical ability but also some bad habits. Students here have grown up taking pictures and looking at pictures but they don't necessarily know how to *make* pictures. That might be more obvious here at the University of Arizona, where we are neighbors to the Center for Creative Photography (CCP). We have the archives of all the masters, and students come here with a romantic idea of wanting to do large-format black and white landscape images, but that is not just what I want students to be thinking about. I have to push them to think about what else photography can be. I don't like to teach just the Western canon because they have too many professors who teach that, so I try to promote a transnational idea of looking at photography and how it can be used to advance socio-political issues.

I demand that my students work hard. I have high expectations of them and of myself. You come to my class, you have to work hard, but I am always available. I would never just write a little line with a grade; I provide substantive feedback. I try to reach all students with whatever works: humor; field trips; collaboration; talking about issues of gender, race, or sexuality, as long as the discussion is productive and respectful.

I also always assign a collaborative project, usually towards the end of the semester. I don't let students pair up themselves. We draw names, because especially for undergrad students, they have to learn to work with people they may not know well. This replicates the model they will find themselves in when they work in the professional fields. I find that teams of three work better than teams of two. We choose a theme for the assignment. It works really well when it has something to do with magical realism or staging constructed realities because of the amount of work involved, and the diversity of production that draws on their different strengths. I show them a number of collaborative artists, such as Robert and Shana ParkeHarrison, and explain how those collaborations work. The students benefit because they learn to lower their egos and think about the end result.

> Students here have grown up taking pictures and looking at pictures but they don't necessarily know how to **make** pictures.

ON PHOTOGRAPHIC COLLABORATION

I have collaborated a number of times, plus I was in a woman's art collective for five years called 6+.[1] As an artist you can work alone, you can hire people to work for you, or you can work in collaboration. School is a good opportunity to model these types of creative practice, particularly the collaboration model. I attended both Columbia College in Chicago and the University of Boulder in Colorado. Even though I had a great education in both schools, it was really interesting to participate in the culture of the competitive art school. It was more cut-throat, focusing on the class "art star" as if to emulate the art world.

I don't believe in creating that environment in my classes because it values the "star" student too much. There will always be the super-mega art stars but there also will be artists who won't necessarily be on the map of fame, but they will have a practice that's meaningful to them or to their community.

I'm not trying to deflate the idea of competition, but I don't feel competition needs to be something external. It can be internal; you compete only against yourself. That's why I like collaboration. As I explain to my students, collaboration isn't useful if someone else is picking up the slack for you, or because there are more people doing it and there's less work for you to do. Collaboration works because when you are working with someone else, you have to put your best foot forward because you all are responsible for the grade and the successful completion of a meaningful project. Collaboration builds community, and as artists we need each other.

ON TEACHING VIDEO

I love teaching video because students don't come in with a preconceived idea of what being a video artist means. (We have a very strong high school photography program here in Tucson, so students come with a lot of rules about what photography is and isn't.) Video is a bit of an enigma for them so it's a fresh slate. Video is a difficult medium because it embodies so many types of media: time, image, sound, editing, lighting, and performance. But because they don't come with preconceived ideas, I don't have as much resistance and they trust me to teach them more holistically.

ON TEACHING ANALOG PROCESSES

Teaching technique is important because it is a position of authorship and authority within your own work. We teach all processes and all camera formats in my program. We believe that being able to control photographic materials is part of the formal delivery message. I see the difference that technical skills make because I am submerged in the art scene in the Middle East and North Africa, where some incredible artists have amazing, interesting, and sometimes subversive things to say, but they don't always have the technical education or facilities to work in. So the work suffers from poor execution and that can hurt the artist because she or he won't be taken seriously. I use this as

examples for my students all the time so they can see how the work would have more impact if it had better technique or the artist thought more about certain kinds of formal issues.

ON CHALLENGES FOR PHOTOGRAPHIC EDUCATION

Some of my perceptions might be unique as an educator because we're surrounded by Native American reservations in Arizona and we have many Native American students in our classrooms. They're struggling with a different set of issues than most other students because they are passing back and forth between two different communities of lifestyles. One of the challenges is to teach why art matters when students are facing basic problems of poverty and social structures that don't fit in the master narrative of the American Dream. Students who come from underserved communities sometimes have more to say in their work; their lives are a struggle and that struggle can find its place in art without having to reach too far. I'm not saying that students who live privileged lives don't have anything to say, but it does take a lot more work to unravel the kind of boutique issues that they first want to talk about, the surface identity issues, friends, family, or struggling with college life. My challenge is to get them to engage in the world around them more critically, and focus less on the work being an exercise of self-therapy. It often takes a lot more work for those who come from communities of privilege, who didn't grow up contending with survival and their place in society; whereas you get a student living on a reservation and they tend to have lived their lives negotiating survival, which often leads to very powerful work. Ultimately, all my students are capable of making powerful work; they all have unique challenges realizing them. Also, it is important to allow each student to express what she wishes in her work. I don't assume a student that comes from dire experiences wants to talk about that in her work. We work together to materialize what she wants to say in a powerful format.

I have a friend, Meir Gal, who teaches in New York City. He tells his students not to go to galleries or museums for ideas. He wants them reading newspapers, listening to Pacifica,[2] thinking about struggles that are unfolding around them. I don't agree with him 100 percent, but I'm pretty close to where he's coming from. I want students to engage in the world around them. My students will say to me, "I am not like you. I'm not an Iraqi Palestinian who grew up in war and conflict."

My response to them is that there are so many issues in the U.S., but they are letting those issues pass them by; many are approaching the issues of their times as if they don't concern them. They are disengaged and I don't have much tolerance for that. It is a difficult process being an artist. It is a very hard world. If you can't get yourself up in the morning to make work that matters, why are you in this field?

ON A FAVORITE CLASS

I designed a class entitled *Discovering Place*, taught online in our pre session of summer school. I wanted to do something that would be integral to who I am as an artist; I travel a lot because most of my work is based in the Middle East and North Africa. The class deals with bodywork in "place," and how to use one's own body to tap into a new space, community, landscape, or location. It addresses how you can quickly penetrate a community or a location through a different kind of tool, your body, which includes all of your senses. Since it's online, most of the students are traveling when they take the class, so twice a week the students receive prompts, which are basically walking exercises. One exercise requires the students to map one of their senses, and only pay attention to that sense. Others are more directed, such as following desire lines in the land or in a social sphere, not a pre-made line like a sidewalk. One direction involves going through a space twice, once with the cocoon of an iPod, and once without, and be cognizant of how the experience changes. For instance, without blocking out the ambient sound that exists in space, we tend to be more present; we look at the people around us. The students realize that their own experience shifts based on what decisions they are making (cocooned or present) and how that develops their understanding of place.

I like it when students walk where they're not supposed to be walking, trying to discover the social aspects of a space. They make images, but they can use any tool: cell phones, cameras, a scanner, or just journal writing. The end result is not about making work, but about discovering a place, revealing what's underneath the surface. With mass media permeating around us, and in a generation where cameras are prolific (on our cell phones, laptops, etc.), we cease to really "see" anymore. This allows experiencing on new terms, which hopefully shifts the way they "see" and more importantly, experience the world around them.

Some of my students took this class two or three times because they felt it helped them in their photo classes afterwards, because the exercises shifted their focus from not just looking and composing a shot but to understanding the layers underneath an image and their own connection to it.

SAMA ALSHAIBI is a multimedia artist working in various media, including photography, video, video/object hybrids, multimedia installations, and sculpture. In her work, Alshaibi, who is Iraqi and Palestinian, focuses on spaces of conflict: the aftermath of war and exile, the power dynamics between the nation and its citizenry, and the interaction between humans competing for resources and power. Issues of war, occupation, and exile often share the stage with a female protagonist. Her work has been exhibited and/or screened nationally and internationally, in venues in Dubai, London, Venice, Paris, Tunisia, Egypt, Greece, Kosovo, and the U.S, among others. She holds a BA in Photography from Columbia College, Chicago, and a MFA in Photography, Video, and New Media from the University of Colorado at Boulder.

David Bate

Professor, Photography
University of Westminster, London, United Kingdom
www.davidbate.net

It is shocking that visual criticism including photographic studies is not taught in schools alongside an analysis of language, cinema, television, and the Internet as key forms that mediate the modern world—but those are not always taught either.

ON WHY STUDY PHOTOGRAPHY

There must be a hundred and one personal reasons that people study photography, most of them to do with curiosity, in one form or another. In the public realm, universities have taught courses since antiquity on the things relevant to their societies: the art of rhetoric, cooking, cosmetics, geometry, music, etc. Photography has joined the list as one of these things today, and rightly so. Education is for the acquisition and use of knowledge—the best photography programs do this too, teaching students to understand how to ask their own questions through making photographs and essays. Photography has a global presence even if it is not a universal language, as global advertising campaigns already found out to their detriment. A positive message in one part of the world may not be positive in another. For this reason alone, photography should be taught to everyone. It is shocking that visual criticism including photographic studies is not taught in schools alongside an analysis of language, cinema, television, and the Internet as key forms that mediate the modern world—but those are not always taught either. These media forms have increasingly come to mediate the university itself; so to not understand what makes them work is a new form of illiteracy.

ON PHOTOGRAPHIC EDUCATION IN THE TWENTY-FIRST CENTURY

Since anyone can take photographs now with no technical knowledge whatsoever, the interesting question is indeed what role education has in relation to the photographic image in its twenty-first-century changed forms. With ever-increasing automation, education is no longer needed to "teach" the technical operations of basic photography. Cameras, computers, and online tutorials can teach users how to use cameras, although this is still not true of more complex professional equipment, where techniques, processes, and printing are still highly specialized. Yet the automation of photography also means that fundamental functions of a camera and lens can become obscure or lost, with ignorance of the effects of lenses, apertures, camera shutters, and the effects of types of prints, for example, essentially creating a de-skilling of photography. On the other hand, automation also means a photographer can attend to other matters, and the new miniaturization of HD cameras means new types of images can be made. A modern curriculum will acknowledge and address these different issues as part of its process of questions about photography, its history, and the theory of photographic images.

Many courses seem to still be taught along the lines of a twentieth-century curriculum, even if the materials have been updated to "digital" technology. While some of this is surely merited, many of the basic presuppositions about photography that a student arrives with "in their head" are no longer the same as they were even fifteen or twenty years ago. Failure to recognize and adapt to this and address the new ideologies will make those photography departments look like most painting departments do today—confused and stuck in a set of questions that belong to another era.

We often hear that education needs to be "innovative" or teach "creative thinking." Being "innovative" means thinking or working on problems that do not yet have a solution, that is, dealing with the new issues, not the old ones. The term "creative thinking" is perhaps an

oxymoron. What often passes for creativity is no more than a random idea. Real inventiveness comes from everyday madness, practical observation, and dealing with practical and technical obstacles. I am with Ernst Gombrich on this, who said that "making" is based on trial and error,[3] or as someone else once said: one percent inspiration and ninety-nine percent perspiration. Thinking comes from the intellect, logic, or concepts, so putting together logic and the imagination via a technology is perhaps less easy than imagined. "Thinking" can often stop creativity, just as well as aid it. Yet all these things should come together and interact for an education program to really work well.

We live primarily in a media environment, especially within metropolitan areas, and experience multiple, mixed image message flows, which demand different skills and education on how to understand those images, or even the complex pleasures we get from them. It is a critical project today to teach students fundamental critical theory skills, including history, sociology, semiotics, and art criticism of the image to help them distinguish the different functions of photography, and the real critical issues involved across different types of photographic image.

ON COMPUTATIONAL PHOTOGRAPHY[4] AND ITS IMPACT ON EDUCATION

There is no doubt that computerized images are subtly (and sometimes less subtly) changing the fields of photography, video, video games, and cinema, with all kinds of effects on perceptual reality. In a way these types of altered perceptual images are creating one of the themes that is a critical issue, and across many examples of new attention. One of these, for instance, is the new feminisms (see for example the website "miss represented"), which are acutely aware that shrinking women's waists and creating featureless faces in Photoshop images has a correlation to the styling of "body image" in women's cosmetic surgery. Real bodies are linked to images in new ways. Such is the mutating field of visual culture. In a more abstract way such issues are also linked to the new space of "personal photography" that has quickly come to lead many website developments. Yet these also offer new opportunities to create artworks; using the algorithmic computations that search engines use to "organize" work is a way to compute new "work."

Photographic education and its practices must address and explore these issues. The warnings about a society that has lost control of its techno-scientific operations, or given too many responsibilities to them has long been a theme of fantasy, but it also addresses real anxieties emergent in industrial and "computerized" societies. In education at least the photographer should be in control of her images, indeed a student being able to "read" her own images is a fundamental component of her education. How else can someone know anything about what she is doing if she doesn't understand something at least about her own work?

ON A TEACHING PHILOSOPHY

Never say no. Shoot first, ask questions later, then ask questions and shoot again.

ON THE MOST VALUABLE LESSON LEARNED IN SCHOOL

I am forever grateful to that teacher who made me see, for the first time, that photography has rules and how developing some approaches to this could help me do what I want. Discipline is double-edged; it is about control, but that enables something to be broken too.

DAVID BATE is a visual artist, writer, and educator most well known for his work on surrealist aesthetics and avant-garde photography. He was one of the first British photographic artists to experiment with digital photographic processes, creating the innovative series *European Letters* in 1992. His work has been widely exhibited and published, including the monograph *Zone*, published in 2012. His critical writings include two books, *Photography and Surrealism* and *Photography: Key Concepts*. He is currently Professor of Photography at the University of Westminster, London, United Kingdom. He holds a BA in Film and Photographic Arts from the famous Polytechnic of Central London course, an MA in Social History of Art, and a PhD from the University of Leeds.

Steven Benson

Professor of Art and Chair, Interactive Media
Southeast Center for Photographic Studies,
Daytona State College, Daytona Beach,
Florida, United States

www.stevenbensonphotographer.com

[A] good photography education that teaches students to listen to what their photographs are saying will help them discover who they are in relation to the world they live in, and which issues are significant to them.

ON THE VALUE OF STUDYING PHOTOGRAPHY TODAY

I don't believe it is a requirement for someone to study photography formally in order to make interesting or meaningful photographs. For example, Roger Ballen[5] studied geology, not photography. His photographs are intriguing, in part, because he hasn't had a lot of the same exposure to, or ways of thinking about, image making, that photo majors generally receive. In a recent *New Yorker* magazine article the writer commented about how the relationship between geology and Ballen's photographic practice brought things to the surface. It is also worth noting that Ballen thinks of photographs as akin to fossils. That said, a good photography education that teaches students to listen to what their photographs are saying will help them discover who they are in relation to the world they live in, and which issues are significant to them. Photography graduates also have a sense of responsibility concerning the impact of the images they create. A relevant photographic education should teach students the importance of collaborative processes—a very important skill set to have in the twenty-first century.

ON TEACHING PHOTOGRAPHY

In our program we teach conceptual processes and creative problem solving with an emphasis on technical skills, because the technical aspect of photography is the core of the process of learning how to express ideas. It's the difference between learning to speak English exceptionally well, rather than reasonably well. The more you're able to understand the vocabulary, the more you're able to express yourself in an increasingly complex and meaningful way, so photography students

This untitled image was taken for an assignment, Randomized Subject, which Steven Benson gives to replicate what might happen once students are working professionals. He prepares a series of random prompts, such as war, money, religion or love, all open to open to numerous interpretations. Students draw a theme and have one week to complete the assignment.

Image courtesy of Megan Hart

need to have several possible options for expressing their ideas. Today that includes multimedia, video, and interactive authoring tools such as 3WDOC, Popcorn Maker, Storyplanet, and Zeega among others. Even from a purely fine art point of view, the complexity of visual imagery has evolved to the point where all of these technologies become important elements of an overall language.

The strong technical component to our program includes a required ten-week summer session for students. We teach large-format photography, color theory and processes, and multimedia. As it relates to the current conversation on the subject of teaching large-format photography, this is the only time the students will be introduced to large format as a tool and as a photographic methodology. Students are not required to use large format in the curriculum; it is another option for them to consider if they feel it makes sense for what they are trying to accomplish.

I've noticed over the past couple of years students have been questioning why they're being "forced" to learn the view camera because at first they don't see a need for it. Their attitude quickly changes once they understand that a view camera slows them down and it is a process that makes them more conscious and selective of when it is worth the effort to make a particular photograph. I'll explain that making images can seem easy and fast when you are using a 32-gigabyte card. Making a thousand exposures of a subject from every possible angle is a good way of learning what works and what doesn't. These decisions will generally take place during the review of the thousand images—after the fact. Because of the difference in the approach required by the slowed pace of photographing with a view camera each subject is carefully considered before making an exposure. It is my feeling that both methodologies have an important role to play in the development of a photographic vision.

ON THE IMPACT OF DIGITAL TECHNOLOGY

The impact of digital technology is, and will be, related to the extent of the visionary use of the technical innovations. Ultimately, I think it is about what kind of tools we have available to us that are going to

make the visual material we create more closely relate to what we feel about what we are shooting or what we want to express to a viewer. If we use these digital tools to get us closer to that, then it is significant. However, if those tools are being used in the same vein of the saying, "If you can't make it good, make it big, and if you can't make it big, make it red"—to turn something that has no relevance, whatsoever,

A relevant photographic education should teach students the importance of collaborative processes—a very important skill set to have in the twenty-first century.

into something that looks like it does—if it is a result of a flawed visual sensibility, then this use reflects a step backward. (I must add that the idea of giving meaning to something that has little meaning is an intriguing notion.)

My greatest concern relates to the unprecedented increase in the number of photographs being produced. It seems to me that as a result of this inundation of visual material there is a reactive decrease in the understanding of what a truly great photograph looks like. This might partly explain why professional photographers are being let go from an ever-growing number of newspapers and writers are given the responsibility to photograph. There is the real danger of having a drive toward excellence replaced by an acceptance of the mediocre as good enough.

There are two primary elements of photographic practice that I consider vital for students to master as we look toward their future: one is an understanding of how to light in a variety of situations and the second is to understand how to recognize a great story along with the narrative intelligence to tell the story in a meaningful way on a variety of platforms. This is what will separate skilled professional image makers from those who simply own a good DSLR and know a little Photoshop.

ON PHOTOGRAPHY

I was definitely seduced by the idea of photography as a transformative process. Around the age of fourteen I noticed there were a lot of very good publications lying around the house that had some remarkable

photography in them. I was intrigued by what I saw. Later in life, when I was perhaps a bit wiser, I realized that a photograph is always as much about what is left out as what is included. A photograph creates a new context for the subject, so the "thing" can be seen in a way either in which it couldn't previously be considered or presenting the subject in a way that it was never intended to be seen. I think that complex photographs identify points in space where internal and external intersect. Every photograph has a surreal quality, and I love that.

ON A TEACHING PHILOSOPHY

My teaching philosophy focuses on looking inward as much as outward. When a student responds to something and feels strongly enough about it that he wants to photograph, print, and show the image in a critique, I want him to think what it is about that photograph that means so much to him. What are the qualities? What do these qualities tell us? My goal is always to help students make the kinds of photographs they are motivated to produce. I really try to germinate a rich learning environment. I have no problem going off on tangents that on the surface don't seem to be related to photography, but are responses inspired by images we are seeing during a critique.

ON IMPORTANT LESSONS LEARNED ALONG THE WAY

I learned four important things from four different people that caused paradigm shifts in the way I was thinking about photography. The first was Jean-Claude Lemagny at the Bibliothèque Nationale in the late 1970s. He looked through my work, maybe sixty prints. There were landscapes, cityscapes—a very wide variety of subject matter made in different parts of the world. The thing that he said that really stood out to me was, "Even though all of these subjects are very different from each other, the soul of the images are the same." Thank you, Jean-Claude, for that. The second was Andre Kertesz. I used to visit him at his apartment in New York when I was in my early twenties. I was one of those photographers who didn't carry a camera all of the time and only photographed if I went out on photo missions. On my way to visit Andre one day I saw something that absolutely blew me away—I wasn't able to make a photograph of the situation because I didn't have my camera with me. Clearly aggravated, I told Andre about what had happened and he just smiled, tilted his head a little bit, and

said, "Steven, always remember it's more important to *see* something than it is to photograph it." The third was Jean Baudrillard. I happened to end up at a picnic with him in Arles.[6] He was interested in my Three Gorges Dam project.[7] Recalling his commentary on what happens to the photographic image when it's separated from its referent, I was curious about his thoughts, because this project, on the Yangtze River Valley, was done before the Three Gorges Dam transformed the area when the reservoir filled behind the dam in 2003. So, in fact, the photographs were not just separated from the referent—the subject of these photographs had disappeared from the face of the Earth. And, he said, "It doesn't matter one way or the other because the photograph isn't a document, it's a fiction." And the fourth lesson: I must gratefully acknowledge the intellectual gifts offered by my professor in graduate school at Cranbrook Academy of Art. Carl Toth taught those of us who had the honor of studying with him how to uncover the armature of visual imagery and the insight to understand the intricacies of the relationship between theory and practice—how we create meaning.

STEVEN BENSON has been an educator in fine art and commercial photographer for more than thirty years. He is a Professor of Art and Chair, Interactive Media at the Southeast Center for Photographic Studies, Daytona State College in Florida. His commercial client list has included AT&T, Ford Motor Co., General Motors, Unisys, Allied Signal, and the Canadian National Railroad, among others. His fine art work has been exhibited at the Centre Georges Pompidou in Paris, as well as at photo festivals, biennials, and triennials in Argentina, South Korea, Germany, Syria, Poland, China, and Denmark. His first book, *The Cost of Power in China: The Three Gorges Dam and the Yangtze River Valley*, was published by Black Opal Press in 2006 with essays by A. D. Coleman and Dai Qing. He holds a MFA from Cranbrook Academy of Art.

Sian Bonnell

Associate Professor
Falmouth University, Cornwall, United Kingdom

www.sianbonnell.com

I tend to see the camera in its original manifestation as a camera obscura, as a space for the imagination.

This image comes from a collaborative "virtual" Exquisite Corpse project that Sian Bonnell ran with a small group of graduate students: Anne Mortensen, Armenoui Kasparian Saraidari and Fedor Toshchev. Students chose one of Bonnell's images as the starting point, sparking her response and then student responses until the project ended 10 weeks later.

Image courtesy of Sian Bonnell, Anne Mortensen, Armenoui Kasparian Saraidari, Fedor Toshchev

ON TEACHING PHOTOGRAPHY

I'm not a trained photographer. My students probably have more technical skills than I do. I don't know how to light with studio lights, for example. I prefer to light with odd equipment, things like torches[8] and other ordinary things that I have lying around. My background was in fine art. I always joke that I was a spectacularly bad sculptor—which is how I became a photographer because I had to record my sculptures before they fell down—but this isn't literally true. I tend to see the camera in its original manifestation as a camera obscura, as a space for the imagination. Subjects, ideas, and light enter the camera interior, get all mixed up, turned upside down and the image that comes out the other side becomes something entirely new. That's the basis for how I conceptualize and teach photography.

Unfortunately, nowadays, I think there is a temptation to teach students what to do to pass assessments or to look for theories to create work around. Whilst there is a place for that, it can be backwards thinking. I try to teach students that although theory is valuable, it must not lead the work, and that unless they absolutely love what they're doing, they're not going to stay focused or push the boundaries in their practice. I try to encourage students to let go a bit and risk not making such safe work. I want them to understand that it's okay to go to the brink of failure and come back from that, because that is how they will learn. I think the best way to learn is to identify what went wrong, and work out how one might have done it differently.

> I try to teach students that although theory is valuable, it must not lead the work, and that unless they absolutely love what they're doing, they're not going to stay focused or push the boundaries in their practice.

ON WHY TO STUDY PHOTOGRAPHY

Studying photography lends itself extremely well to a form of creative thinking useful in all kinds of life and employment situations. It instills self-confidence and the skill to glean information from any circumstance. What I find exciting about photography is that in almost every situation, either in discovering art, history, or the news—whatever is happening in the world—it is always via the still or moving image. So photography has the most incredible power.

SIAN BONNELL, who has more than twenty years' experience teaching photography, is a widely exhibited and published award-winning artist who is known for her earlier work utilizing found objects and household articles placing them out of context within her rural and coastal environment. She photographed these interventions as documents not just of the object, but also the event. She also runs TRACE, a curating and publishing project, from her home in Cornwall where she is currently based. Dewi Lewis Publishing published her book, *Everyday Dada*, in 2006, and her work was featured in *Auto Focus, the Self Portrait in Contemporary Photography*, edited by Susan Bright and published by Thames and Hudson. Her many awards include twice being nominated for the Prix Pictet, an honorary fellowship in the Royal Photography Society and a Photoworks fellowship at the British School at Rome. She holds a BA (Hons.) from Chelsea School of Art, United Kingdom, and an MA in Fine Art from Newcastle upon Tyne Polytechnic, United Kingdom.

ON THE FUTURE OF PHOTOGRAPHY

It's a big question. We hosted a symposium where we asked what the future of photography was. One person in the audience said simply "sound." I thought that was an interesting answer because of where video sits in photography courses. Once you introduce video, students actually start to engage with photography a little better. They realize that everything doesn't have to be so big. They can make slideshows with sound. They can project an image. So I think the future of photography has to include motion and sound.

ON TEACHING TECHNIQUE AND DIGITAL PINHOLE PHOTOGRAPHY

Technique is essential, and at Falmouth we teach both analog and digital techniques. For example I often introduce them to "digital pinhole" as a method to integrate analog with digital. Digital pinhole images are so beautiful because they have a very soft color reminiscent of early photography. To make a digital pinhole, students can either buy a properly calibrated pinhole online (at pinholesolutions.co.uk) or they can make one by drilling a quarter-inch hole in a body cap, and then with gaffer's tape, attaching either a brass shim or some kind of fairly thick foil that has been pricked by a pin to the back of the body cap and putting the body cap on a DSLR. What's cool about digital pinhole is this marriage of old and new. It's a great way to show students how photography really works.

Jean Brundrit

Senior Lecturer, Photography
Michaelis School of Fine Art, Cape Town, South Africa

www.michaelis.uct.ac.za/staff/brundrit

Just as we teach English as a school subject, we should be making a case to have visual literacy taught in schools because even though photography is a language, I am not sure that photography is a universal language.

ON THE NEED TO TEACH TECHNIQUE

Technical skills are important for controlling the visual qualities in the final image, which in turn influences how the image is read. To speak clearly, students need a technical vocabulary. That should still include analog processes because film and silver prints have different qualities than a digital print does. Darkroom printing still has a "magic" experience to it and it has a historical relevance that gives a richer and broader photographic education. The experience of taking a few hours to make a print gives students an opportunity for real examination, both of the print and of themselves as art makers. The question is where to put analog processes in the undergrad curriculum, not whether they should be there.

That said, photography programs shouldn't focus just on teaching technique. Students should be taught central core competencies, but then they should be expected to teach themselves additional technical skills as needed. We should provide them with the skills so that they know where to look for more advanced or varied technical information.

ON TEACHING PHOTOGRAPHY

We should encourage visual intelligence by challenging students with innovative projects and encouraging them to extend themselves as practitioners. I try to engage with the students' ideas and help them to tease them out and develop their concept. I make suggestions but encourage them to make their own decisions and own their images. In a nutshell, my teaching style is engaged and encouraging with open-ended critical input.

ON WHY TO STUDY PHOTOGRAPHY

We don't question why students should study English. Photography is a language, like English, requiring the same levels of specialization. Just as we teach English as a school subject, we should be making a case to have visual literacy taught in schools because even though photography is a language, I am not sure that photography is a universal language. Its meaning shifts in different contexts and photography students understand that. Apart from getting a teaching job most of the value of a photographic education is revealed by the images students make as a result of their education.

JEAN BRUNDRIT, who teaches photography as part of the fine art courses offered at Michaelis School of Fine Art, Cape Town, South Africa, is a visual artist who works with photographic media, video, and site-specific installations. Her work, exhibited in South Africa and internationally, is intensely political, and focuses on exploring identity, specifically lesbian identity and strategies of visual representation, and most recently violence within a South African context. She holds a BA in Fine Arts and an Advanced Diploma from Michaelis, and a MFA from the University of Stellenbosch in Cape Town.

David Campbell

Educator and Author
www.david-campbell.org

Regardless of the platform—digital or print—if you don't have an element that can be social and mobile in your project you will inevitably miss out on a large part of the audience.

MB: WHAT CHANGES HAVE YOU SEEN IN PHOTOGRAPHIC EDUCATION?

DC: My expertise is in documentary and photojournalism so I can't speak about all photography education. I just finished a major report for World Press Photo on multimedia, and we looked at how people were telling stories, based on expanding the idea of the photographic. I don't think many documentary photo programs have expanded the idea of the photographic. The photographic world is generally fairly conservative and most of them see the Internet as a threat or a competitor. If you start from that position, your premise is fundamentally flawed. The Internet is not a threat; it is our environment. Photo education must bring that idea to students, as well as an understanding of the political economy in which photography operates today. That is missing from most programs.

MB: IT'S INTERESTING THAT YOU NOTE THAT PHOTOGRAPHERS SEE THE INTERNET AS THEIR ENEMY BECAUSE THAT'S ALSO A COPYRIGHT ISSUE.

DC: It's not just the copyright that is viewed as a problem. Photographers think the Internet has undercut their editorial paymasters: the magazines and newspapers that sustained photo journalism for about thirty years or so. This is a myth. Looking at the industry as a whole, relatively few people were sustained that way. The majority of photojournalists and documentary photographers have always worked freelance with multiple sources of income subsidizing their work. Most people don't realize that journalism has never paid for itself; it has always been cross-subsidized by advertising. The fundamental change in the media economy is that advertising has collapsed and that's what's forcing newspapers to lay people off. It's true that the Internet has had a contributing role in that, but the Internet is not the cause.

MB: HOW DO YOU REPLACE THE LOST ADVERTISING WITH A SUSTAINABLE MODEL, SO THAT WE DON'T LOSE ALL PHOTOJOURNALISTS?

DC: We aren't losing photojournalists. We have better photojournalism now than ever, but I have to distinguish the practice from the business to answer your question. The single-model business is gone forever, but I take the historical view that most photojournalists always worked freelance and were cross-subsidized, and we're just going to have to do more of that: more partnerships, more collaborations, more group work, and more grants. Photojournalists are going to have to do more commercial jobs so they can go off and do projects they really want to do, as they always did. There is also an audience for news on the Internet. It's a myth that people who consume news on the Internet have short attention spans and don't want hard news stories. People who use multiple devices and mobile devices to access news are actually consuming more in-depth news than before. There are great opportunities for photographers. We will have to figure out how to replace the lost advertising revenue, and many media organizations have created new revenue streams other than advertising.

DC: You have to understand how news gets to people. The key to me is to understand what's actually happening in the media economy so you can think about how you position your story in relationship to its potential audiences and partners.

DC: We have to teach a critical ethos towards all forms of information, visual or non-visual. That's seriously lacking in education. Another myth I'd like to dispel is that I'd really like people to give up on the idea of objectivity, and philosophically if you give up on objectivity you have to let go of subjectivity, so you can't criticize documentary images as just being "subjective." Storytelling is about being reflexive, and being transparent about that. There are these two impulses: to document and to understand that documentation involves construction and manipulation. This gets to the objectivity/subjectivity debate. Anyone who tells you the photograph speaks for itself is wrong. We never bump into an image by itself; it's always with text or next to other images, so why should we expect it to speak by itself?

I am not worried about citizen journalism because we have to get away from the automatic assumption that professionals always make better photographs than amateurs. As much as journalism is a professional practice, it's not the same as flying a plane or brain surgery; some citizens can do it better than professionals. We shouldn't focus on the labeling of people by whether or not they are paid. We should focus on the practice of journalism and judge that. For example, if you go on Vimeo you see endless good stories and films. Very traditional outlets commission few of them. What professionals can do better is tell a story as opposed to take a snapshot. In Australia, as one example, there's a great new online site called The Global Mail,[9] which has got excellent journalists from previously established newspapers, and they're producing excellent multimedia.

DC: Definitely. Even though many photography programs view the moving image as something that is a bit foreign, the boundary between still and moving has always been blurred. Still images in the nineteenth century were often presented in magic lantern shows in ways that made them appear to move. We need to keep blurring that boundary and not get caught up in terms of photographer versus videographer, but just think about which is the better mode of delivery for the story we're telling.

DC: The academic world is even more conservative than the photography world. The biggest challenge is coming to grips with what's happening in the media economy. This statement is a bit self-serving because that's what I focus on, but I really do think we have to understand that the photography world is fundamentally transformed now. What we should be teaching students is how to think about doing a project and then figuring out what platforms are best for that project to get it to the intended audience. Regardless of the platform—digital or print—if you don't have an element that can be social and mobile in your project you will inevitably miss out on a large part of the audience. But to understand social media you have to participate in it and so few educators do that.

DC: For the program I teach in Beijing, the one that challenges students the most is the twenty-four-hour news story. We give them a topic and then, working alone, they must produce an entire package that includes audio, text, and multimedia in twenty-four hours.

DAVID CAMPBELL is an educator, writer, researcher, and producer who specializes in visual journalism and storytelling. A former press secretary/speech writer for a prominent Australian senator, he switched to education where for two decades he taught visual culture, geography, and politics at universities in the U.S., Australia, and the U.K. Currently he works independently, but has retained affiliations with various universities, including the Durham Centre for Advanced Photography Studies at Durham University; the Northern Centre of Photography at Sunderland University; the School of Political Science and International Studies at the University of Queensland, Australia; the Program for Narrative and Documentary Studies at Tufts University, Boston; and the MA program in International Multimedia Journalism located at Beijing Foreign Studies University. Campbell holds a PhD in International Relations.

Anyone who tells you the photograph speaks for itself is wrong. We never bump into an image by itself; it's always with text or next to other images, so why should we expect it to speak by itself?

Jeff Curto

Professor of Photography
College of DuPage, Glen Ellyn, Illinois, United States

www.jeffcurto.com

*While students often think the technical is the
hard part, photographers know that's not true.*

ON TEACHING PHOTOGRAPHY

My experience teaching in a community college may be different than
that of those teaching in other institutions, but an overarching goal I
have is to make photography a more integral part of everyone's life in
a pure way, regardless of whether the student ends up becoming a
commercial photographer, a fine art photographer, or a hobbyist. Even
if a student finishes only one class in our program she should be able
to go out and see the world in a different way, because we have made
her more aware of what the world looks like. Educating students as to
what possibilities exist in photography and how photography ties into
the larger visual world is a big part of what I do.

Even before we had the digital revolution the big question we all
tried to answer was: What is the difference between technology and
the other part—whatever you call the other part: vision, intuition, or
style? The dilemma has always been walking that fine line between
technology and the other part. While students often think the tech-
nical is the hard part, photographers know that's not true. So I try
not to spend an inordinate amount of time teaching technology and
spend more time talking about the goal for their images. For me, as a
photographer now, not a teacher, my primary interest has always been
in the thing that used to be fashionable: beautiful images of the world's
beautiful places. I know that may sound pedestrian in today's photo
world but I grew up in that f/64 world of Ansel Adams and Edward
Weston. I grew up seeing form and the quality of light as being impor-
tant, looking at the world as a sculptural object in a two-dimensional
picture space. I realize that in 2013 this might put me into a certain
group of "gray beards" but I am okay with that.

This image, which illustrates Jeff Curto's assignment, Edges, was taken
in Coney Island, a place at the edge of the city, where people are on
the "edge" of their seats on rides that trigger the "edges" of emotions.
Image courtesy of Katerina Drury

ON CHANGES IN PHOTOGRAPHIC EDUCATION

When I first arrived in our department, the education a student received was primarily technical. Slowly, my new colleagues and I started to bring our MFA backgrounds in and we began to ask students what images mean. It was shocking to others when we first brought that to the community college environment, but it eventually was a sea change in how students thought about photographs. The other change is that because education is so expensive we now ask the question: What is a photographic education worth and how should a photographer be educated in today's world? The reality is that we face a world where students can find the same information we might provide in a classroom in seven different ways for free on the Internet in ten minutes. We need to come to grips with it. Even if the information exists on the Internet, college still provides a live community of people to bounce ideas off. Ideas don't just come from photography; they come from literature, art, the natural world, social experiences, and other people.

Also, the great amazing equalizing advantage that every faculty member has today is the Internet and blogs like LensCulture, Flak-Photo, or JPG magazine (jpgmag.com), where we can see an organized collection of interesting images. I do make my students look at those things even if it's through force or coercion.

ON A TEACHING PHILOSOPHY

I teach an introductory class once a year. I try to get them in front of a lot of work so they can become more visually literate. For example, in an intro class I might toss in a half dozen Lee Friedlander pictures and suggest/ask them, "Are these any good? If so, why are they good and if not, why are they not good? What would you do differently? How would you articulate this idea in a photograph?" Then afterward, tell them about Friedlander and where he came from and what he's done. Or throw them the really difficult images, the ones that are bland and banal, that have nothing to do with beauty and see if they can figure out why they are interesting. Those kinds of things are really valuable for students to do.

Basically, I'm trying to get them to think through the issues related to how photography interprets the world and why and how photographers make the sorts of choices they make. In the end, I hope that strategy comes back to them in their own images and their own photographic practice, making them more thoughtful photographers.

ON CRITIQUES

For beginning classes, I will ask students to pick three pictures, take them off the wall and bring them back to where they are sitting and do some sort of keyword brain dump on those three pictures. And then we will put them back up and use the words that they have come up with as a springboard to talking about these pictures. In more advanced classes, I use a more traditional approach of articulating what the image is about and why I should care, but I usually let the image creator lead that discussion.

JEFF CURTO, who has been teaching photography since 1984, was named an Apple Distinguished Educator in 2013, becoming part of a global community of 2,000 education leaders recognized for exploring new ideas, seeking new paths, and embracing new opportunities. He hosts two popular podcasts about photography, one that records his History of Photography class sessions from College of DuPage (photohistory.jeffcurto.com) and another that discusses photography's creative aspects (www.cameraposition.com). Before joining the College of DuPage, where he is a Professor of Photography, he worked as a photographer, specializing in event and public relations photography, architectural interiors and exteriors, portrait, and product photography. He now maintains his own fine art photography business and his work is held in numerous private and corporate collections. He holds a BFA from Illinois Wesleyan University and an MFA from Bennington College in Vermont. He has the distinction of attending the last workshop that Ansel Adams taught in 1983 in Carmel, California.

Barbara DeGenevieve

Professor and Chair, Department of Photography
School of the Art Institute of Chicago,
Chicago, United States

www.degenevieve.com

Photography ... is a vehicle for understanding how the contemporary world has become what it is.

JANNAH TATE
VIDEO STILLS FROM "ONE AND ONLY"

This image was taken in response to a video assignment for one of
Barbara DeGenevieve's classes, and as do many of her assignments,
this one has a performative element.

Image courtesy of Jannah Tate

MB: WHAT IS THE VALUE OF A PHOTOGRAPHY EDUCATION?

BD: I must contextualize my comments by stating that I teach in an interdisciplinary and conceptually oriented art school. Students are challenged to think as well as make; they "learn how to learn" by making research an integral part of their practice. A good photographic education includes photo history, art history, media history and theory, critical theory, semiotics, and in-depth critical analysis of the work produced by students. Our students take classes that give them professional analog and digital skills that would allow them to work as commercial photographers, printers, retouchers, or to open their own business if they chose to do so. However, no matter which class they take in the photo department at SAIC, students are asked to consider if the medium is appropriate for the expression of their idea—and the conceptual idea is always of primary importance. Our job is to teach our students ways in which they can be artists, not "professional photographers." We're teaching students *how* to think, but not *what* to think; we're exposing them to transferable bodies of knowledge and hopefully setting in motion a process through which they will be equipped to start connecting the dots between their research, theory, the information they gather in all of their liberal arts classes, and what they create in their own individual art practices.

I've had students who have gone on to be excellent doctors, lawyers, entrepreneurs, etc., because they had an education in photography that taught them how to think critically, not just about photography, but across fields of study and bodies of knowledge.

MB: WHAT IS YOUR PHILOSOPHY OF TEACHING PHOTOGRAPHY?

BD: Photography is one of the most important subjects that can be taught, because aside from a skill base, it is a vehicle for understanding how the contemporary world has become what it is. Photography has been at the center of cultural change more than any other medium. In teaching photography, you can address all the important issues of contemporary life including ethics, privacy, identity, representation, race, gender, social justice, psychology, sociology, global cultures and the representation of cultures other than one's own. It serves to make students aware of the ways in which the visual environment operates and manipulates everyone in it. Some of these issues have become the mantras of the art world and might seem dated, but young students, completely enthralled by their digital access to the world, will have no, or very little understanding of any of it. Cultural memory is shortsighted, and the built-in obsolescence of digital technology is made to keep it that way. Personally, I think students (from middle school through college) would have a better sense of the world and how things operate by having photo, media, and technology history be part of a general education.

Students, to be well rounded and informed, should study philosophy, critical theory, semiotics, global histories, be involved in their own research, take classes in chemistry and science, sociology, literature, race and gender studies, ethics, business practices, etc. Those who graduate with a degree from a photography department will be incredible artists and/or teachers of studio and media history. They also could work in any business that hires consultants or hires non-linear thinkers for their think-tanks or jobs that require creative thinking; they would be amazing entrepreneurs. Because their photographic education would make them critical observers of the world, sensitive to cultural differences, they would be perfect as ambassadors, surveillance experts—and any career they felt they wanted to enter.

MB: SHOULD PHOTOGRAPHIC DEPARTMENTS HOLD ON TO ANALOG PROCESSES, AND/OR WHAT VALUE DOES TEACHING ANALOG PROCESSES IMPART?

BD: Yes. It won't take long (and for some it's already happened) for technologies to be naturalized, to become an unquestioned part of the cultural landscape with no connection to history, context, or social implications. People accept the newest technology for its novelty without critically analyzing how it operates, and on whose terms it operates as it moves into the world. The recent controversy over the government's access to phone records is an interesting example. What's the big deal when we've already given up any semblance of privacy every time we use the Internet to purchase something, or use social media to expose both body and psyche? Teaching analog (for as long as it's possible) will eventually be seen only as a quaint acknowledgement of a nostalgic past if it's not taught within the context of historical lineage leading to current digital technologies. Despite the fact that the majority of images will now be viewed either online or on a hand-held device of some kind, there will always be artists using photography, making prints, hanging them in museums and galleries, and some will even use analog processes because they like prints made with light hitting a light-sensitive surface.

MB: IS THE AGE OF THE STILL IMAGE OVER, AND SHOULD WE BE TEACHING VIDEO IN A PHOTO PROGRAM?

BD: Painting was supposed to be dead years ago. When it actually does die, maybe I'll think this question is something interesting to be pondered. Until then, of course, the age of the still image *isn't* over, and yes, video should be taught along with photography. We should be the "Department of Lens-Based and Digital Media" or some other sexy title that would incorporate photography, filmmaking, video, and new media. The curriculum would include any camera or digital device (personal or public) that makes any kind of still or moving image. It would be a studio art department with a curriculum that would also include the entwined histories starting with the camera obscura as the point of origin, moving through the nefarious and political uses of each type of image-recording device, paralleling the aesthetic uses of each, paralleling the commercial uses of each.

BD: There are several worlds of photography so I'm not quite sure how to answer that. And when he says "photography graduates," is he talking about grads from places like Brooks that are very technically and commercially oriented, or grads from places like the top three academic photo programs (Yale, SAIC, and RISD) that are all much more interested in the theoretical, social, cultural, political places photographs occupy in the world? In his writing, Rubenstein pretty much lumps them all together. He teaches in an interdisciplinary program very much like ours but he seems to know little about what goes on in the best academic programs in the U.S. SAIC has been a philosophically interdisciplinary school with no majors since at least the 1960s, and over the years it has refined curricular goals making learning across media and bodies of knowledge the core of its educational philosophy. I think a lot would be lost if there were no academic photography programs producing graduates because these are programs that aren't just interested in technology. And if medical scientists, astronomers, physicists, historians, etc., would open their linear minds to the possibility that they might be able to learn something from collaborating with non-linear thinking artists/photography graduates, the information gathered from their mundane and simple uses of photography might produce different ways of understanding what is being studied and really rock "the world of knowledge."

MB: WHAT IS THE MOST SIGNIFICANT CHANGE YOU'VE SEEN THIS PAST DECADE THAT HAS IMPACTED PHOTOGRAPHIC EDUCATION?

BD: Digital technologies have improved. It is easier to produce a digital print that closely replicates darkroom results, and the digital transformation in the ways that images are created and transmitted play into every aspect of contemporary/global life. These changes have made it apparent that photography programs need to update the ways in which image creation is talked about and what photo and media history must include. More than anything, I see the need to contextualize and understand the trajectory of "seeing" and "making," from the discovery of the camera obscura to the announcement of the discovery of photography in 1839, from the printing of images (paper negatives as reproducible versus the daguerreotype) to the electronic transmission and instant dissemination of images, and from the *carte de visite* to Facebook, where the social aspect of photography continues its importance in the creation of personal identity.

What I'm realizing is that people don't change in their basic psychological needs and desires, but as technologies become more sophisticated and complex, the mechanisms of the ever-expanding range of technology are more easily hidden by their purveyors and overlooked by the users. I think students who use the technology are totally unaware of any of this and will use their devices without critical analysis of what they're doing. In saying this, I'm not vilifying technology. It's here to stay and for the most part, we're better off for it. But would our use of it change if we knew about the back-stories? I want students to have a sense of the history embedded in everything they use, and that the history is filled with problematic issues that need to be considered. This should be a part of the discourse in intro classes and through every level beyond.

BARBARA DEGENEVIEVE is an educator, author, and interdisciplinary artist who works in photography, video, and performance. Her widely published writings and exhibited work focus on subjects including sexuality, gender, transsexuality, censorship, ethics, and pornography. She has been awarded two National Endowment for the Arts Visual Artists Fellowships, and has been the recipient of three Illinois Arts Council grants among others. She earned an MFA in Photography from the University of New Mexico in 1980.

Dornith Doherty

Professor of Photography
University of North Texas, Denton,
Texas, United States

www.dornithdoherty.com

The innovative thinking and creative approaches to problem solving that underpin a fine arts or photographic education are difficult to teach but are important aspects when considering the value of the degree.

ON THE MERITS OF A PHOTOGRAPHIC EDUCATION

There is real value in studying photography. Photographic images are everywhere, and have become integrated into the way we communicate. Through studying photography, students learn to engage critically with visual language and are able to evaluate and interpret images, which is a skill that will help them with their future no matter where they go or what they do. As a studio art practice, the photographic tools are more advanced, so it's easier to make a technically acceptable, but mediocre, image. But great photography has always transcended the tools to meld the photographer's vision with her ability to make an image. The innovative thinking and creative approaches to problem solving that underpin a fine arts or photographic education are difficult to teach but are important aspects when considering the value of the degree.

ON TEACHING PHOTOGRAPHY IN THE TWENTY-FIRST CENTURY

We see our program as a lens-based media program. Our goal is to give the students a solid background in the broadest range of art-making tools possible so that we do not limit their choices. In line with this philosophy, we continue to teach analog processes as well as digital and video. We find that many students love working in the darkroom, even though it's more frustrating and time consuming than printing digitally. We give them the freedom to continue working with film if they want to; however, most students use digital imagery either for prints, video, or online work for their final exhibition in their senior year.

I also believe that, while undergraduate students need a really excellent technical foundation, it should be combined with developing their ideas. Photography is a very creative practice that is based on the indexical relationship between the photographer and the thing being photographed. Allowing students to address the theory and conceptual aspects of photography at the same time that they're learning the technical aspects is really important. In photography the content has to be grappled with from the very first time that you pick up a camera.

ON THE CHALLENGE OF INTEGRATING DIGITAL TECHNOLOGY

Digital imaging is a constantly shifting terrain and there is no consensus in education yet on how or where to integrate it into a still photography program. I routinely receive emails from my colleagues questioning when to introduce digital. Should it come before film or after film, for example? At my university, we've decided to teach Photo I as a digital class (except for one pinhole assignment), and Photo II as a hybrid where students learn darkroom processes.

Originally, digital was difficult to integrate because it's a very different process from traditional photography. It's a synthetic process much more akin to painting, although it doesn't have to be practiced that way. Understanding how the process is different from traditional photography, which is more of a subtractive process, and how that plays into conceptual and ethical questions about photography is important for students to understand.

The main challenge we face is budgetary. We are on a schedule of replacing some equipment on a three-year cycle, but we have many

pieces of equipment that don't fit into a university IT department's traditional scope. This is an ongoing concern for us. We are faced with shifting practices that impact what equipment is necessary and whether to replace machines or move on to a new type of equipment altogether. For example, we used to have to manage scanners, but now it's working out the details of large-format printers and ink use.

ON A CRITIQUE METHOD

My photographic critique method is based on the traditional method I experienced studying in undergraduate and graduate school. Students pin up work, which is then discussed. I've added a requirement that students also present a written project statement because it helps them to clarify their ideas when they are talking about the work. This project statement can develop and change over time as their concerns do. I usually have the student present their work verbally before the class discusses it. It allows the class to see what he or she is trying to do and whether the artist's intent matches the image. As a class, we discuss the work in conceptual terms, what other work it may reference, and any technical improvements that might be necessary.

ON A TEACHING PHILOSOPHY

Helping students learn the art of photography is a rewarding and important endeavor. Encouraging their self-expression through providing a strong technical base combined with an understanding of historic and contemporary work is essential. I also think that sharing my own continued dedication to my artistic practice is important.

I strongly believe that students need to develop their project ideas independently through research, inspiration, and conversation, but from time to time I give a topics class that explores a particular aspect of contemporary art.

DORNITH DOHERTY, whose work focuses on the complex relationship between the natural environment and human agency, has maintained a robust career as an educator and an artist. Her work has been widely exhibited nationally and internationally and is included in the permanent collections at prestigious museums including the Museum of Fine Arts in Houston, Texas; the Museum of Fine Arts in Milwaukee, Wisconsin; the Minneapolis Institute of Arts in Minnesota; the Yale University Library in New Haven, Connecticut; and the Museet Fotokunst in Odense, Denmark. She has been awarded both a Guggenheim Fellowship (2012–3) and a Fulbright grant, among others. She was on the National Board of the Society for Photographic Education and she was named Honored Educator in 2012 at the South Central Region Conference of the Society for Photographic Education. She holds a BA with dual majors in Spanish Language and Literature and French from Rice University and an MFA in Photography from Yale.

Originally, digital was difficult to integrate because it's a very different process from traditional photography. It's a synthetic process much more akin to painting, although it doesn't have to be practiced that way.

Jim Dow

Chair, Visual and Critical Studies,
School of the Museum of Fine Arts,
Boston, Massachusetts
Faculty
Tufts University, Medford, Massachusetts,
United States

www.jimdowphotography.com

Students should study photography because it is a twenty-first-century liberal art.

ON TEACHING PHOTOGRAPHY

My basic operating system or method is to give each student his or her own voice because nobody owns photography. That's why I created the *Is Photography Over?*[10] assignment, because it addresses how photography's been used and more importantly, who used it. The group of the great and good speaking in San Francisco desperately wanted to own photography because that's what they make a living at. What I found really encouraging and interesting is that the students responded, "Well, so what? There's a lot more interesting things than what you people are talking about." With no disrespect to the individuals, they represent the photography mafia. The students are coming into a world where that mafia no longer has much power, and it's decreasing with each year.

> We need to ask the students to invest a level of seriousness into their creative process that isn't present in most of the images they see and one of our jobs as teachers is to help students set up a framework to filter out the mediocre.

ON WHY STUDENTS SHOULD STUDY PHOTOGRAPHY

Students should study photography because it is a twenty-first-century liberal art. As educators, we have the obligation to provide them with a high quality liberal arts education so we need to push them to understand the world that's outside the medium of photography.

ON EDUCATING STUDENTS TO DIFFERENTIATE THEIR IMAGES WHEN THEY SEE SO MANY EVERY DAY

We need to ask the students to invest a level of seriousness into their creative process that isn't present in most of the images they see and one of our jobs as teachers is to help students set up a framework to filter out the mediocre. This goes back to teaching them to look critically and to understand the photographic canons of the past. Many of the things they need to become sophisticated are not of this moment. For example a sepia Instagram photo of the landscape—even though you recognize it as a digital trick—still evokes this tiny click of nostalgia. If you see a journalistic picture taken by someone with an iPhone of a person of color scuttling in the shadows, it's right out of *Heart of Darkness*.[11] I don't care if it's taken by someone who doesn't consider themselves racist, when that image goes out into the world as a text it's a racist image because of historical references and the kind of damaging generalities such things perpetuate. Those are the kind of things I think are important to spend a lot of time talking about. And that's why students spend $50,000 a year. I tell the students if you don't understand the delivery system that gave you what you've got, then you're uneducated. You're liable to take what you get at face value. In some cases students are put off when I present a well-known artist's work and suggest that it is a sexist or racist image on its own, even if that wasn't

the photographer's intent, but for the most part, I think our students are really interested in that stuff. A lot of students in school, particularly the younger ones, have come from high-school experiences where they have been pretty marginalized. They were artsy, transgendered, gay kids who didn't play sports—whatever. So they were outside the mainstream and they're on pretty familiar turf when you start talking about the responsibility of representation.

ON WHETHER WE SHOULD BE TEACHING VIDEO IN A PHOTO PROGRAM

In my own photographic work I'm as traditional as it comes: I shoot 8 x 10 color on a tripod, get it processed, scan it and print it, but students today need a much broader education. I've proposed that we should junk photography, video, and film departments and create a lens-based practice department. We're all fighting to buy the Canon 5D Mark II or whatever, so let's combine resources, buy a bunch of them, and teach everyone the common skills and then let students branch out. If a student wants to focus on making prints, fine. That's a special skill. If they want to focus more on video editing, fine, let them focus on that.

JIM DOW is an award-winning photographer who specializes in photographing places. More precisely, he's interested in the mark that people leave on the rural and urban landscape and the capacity that photography has to describe that. Using an 8 x 10 land camera, Dow chooses classic Americana as his subject, including: folk art, roadside architecture, country courthouses, baseball parks, soccer stadiums, barbeque joints, and taco trucks. His work has been widely exhibited nationally and internationally and he is a recipient of a Guggenheim Fellowship, a National Endowment of the Arts Individual Artist Grant, and a New England Foundation for the Arts Fellowship. PowerHouse Books published his retrospective monograph, *American Studies*, in 2011. Dow, who is currently teaching for Tufts University at The School of The Museum of Fine Arts, has been teaching photography, photography history, and contemporary art for more than thirty-five years. He earned a BFA in Graphic Design and an MFA in Photography from Rhode Island School of Design.

I've proposed that we should junk photography, video, and film departments and create a lens-based practice department.

Larry Fink

Professor of Photography
Bard College, Annandale-on-Hudson,
New York, United States

www.larryfinkphotography.com

My job is to see whether or not I can slowly, not quickly, reach inside and grab the heartstrings of the student and give her the courage to speak from that heart and tell the stories of her existence

ON THE VALUE OF A PHOTOGRAPHIC EDUCATION

Photography creates associative thinking whereas education these days is basically specific and practical thinking rather than associative. So the value of a photographic education is that it's a marvelous discipline for rapid-fire associative perception, which is the ability to perceive any number of things on a field of reference and be able to move them around in ways that are more poetic, or that clarify the interpretation. Associative thinking allows the imagination to soar, and we want the imagination to stay alive in human beings.

In practical terms, then, studying photography has value. But in the cynical, material world of commercial culture, which is what we have, the value of a photographic education is nil. But if you think in romantic terms, think that each individual is his own renaissance, then training in all art is absolutely necessary.

And if we think about visual literacy, the idea of being able to read a picture, which is to say to read a coding of experiences, certainly photography is absolutely essential. While photo education might not matter on a global scale, for the small imagist town in which we live, it keeps things cogent, discursive, and vital.

ON TEACHING PHOTOGRAPHY

I don't teach photography. I teach the child; that is, I'm interested in my students because they're the people who teach me about what it means for them to be alive, which means what it means for me to be alive, because we all work in coordinates. When I look at their work, I try to see whether or not the energy within the work has anything to do with what I start to know about them. Hip kids, as I see them now, sometimes aren't ready to really spill the beans about their experience: they hide behind nouveau concepts, pervasive in the intellectual world, one kind of postmodernism or another. They'll look at photography by Jeff Wall, Gregory Crewdson, or whomever, and think they'd like to work that way. But any good artist comes to those kinds of original impulses by way of a whole track record of experience. My job is to see whether or not I can slowly, not quickly, reach inside and grab the heartstrings of the student and give her the courage to speak from that heart and tell the stories of her existence.

ON TEACHING TECHNIQUE

Now that I've just spilled the beans about the emotional primacy and all of that, it doesn't necessarily supersede the fact that pictures are structures. Prints are prints and have to be adhered to in rigorous ways. That's harder with digital because it does whatever you want it to do, and today's kids come to photography with no understanding of what the actual medium was and so no understanding of what the criteria could be. If you go back to the origins of photography, each picture format—square, rectangle or whatever—had some kind of organizational presets. The student has to be made aware of how the elements in the frame actually have to coordinate so that they create a language of visualization which serves that primary need of talking about what it is that they feel, see, experience, and cohabitate with.

They should be taught that printing is not a neutral ground; it's more much more expressive and orchestrated, almost like painting. I

don't think that we live our lives just describing, we live with various subjective and objective impacts and we should accord that to the photograph as well.

ON DIGITAL TECHNOLOGY AND CHANGES IN PHOTOGRAPHIC EDUCATION

I'm not much interested in the conversation about digital because I don't think it has created fundamental differences. Sure, digital photography is like [the plant] digitalis, foxglove, which is both a curative and a poison. How can you reject digital? It's seductive, saturated color, hyperventilated kinds of essences, and it does everything. But it also takes away the ambition or the insight that one can create something of one's own. The invention of the Leica was a more fundamental shift because then Cartier-Bresson and the others could photograph the world without clunking around with big clumsy tools. I don't think digital photography is a fundamental shift like that.

Even so, I'll tell you from my own practice I haven't shot on film or used flash in a while because digital cameras almost see in the dark. The only reason I used flash 150,000 years ago, as old as I am, is because I couldn't get the quick clarification of my vision in available light. With digital I can work intuitively with the sensuality of available light, which is glorious, but it doesn't fundamentally change *how* I see.

I think that the curves and the bells and the whistles of Photoshop are extraordinary. You can make better prints and even more subtle prints than you can with silver, but that doesn't necessarily change the *intention* of your print. I have to remark to myself that sometimes I think that I was waiting for digital to come along because I like to get it really concise. In digital, if I want something out of the composition, it goes away. I did that when I printed silver too, but it's much easier with digital.

For example, I was photographing the [2008] political primary and I had one image of Hillary [Clinton], which was great, except she had her eyes closed. Why not make it a good one? So my assistant and I searched around the digital contact sheets and we found three or four sets of Hillary eyes, popped them into the image, but none of them worked. We reversed those eyes and flipped them upside down and they worked perfectly.

ON THE TRUTH OF A PHOTOGRAPH

I don't care at all about truth as a matter of fact, because I've always been a subjective documentarian. My nickname is subjective. I come from my sensual being and my gut. I am very prone to context and I'm definitely involved with the real world, but I'm interested in how the real world occurs to me.

ON TEACHING VIDEO IN A PHOTOGRAPHY PROGRAM

Anything that describes anything should be taught. It's just parochialism to protect the sanctity of a still photograph and not teach video. Why would you want to not teach something that is available and incorporated into associative life?

LARRY FINK has been a professional photographer for forty-five years, maintaining robust commercial and fine art practices. He has had solo shows at the Museum of Modern Art, the Whitney Museum of Modern Art, the San Francisco Museum of Art, the Musée de la Lausanne Photographie in Belgium, and the Musée de l'Elysée in Switzerland, among others. He shows work in galleries regularly in New York City, Los Angeles, CA, and Paris, France. Along with two John Simon Guggenheim Fellowships in 1976 and 1979, and two National Endowment for the Arts, Individual Photography Fellowships in 1978 and 1986, he was awarded an honorary doctorate from the College for Creative Studies, College of Art and Design, Detroit, 2002. His commercial work includes advertising campaigns for Smirnoff, Bacardi, and Cunard Lines, and his editorial client list includes *Vanity Fair, W, GQ, Detour, The New York Times Magazine,* and *The New Yorker.*

Joan Fontcuberta

Artist and Educator
www.fontcuberta.com

The quality of a teacher lies in his capacity to transmit enthusiasm: without enthusiasm we're condemned to pedagogical disaster.

MB: PLEASE DESCRIBE YOUR STYLE OF TEACHING.

JF: We can't teach photography without having agreed that we understand photography, because more than just a systematic language of a representation or a visual culture, photography embodies an ideological attitude. It's more than just an "art" or a "trade."

For me, teaching has never been separate from the act of creation. I am from the generation descended directly from the late 1960s movements of conceptual art and structuralism. For this generation, talking about art or transmitting artistic content is a way of making art, that is, theoretical reflection and teaching are inherent in all artistic gestures. Moreover, in classes, when I debate with students, certain ideas come to me that nurture my own projects afterwards. I always say that I teach in order to learn.

These days, I'm not grounded in any one university because I need freedom of movement for my projects, but I frequently hold conferences and seminars. I've been a professor in many different contexts. For example, the courses that I most recently gave at the Universitat Pompeu Fabra in Barcelona were about audiovisual communication, in which the students—half of whom were from other European countries via Erasmus[12]—chose to explore cinema and television. I gave a class called "Contemporary Photography," in which I intended to brush a historical and conceptual varnish over photography for the students, all future professionals of imagery. I devised a framework postulating that the twentieth century—the age that epitomized iconoclasm—didn't really exist and that therefore it was necessary to find the ties between the production of images in the twenty-first and nineteenth centuries. It was a way of tracing the medium's historical roots and understanding that all the values pertaining to contemporary photography—identity, truth, memory, documentation, archiving, etc.—had a precedent in the techno-scientific culture of the nineteenth century.

MB: IN AN INTERVIEW WITH JAMES ESTRIN YOU SAID THAT YOU THOUGHT PHOTOGRAPHY SHOULD BE TAUGHT IN A PHILOSOPHY DEPARTMENT, NOT A FINE ART DEPARTMENT, BECAUSE PHOTOGRAPHY IS ABOUT THINKING, NOT AESTHETICS, WHICH YOU LIKENED TO "DRESSING" ONE'S BODY. WOULD YOU EXPAND ON THIS THOUGHT?

JF: I understand photography as a tool for pondering reality, and its purpose therefore exists beyond personal expression and artistic research. These days, images aren't simply representations of the world, but rather, they become the world. With that in mind, it's important to learn to live in images, but most of all it is important to survive in images. Photographers produce a good portion of the world's images and we must take great responsibility because we generate modes of reality. It's from these modes that people make life-altering and life-defining decisions. Photography is the principal bridge between the objective world and subjective perception. Bill Gates affirmed that he who wants to control public perception must control images. The Spanish thinker Vicente Verdú talks about a present "capitalism of fiction" in which images, just like those who generate fiction, are the most highly valued goods. In this context I would say that the first step for a true achievement in photography education would be for us to learn to "write about it"; the second step would be to learn to "read about it." This phase isn't yet over, that is, we find ourselves in the

illiterate future advocated by Moholy-Nagy but aggravated by a new circumstance: the proliferation and circulation of images is what gives them meaning today, exactly the new scenario that we're discussing here. You don't need to know much to decode photographs according to historical, aesthetic, semiotic, and most importantly ideological parameters: today the economic and political use of images prevails. Perhaps James Estrin's interview would have given rise to the conclusion that more than anything, photography should be taught in political science departments.

though things have been changing, I sense that schools, specialized publications, and the critical canon continue to be entrenched in this obsolete dichotomy, against the grain of our evolving cultural reality.

> I understand photography as a tool for pondering reality, and its purpose therefore exists beyond personal expression and artistic research.

MB: AS A FOLLOW-UP TO THAT QUESTION, HOW HAS THE TEACHING OF PHOTOGRAPHY IN ART SCHOOLS IMPACTED THE DISCIPLINE? ARE CONTEMPORARY PHOTOGRAPHS OR PHOTOGRAPHERS LACKING CRITICAL THOUGHT?

JF: I always try to inspire critical curiosity in my students. I want them to learn how to learn. Learning is more passionate than anything; it's what moves me. The quality of a teacher lies in his capacity to transmit enthusiasm: without enthusiasm we're condemned to pedagogical disaster. I'm therefore convinced that a teacher has to love what she teaches and whom she teaches. There are close students in formal education, but there is also a wider public, and by engaging this public I like to think that I contribute to contemporary philosophy. But in the end, since my work is polyhedric, it seems good that every spectator projects his own interests and desires onto the work. Only the very worst art reductively expresses nothing more than what the artist intended. It's always exciting when my classes transcend my lesson plans.

I believe that there is a link between stylistic and conceptual educational traditions. You can establish professorial affiliations with students who become teachers of other students—the links can be more clear or fuzzy, but they're there. But now we're experiencing a new phenomenon. Traditionally, didactic methodologies have been structured differently with regards to how they address future producers and consumers of images, that is, to art students, or to the general public, respectively. It was only logical, since conceptual devices for writing and reading differed as active and passive, respectively. And even

Today we are all at once producers and consumers and this ambiguity of roles requires a radically new pedagogical agenda. In an article that was published on the website ZoneZero, Alasdair Foster[13] compared the change that is sweeping the world of images with the Protestant reform that shook Christianity in the sixteenth century. In the Catholic Church, the ministry of faith forms an oligarchy of "professionals" (the members of the clergy, the priestly class). Luther and his followers challenged this by proposing to "de-professionalize" the ministry, setting the interpretation of sacred scripture free to roam in the realm of personal and individual consciousness. A Protestant minister can be an expert, but his knowledge is at the service of the community without necessarily implying authority over it, the same way a layperson can give a sermon at her congregation. In the art world, in photography and visual communication in general, this same change is occurring. The hierarchical distance between professionals and the public tends to decrease, even disappear altogether, and so the positions of consumer and producer have become interchangeable. The image is today ubiquitous because we all make and handle photographs; we all generate and receive graphic information. How do we face this, then, with a pedagogy that is consequential in this new reality? We need to find an answer soon.

MB: WHY SHOULD SOMEONE STUDY PHOTOGRAPHY TODAY? WOULD THEY BECOME BETTER ARTISTS IF THEY STUDIED SOMETHING ELSE?

JF: Recently a journalist at *Aperture* asked me something similar and I'd like to re-explore the answer I gave then. Maybe we're experiencing the evolution of *homo sapiens* into *homo photographicus*: the image supplies knowledge. In the age of *homo photographicus*, where does

a photograph's value reside? We frame through the viewfinder and pull the trigger: a series of invisible automations guarantees the production of a plausibly decent image. We can logically aspire to different levels of excellence, but today photography's technical component (that is to say, the physical fabrication of the image) is easy and doesn't require much effort. The creative and intellectual merit, then, lies in the capacity to convey intention with an image, to make it significant. Definitely, the merit is whether or not we're able to express a concept, to have something to say and if we know how to use photography as a vehicle to say it.

Therefore, the first thing that we need to be aware of is that we can no longer categorize the quality of photos by using the stark dichotomy of "good" and "bad." There are no good or bad photos; there are only good and bad uses of photos. An image's quality no longer depends on its autonomous value, but rather the application of its formal characteristics to a determined use and intention. The same image can be inadequate in one context and in another contribute powerfully to lifting the viewer's spirit. However, a satisfying result of intent depends on having "something good to say." And in this sense, the photographer has to have accumulated life experiences and learned to translate them into her work. Remember the wisdom of the old teachers. Ansel Adams said, "You don't make a photograph just with a camera. You bring to the act of photography all the pictures you have seen, the books you have read, the music you have heard, the people you have loved." Studying another discipline will always help, but it is important to have the curiosity and the commitment to fully soak up life.

MB: YOUR WORK SUGGESTS WE SHOULD NOT TRUST MEDIA. DO YOU TEACH YOUR STUDENTS TO DISTRUST MEDIA, TO DISTRUST PHOTOGRAPHY?

JF: The media's pre-eminence has brought us to a *mediacratic*[14] state that determines public opinion and political agendas. However, in this *mediacracy*, we suffer from ambivalence between the supposed vocation of civil service and the enterprising capitalist logic oriented towards the quest for wealth and power. The tension between the common and corporate interest is a constant source of specter conflict for which citizens must be prepared. My work tries to warn of this contradiction but it does so metaphorically about photography and its convincing credibility. It's of note that I grew up in a totalitarian regime that manipulated the media to benefit its own legitimacy, and later I worked in journalism and publishing, something which familiarized me with illusion and simulation. Therefore, I like to say that my projects are like vaccines that should help immunize us against any and all means of authoritarian discourse. And these discourses are not exclusively from the media; we find them in many institutional platforms, such as social organizations, academia, science, religion, and of course, the world of art and design.

MB: IN YOUR OWN WORK YOU DISCUSS THE CONCEPT OF TRUTH AND THE CREDIBILITY OF THE PHOTOGRAPH AND YOU CREATE IMAGES THAT PLAY ON WHETHER PHOTOGRAPHY REPRESENTS THE WORLD. DO YOU THINK VIEWERS STILL RELY ON PHOTOGRAPHS AS EVIDENCE?

JF: We can consider the history of photography to be a dialectic process between the image as description and the image as invention. That is to say, between documentation and fiction. But today we cannot accept these poles as mutually exclusive concepts, because one impregnates the other; it is not natural opposition that separates them, but rather a change of perspective. Reality is nourished by fiction in the way that fiction is a narrative essentialized out of an inherent need to understand reality. I believe that historians of photography such as Beaumont Newhall or Helmut Gersheim have given us a slanted version of history, presenting the camera as a tool that supplies reality and demonizing any outbreak of fiction. But today we are critically disposed to accept that in all experience there are realities hidden beneath appearances and also that there is no single regime of representation that effectively and universally imposes a single evidence. That being said, I would also add that the transition from photography

...more than anything, photography should be taught in political science departments.

to post-photography has distanced us from truth and memory as essential values. Today's public has learned to completely distrust the pretension of objectivity.

JF: We find ourselves in a situation characterized by a brutal, whirling mass of images and absolute accessibility. I believe that this situates us in a post-photographic age, in which photography distances itself from its foundational values, which are linked to empirical knowledge, in order to limit itself to gestures of immediate communication. Connectivity prevails over representation. This age culminates in a process of secularized visual experience with the image ceasing to be the dominion of mystics, artists, experts, or "professionals." We all produce images as a way of relating to others and we are all public. This desacralizes photography and in a particular way, its documentary character, and that status of documentary gives more context than a stylistic or ideological intention. Accepting this can relativize the propagandistic legacy of documentary photography.

JF: There are no ethics in photography. There are only ethics of the photographer. The photographer can become an activist and manage images at the service of resistance and emancipation. Today conflicts are settled above all in the realm of images. Serge Daney, director of the magazine *Cahiers de Cinema*, has said that today a cause without images is not just overlooked, but also lost. It is the responsibility of photographers to not contribute with anesthetic images for consumption but rather to provide images that shake consciousness. It's also our responsibility to find those images that are still missing.

JF: It's not just, as Michael Fried has said, that photography is more important than ever as an art form. It goes far beyond art. It affects our way of being and thinking. Put simply, photography constitutes the metaphysics of contemporary visual culture. All the current forms of visuality come from the use of the camera and from the formation of the images by way of the light.

JF: I understand authorship and artistry equally as trending towards a condition that we may call "digital humanism"—a phenomenon that deals with delicate concepts affecting the stability of the art market and image economy. (Take for example, copyright law and intellectual property, which today are concepts impacted by *copy left* tendencies.) That being said, this idea can be judged by legal and theoretical frameworks. I'm not an expert on law. I understand laws as the rules of a game that a society imposes on itself to prevent internal conflict, and these rules always differ according to situational and historical context (they can therefore also always be changed)—so I'm more interested in what our collective sensibility and intelligence could one day establish, as opposed to what creates copyright law today. That being said, authorship is the foundation of property. We can argue whether or

There are no ethics in photography. There are only ethics of the photographer.

not it comes from natural, intrinsic values or acquired cultural ones. I believe for example that property is primarily an ideological and political construction, which over time certain cultures have been able to overcome. In the West, some utopias have tried to regulate it; socialism, for example, allows for private property such as my toothbrush but

not in terms of capital or the means of production. Today, the Internet and digital humanism privileges the culture of sharing over the culture of private property. This weakens authorial authority and lessens the weight of the individual. We will come more and more to value the

Pretentious art is boring!

intensity and efficacy of artistic endeavors, moving away from the traditional obsession of originality. We will eventually explore new forms of authorship: collective, interactive, and participatory authorship and more than anything, the emergence of work that is voluntarily "authorless." Ultimately, I believe that this changing sensibility will favor more democratic and less solipsistic expressions of creativity. Now, as professors, we should avoid trying to lead our students toward this change: they're the ones who will be leading us.

MB: YOUR PHOTOGRAPHS ARE HUMOROUS AND ALMOST PLAYFUL, A CHARACTERISTIC LACKING IN SO MANY PHOTOGRAPHS. HOW DO WE ENCOURAGE YOUNG ARTISTS TO INCLUDE HUMOR IN PHOTOGRAPHS?

JF: Humor isn't just important in art, but in all aspects of life. Laughing is a symptom of good health and a medicine for the spirit. It is also a liberating, revolutionary act. Remember Umberto Eco's *The Name of the Rose,* in which the villains try to eliminate laughter. I champion humor because for me, humor is a strategy for introducing criticism. We should be fed up with pseudo transcendentalist pretension. Pretentious art is boring! The problem is that a hegemonic trend in contemporary art seems to have set up an installation in what we may call *anhedonia,* the rejection of joy, the repression of feeling, headed for a grave, tedious, and soporific reality. For these ideologues, humor is insubstantial foolery; it is anti-artistic stupidity. For them, "true art" must either be solemn, epic, and boring, or not exist at all. Irony and fun are antidotes to this nightmare.

JOAN FONTCUBERTA, a Catalan photographer, writer, editor, curator, and educator, is known as a highly inventive contemporary image maker, always investigating and questioning the photographic medium. His work has been extensively exhibited nationally and internationally. It is distinguished by original and playful conceptual approaches that explore photographic conventions, means of representation, and claims to truth, particularly his best-known works such as *Fauna* and *Sputnik.* He challenges concepts of science and fiction in interdisciplinary projects that extend far beyond the gallery space. He has taught at the Faculty of Fine Arts at the University of Barcelona, the Pompeu Fabra University in Barcelona, and at various well-known international universities, including Harvard University. In 1994 he was awarded the *Chevalier de L'Order des Art et des Lettres* by the French Minister of Culture. He received a degree in communication from the Universitat Autònama de Barcelona in 1977, and worked in advertising early in his career.

Allen Frame

Adjunct faculty
School of Visual Arts, Pratt Institute and the
International Center of Photography, New York,
New York, United States

www.allenframe.net

Given that educational costs have risen so far out of proportion to inflation, I am amazed that I have never heard one complex discussion about this in academia.

ON TEACHING PHOTOGRAPHY

I want students to work on projects that interest them, because I think it's difficult to be motivated to learn or to improve oneself technically, or just to make work for critique, without having a compelling connection to subject matter. If students aren't working on something that engages them, I try to help them discover what does engage them. If they don't have ideas, I may grill them with questions about what's going on in their lives and then discuss the possibilities of approaching some of this material.

For example, I had a student who had just moved from Mexico City to New York to study and wasn't particularly connected to anything in her new surroundings. Through my questions, we got into memories and childhood experience, and she remembered a conflict she had with her mother when she was ten or twelve years old. Eventually, she appropriated Google Street View images to reenact the painful experience. Her conceptual strategy, combined with autobiographical content, created a powerful direction for her. It was a breakthrough towards developing a strong point of view and sense of authority with her work.

Sometimes because of the psychological content that unfolds, students will say, "Oh this is like therapy," and I'll say, "If you think it's like therapy you haven't been in therapy."

I hate giving assignments—"photograph this or photograph that"— but I might ask students, "What do you remember from yesterday?" I'm trying to get them to become conscious about what they're noticing, and how they're filtering things and to think about why, to understand what is on their minds, and what about it is significant.

ON CRITIQUES

I like images to go up on the wall because I love being able to rearrange photographs and edit easily. Now with digital cameras, sometimes students have files but not prints and want to project their work. In those cases, we look at it one by one but then I ask them to show it to us as a grid so we can see everything at once.

When I start a critique, I prefer letting the class look at the images first and write their thoughts down. This helps them to articulate what they're thinking, and as they formulate their thoughts, they also become more invested, and the critiques become better. If you just respond right away, I think you may miss getting into those layers of thought as deeply. Students do resist getting their pen out, because it feels so very literal, but I know that it leads to a better discussion. I usually let them go first, and then take a turn. I like to remove the work I don't think is interesting, get it out of the way, and concentrate on what's working. When you pare work down that way and the images are not masked by all of the extraneous things that aren't working, sometimes what remains can be startlingly clear.

ON CHALLENGING TEACHING MOMENTS

Very recently I was challenged by a student's resistance in class. She was very defensive about her work in our critique. I felt it was unfair to all of us; we had really given her our best feedback, and she was complaining about it. I got really irritated and I became uncharacteristically blunt and critical. It was getting too emotional, and two different students stepped in with calm, completely empathetic, gentle, and articulate comments, and I thought, "Wow, they came to our rescue."

It was a good lesson. I let them know how much I appreciated their maturity and evenness.

ON THE MAIN CHALLENGE PHOTOGRAPHY EDUCATION FACES TODAY

Cost. Given that educational costs have risen so far out of proportion to inflation, I am amazed that I have never heard one complex discussion about this in academia. All I hear are conversations about how to be more competitive and prepare students to get jobs, but data that I've seen suggests that more than 90 percent of people stop making work once they get their degree, so, in practical terms, the conversation is about preparing a small percentage of them to get whatever positions remain in the field. I've come to realize that thinking too much about the practical results of their education is misguided. We should be talking about the value of education, these things that happen in the classroom, where people are processing their experiences or looking into somebody else's material, and learning a lot observing human dynamics and understanding how issues break down. Figuring out how to talk about this content, and seeing how the content and the approach work together intricately, seems to be a lesson that is applicable in so many ways, and is more important than sending them out to be the next art star. This is a conversation where the results matter less than the thinking, articulating, and dialogue that occurs, although learning how to transform that insight into a result is also a valuable lesson.

I think that one of the challenges of photography education is to get away from thinking that we are preparing photographers, since statistically, we fail at that. Instead, we are preparing students to think critically and creatively, to be problem solvers, and to push themselves to make their lives more meaningful, which is useful no matter what profession you're in.

ALLEN FRAME is a New York-based photographer, critic, author, and director. He teaches photography at the School of Visual Arts, Pratt Institute, and the International Center of Photography. His book *Detour*, a compilation of his photographs over a decade, was published by Kehrer Verlag Heidelberg in 2001. He is represented by Gitterman Gallery in New York where he has had solo shows in 2005, 2009, and 2013. As a director, he's worked in both theater and film, including a documentary about his father's death called *Going Home;* most recently he served as an Executive Producer of the feature film, *Four*, released in 2013. Frame co-founded the contemporary art center Delta Axis in Memphis in 1992, and he has curated exhibitions for non-profit art spaces including PS122, Art in General, and the Camera Club of New York, where he is currently board president. In 1990 he co-created Electric Blanket, an epic slide show about AIDS, which toured throughout the U.S. and to Norway, the U.K., Germany, Hungary, Japan, and in 2003, to Russia. He has a BA degree from Harvard University.

We should be talking about the value of education, these things that happen in the classroom, where people are processing their experiences or looking into somebody else's material, and learning a lot observing human dynamics and understanding how issues break down.

Bill Gaskins

Visiting Associate Professor
College of Architecture, Art and Planning,
Cornell University, Ithaca, New York, United States

www.billgaskins.com

Technology allows students to confuse a skill set with being visually literate.

ON TEACHING PHOTOGRAPHY

Alexy Brodovitch wrote an essay[15] on education where he wrote that art school was the place where students go to learn how to create clichés. That resonated with me, so I created an assignment where students have to curate a presentation of photographic clichés. One of the things they conclude is that "everything's a cliché, professor" but I tell them that some clichés are more transparent than others and the challenge is to make the cliché recede to the lowest layer of the photograph as opposed to the top layer of the photograph. The best response to this challenge once came from an architecture student who was the typical male wanting to take nude photographs of his girlfriend. I told him he needed to understand the role that the female nude has played and continues to play in visual culture and figure out how to challenge the tropes that are around the phallus-centered gaze of female flesh. He admitted that he had never ever considered that. He then photographed his girlfriend, made slides of the photographs, projected them onto his nude body and then photographed that. He truly made the nudity at once primary and secondary because of the formal complexity that resulted from photographing *his* nude projection.

ON CHALLENGES FOR PHOTOGRAPHY EDUCATION

I identify several challenges. First, how do we make the students smarter than the technology that they're using? Technology allows students to confuse a skill set with being visually literate. Also students today—as digitally savvy as they are—don't know what they think. Too much social networking and a 24/7, 365-days news cycle is distracting.

Dynamic social and intellectual diversity remains a challenge to art education. Many students attracted to art and design education can't gain admittance because they're often without secondary school support to produce a portfolio, a college prep curriculum, nor the funds for tuition, room, board and materials, which remain the primary metrics for admission. Many of the students who can't get in are the students I would also like to have in my classrooms because these are the students who are going to the museums, reading, writing, thinking, and making work in spite of the structural impediments.

Cost is the biggest challenge for photographic education—for both the education and the digital photography tools required today. Frankly, I think the planned obsolescence of these tools is simply not sustainable. And once students graduate they lose access to either new or old imaging technologies so their entire relationship to photographic production changes.

Finally, we face a zeitgeist that says anything can be art and anyone can be an artist. This is an oversimplification and complete misreading of Duchamp's response to Word War I. He was making an anti-war statement, not an anti-art statement. Yes, Duchamp *did* choose to put a bicycle wheel on a stool as an anti-aesthetic statement—but not just for the sake of saying art can be anything; it was also to state that the world had gone mad after the worst war in history and artists needed to act like the world had gone mad.

The complimentary myth to "anything is art" is that "everyone is a photographer." The supreme challenge for the people coming into this medium is to understand that if a billion images are made daily, how are you going to separate yours from the billion of photographs made?

That starts with understanding that there is a profound difference between taking and making photographs. As I like to say, at Cornell, engineering students don't call themselves engineers, medical students don't call themselves doctors, law students don't call themselves lawyers, but photography students call themselves photographers. This suggests a lack of respect for the difficulty of mastering the medium. I believe if we can dam the river of photographic clichés and help students understand that being a photographer or an artist is not something everyone can do without merging technical training with social and intellectual cultivation, our students will become smarter than the technology they use.

As an artist, teacher, scholar, and author, **BILL GASKINS'** work meets at the intersection of the visual and the liberal arts, examining race and representation; photography and the portrait; contemporary art, the politics of visual culture; and the artist as citizen. His monograph *Good and Bad Hair: Photographs by Bill Gaskins*[16] explores the role of hairstyling and photographic representation in African American culture(s). Gaskins received his BFA from the Tyler School of Art, a MA from Ohio State University, and a MFA from the Maryland Institute, College of Art. Most recently he extended his work with the photographic portrait by completing his first venture into cinema, *The Meaning of Hope,* a short film on the most essential human resource.

As I like to say, at Cornell, engineering students don't call themselves engineers, medical students don't call themselves doctors, law students don't call themselves lawyers, but photography students call themselves photographers.

Chris Gauthiér

Assistant Professor, Photography
Utah State University, Logan,
Utah, United States

www.christophergauthier.com

I stress to my students that they have a moral responsibility for what they do and what they make.

ON WHY TO STUDY PHOTOGRAPHY

It's one of the few disciplines in a university where with an undergraduate degree you can walk out, get a job almost immediately, and within a very short period of time you can have a career. I know that people are pessimistic about the state of professional photography, but we're always talking about the good old days. To be successful you still have to look at the world around you and make something other people will be interested in seeing. You have to think about what clients want and how to fulfill their needs. It's simply about adaptive thinking. We stress that in our program. For example, we teach students how to shoot a still life, we don't give them formulaic lighting scenarios. We require them to research other photographers, and be adaptive critical thinkers because that will help them in the industry when the client throws a curve ball at them.

ON A TEACHING PHILOSOPHY

I became an educator because I had a moral crisis; I was a successful commercial photographer but I was at the point where I realized I was part of the machine that was propagating consumptive behavior. I realized I was helping McDonald's make billions of dollars, but I was not adding to the collective benefit of society. Teaching was a way to do that. I wanted to bring that dialogue to the classroom. I stress to my students that they have a moral responsibility for what they do and what they make.

ON CHALLENGES FOR PHOTOGRAPHIC EDUCATION

As artists we're constantly becoming aware of moral crisis points, and we make work that brings others and ourselves through a paradigm shift. One inescapable example of this cognitive dissonance is being both an environmentalist and a photographer. In this example, points of crisis, which the new generation of photographers—our students—should begin to consider include: Where are the raw materials coming from in the first place? How much are we using? How much damage is caused from the tiniest bit of selenium or precious metals that are in our digital technology? How can we sustain ink jet printing when making ink in plastic cartridges is one of the most environmentally hazardous processes in the world? We should develop curriculum around those active conversations. It is vitally important to be addressing the ethical, social, and environmental concerns in photography programs.

ON TEACHING PHOTOGRAPHY

Generally speaking, digital technology has impacted both photo education and photography. I become frustrated with the mindset that digital is the solution for everything, but it shouldn't negate what we've already been doing. Digital also has made us more screen-based. Students think they've "seen" a photograph if they see it on the screen. It's like opening up an art history book and believing that you've "seen" a Jackson Pollock painting. You really haven't. You've seen a cheap reproduction of a Pollock; it's not even close to the same thing. That's also true for thinking you've seen, say, an Ansel Adams photograph when you've never seen the print.

I generally still require students to show prints because I am resistant to projected critiques. I think they negate the idea that a photograph is ultimately an object on the wall or an object that has been printed in some way. However, if it is a fairly complex assignment that requires a lot of postproduction, then I will hold a projection critique. This allows us to perform real-time technical changes if necessary. It speeds up the learning process because if anyone runs into a problem, we literally work out a solution on the spot in Photoshop.

ON PHOTOGRAPHY

For me, a photograph is an object that looks as though it happened at one moment in time and space. Whether that time is elongated and stretched or whether it's finely captured in that decisive moment; it has to look flawlessly optical or at least have the illusion of being originally optical. It's what I refer to as the myth of truth. Photography relies very heavily on the myth of truth.

If you can see the edges, if it looks cut and pasted, if you've literally done montage to it, well, that's not a photograph, that's something else. For example, a lot of artists today take images off of Google and present them as photography. I wouldn't call that photography. It's still valid, but it's not photography.

CHRISTOPHER GAUTHIÉR has been teaching photography for more than ten years. He has successfully combined careers as an educator, commercial photographer, and activist whose personal work focuses on autism and the impact of environmental insults on human health and development. His photography can be found in the permanent collections of the Mississippi Museum of Art; Webster University, the Netherlands; Koltsovo Airport, Yekaterinburg, Russian Federation; and in private collections nationally and internationally. He holds an MFA in Photography from Ohio State University.

Students think they've "seen" a photograph if they see it on the screen. It's like opening up an art history book and believing that you've "seen" a Jackson Pollock painting. You really haven't.

Rafael Goldchain

Professor and Program Coordinator
Sheridan College, Toronto, Canada

www.rafaelgoldchain.com

Education should not be so narrow that it turns the photographer into a bit of a disabled artist who has a narrow vocabulary, a narrow range of ideas about photography, and a narrow range of skills and abilities.

ON WHY STUDENTS SHOULD GET A PHOTOGRAPHIC DEGREE

I use a very convenient analogy, which may be too simplistic, but it goes right to the core. I tell students, "Okay, we all speak English. We even write English, however, just because we use English we are not all extraordinary writers who write extraordinary literature." And the analogy is that even though we all use cameras and we all take pictures, that doesn't mean that those pictures are extraordinary images of lasting value, have a profound impact on us as a society, or impact our consciousness and our understanding of ourselves. A photographic education is a necessary step in learning how to make those kinds of photographs. Students need to master the iterative creative process; technique and technology; and the business side of photography, which hopefully enables photographers to have a viable practice, whether that's an art practice or a commercial practice. Considering that most applicants are not aware of photography as a business we try to explain to them in simple terms that they need to make sure that they don't get sued, or have to sue someone, and that to have a successful photography business or practice they actually need to make more money than they spend. If they really understand those two things, then I think they're okay.

ON THE SCHISM BETWEEN FINE ART AND TECHNICALLY FOCUSED PHOTOGRAPHY PROGRAMS

Historically that split has been at play in most Canadian universities, but not at Sheridan. We don't draw a line between fine art and commercial. I think these schisms hurt photography education because when you're young, you swallow pretty much undigested what your professors present. Teaching students that fine art has a higher social or artistic value than the work of someone who wants to be a commercial photographer is a reductive, simplistic view of what commercial photography entails. Great photographers like Richard Avedon or Irving Penn have always moved back and forth between genres. Rather than reinforcing the schism, we should be teaching students to understand the visual and technical complexity of what photographers like Avedon and Penn were trying to attain. Education should not be so narrow that it turns the photographer into a bit of a disabled artist who has a narrow vocabulary, a narrow range of ideas about photography, and a narrow range of skills and abilities. The kind of student we need to be putting out there is a student who's broad

> And the analogy is that even though we all use cameras and we all take pictures, that doesn't mean that those pictures are extraordinary images of lasting value, have a profound impact on us as a society, or impact our consciousness and our understanding of ourselves.

and inclusive, and open-minded about the possibilities available to a photographer.

Maybe we just need a couple hundred more years for photography to shed its trade heritage and then the distinction between fine art photography and commercial photography will be erased and we won't need to legitimize it as art in the eyes of critics and academics by making it bigger, more provocative, or by adding some art history references or by pulling postmodern maneuvers.

ON WHETHER VIDEO FITS IN A PHOTOGRAPHY PROGRAM

There is no conclusive answer to this question. We have chosen to put in two video courses at the fourth-year level, although I'm already thinking that they should be in the third-year level. All of the cameras that our students get from us here shoot video. We believe video needs to become part of the toolset of the photographer, and that's being driven by technology, but I know that's a really poor reason that is philosophically unsound and lacking in intellectual rigor. The other answer lacking in intellectual rigor is that clients are requesting it and if you want to make a living you ought to be able to make a daft video here and there in order to keep your client happy. But adding video may have unexpected outcomes, which, if I get really visionary here, may cause some academic changes in the future such as more interconnection between programs that teach filmmaking and photography programs. I was in a studio not too long ago and there was an L.A. based photographer doing a shoot. At some point he stopped taking pictures and he turned on the video part of the camera and continued to interact with the model. The model knew that what she was doing now was for motion so she was behaving differently. But the lighting was the same, the studio was the same, everything was the same, except that the photographer was capturing motion. So that is a video evolution out of photography, rather than out of filmmaking. The opportunity for hybridization is there.

RAFAEL GOLDCHAIN is a Chilean-born, Jewish artist who moved to Canada in the late 1970s. Prior to teaching full time, Goldchain worked as a medical photographer and as a freelance commercial photographer. He has been a full-time professor at Sheridan since 2000, working with a team to transform what had been a two-year commercial degree into a more inclusive four-year degree by identifying five aspects crucial for a photography education in the twenty-first century: the conceptual, visual, social, technical, and business. He published his first book, *Nostalgia for an Unknown Land* (Lumiere Press) in 1989, followed by *I Am My Family: Photographic Memories and Fictions* (Princeton Architectural Press) in 2008. He has garnered numerous awards including the Duke and Duchess of York Prize in Photography from the Canada Council for the Arts. His photographs have been exhibited internationally and are featured in many private and public collections including the Bibliothèque Nationale in Paris, the Canadian Museum of Contemporary Photography in Ottawa, and the Museum of Modern Art in New York. He earned a BFA from Ryerson University and an MFA from York University, both in Canada.

Jim Groom

Director of Division of Teaching and Learning Technologies
University of Mary Washington, Fredericksburg,
Virginia, United States

jimgroom.net

Rather than saying this is what you can't do online, schools should be trying to create new methodologies that we haven't even imagined yet.

PREFACE

Digital Storytelling,[17] also known as ds106, is an innovative approach to open online education. The interdisciplinary class is an ongoing experiment, morphing in the spirit of how social media and technology morphs. It was created by Jim Groom, Martha Burtis, and Alan Levine from the University of Mary Washington's computer science department as a technology introduction to photography, design, audio, and video, and an experiment in developing an architecture to provide every student in the class with his or her own domain name and web host. The free course happens at various times throughout the year, but students can join and leave at any time.

ON INNOVATION IN ONLINE EDUCATION

Our ds106 program is a very interesting model for using the web as a platform for teaching and learning. It is iterative in the most intense and rapid way. We are successfully, as a community, figuring out what it means to merge the idea of how to work and share work online and also how you interrogate the online spaces like Twitter, other social media, etc. It's also a space where people can be creative and define that creativity across a whole wide range and spectrum of media. Even though the course involves media, the ds106 team works out of the computer science department. Our expertise is in web narration, communication, and web development, not photography or video. Going into its third year, ds106 has evolved into an online space that collaborates with other institutions. We have 25 to 50 students on campus registered in the class, then maybe 200 others students participating online at various universities—including in Brian Ralph Short's class at the University of Michigan and Michael Branson Smith's class at York College (part of the CUNY system) in New York—doing the

Classes like ds106 require collaboration and experimentation, and that's not easy in an academic environment, which tends to be very conservative.

class at their own pace and asynchronously. The beauty of ds106 is that it is a class designed architecturally to reflect the web. It's a class that models its own community, and it will change. It is not the total solution to online education, but most of the students love the idea of being in a class with real-life implications. What I mean by that is because this class is taking place in real time on the web, whatever students do goes out to the whole online community. They are obligated to be open with everything they produce. But the class also connects them to a community of students they wouldn't otherwise engage with and offers the opportunity to get feedback from professionals in their field. We think digital storytelling is the space where you're constantly narrating your life on these various social media, and that's a quotidian narrative at the most minute level, but also profound when you think about the identity, privacy, and narrative implications. We're interested in these things, but we don't have the answers, so as a group we're still pushing the definitions.

ON CHALLENGES FOR PHOTOGRAPHIC EDUCATION

Classes like ds106 require collaboration and experimentation, and that's not easy in an academic environment, which tends to be very conservative. For education to innovate in this space, it has to be experimental. Sure, we are definitely crazy, interesting, and cool, but ds106 was a group effort that allowed us to redirect the idea of teaching online to the acceptance that faculty should have their own domains and be allowed to experiment. Our university president is excited about what we're doing and gave us some funding so essentially we got thirty faculty together and showed them how we do what we do and gave them the power to do it themselves. This year we're going to give all the freshmen their own host and domain with the idea that students and faculty working together can build these structures and networks of nodal learning that are radical. We've discovered that when you build something and don't put too many rules on it people will come back and show you how to use it in a completely different way. Creating these same environments will be a challenge for others because of the various obstacles that exist in most academic environments. We can have an open, discursive, expressive culture if we can interrogate the things that are defining us and that's why we want our students to have their own domains and web hosting.

ON TECHNOLOGICAL CHALLENGES

We distribute the blogging responsibility to the individuals so students have full control over their work. We've found that we avoid problems with copyright this way because if they get a takedown notice, it's less consequential than if it were the university getting the notice. So by distributing out the projects and ownership we've actually made the web that much safer for doing this kind of stuff rather than putting it all within a university site, which is just inviting the copyright hawks to come and get us.

ON CHALLENGES FOR ONLINE EDUCATION

Online education and the faculty who teach it must fight to be taken seriously. Rather than saying this is what you can't do online, schools should be trying to create new methodologies that we haven't even imagined yet. We also should be teaching K-12 students how to use social media and YouTube, etc. We will be grossly irresponsible if we don't do this because these students are using this space with no guidance otherwise.

JIM GROOM is an author, technologist, and educator. As Director of the Division of Teaching and Learning Technologies and adjunct professor at the University of Mary Washington in Fredericksburg, Virginia, Groom is an expert in the field of instructional technology. His fifteen-year career in education has focused on the development of teaching and learning in higher education. He spearheaded the innovative ds106 open online course in digital storytelling and regularly speaks on the subject. He holds a BA in English Literature from the University of California, in Los Angeles, an MA in American Literature from Queens College, Flushing, NY, and an MPhil in English from CUNY.

Charles Harbutt

Associate Professor
Parsons The New School for Design,
New York, New York, United States

www.charlesharbuttphotographs.com

Theorists teach the theory of photography: they teach everything about photography except what to do to make a good photograph.

ABOUT TEACHING

I never tell young students what to photograph, and sometimes that upsets them because they are still in a high school mode. In the first few classes, I lecture and show a lot of other people's work to get them started, but after that I don't fill in the blanks for them. Part of teaching is forcing students to take responsibility for their projects and not tell them what to do. One of the problems is their work is very safe and center-loaded, literally and metaphorically. They have the little circle in the middle of the finder and they put the subject in the middle of the circle and then shoot. The composition comes out symmetrical: the expression "dead center" isn't meaningless.

One of the problems is their work is very safe and center-loaded, literally and metaphorically.

ON A CRITIQUE METHODOLOGY

My critiquing method is simple. My first question is, "What have you been up to?" I listen to their response and look closely at the work to see if it looks remotely connected to what they've told me, and if not I'll just talk to them, trying to draw out what's really on their minds. It doesn't matter in the end if the student's intent matches what the photograph is actually saying; it only matters what the picture is saying. You may think you are doing this over here and yet you're hitting a target over there. It's like *Zen and the Art of Archery*. If you want to hit the target, don't aim!

ON CONTENT VERSUS SUBJECT MATTER

The content of a photograph as opposed to its subject interests me, both in my own work and in teaching. It takes students a while to see this, that photographic qualities such as tonality, distance from subject, shapes, framing, all these things, inform the meaning of a photograph more than the subject matter and making a student aware of this may reveal to him or her what—to give one example—his real emotions about his family are from what he believes is nothing more than a family snapshot.

ON A DEFINITION OF PHOTOGRAPHY

I love photography because you can't define it. It's true that photography is a medium where a thing itself makes its own picture, but what that thing is, is very slippery. I like pictures that boggle the mind, when they expand the notion of what is real. You can't do that in another medium because you don't start with anything real. As long as you're faithful to the notion that whatever you're looking at was actually in front of the camera one time or another, and hasn't been fiddled with, you've got a very interesting medium because you're not talking about an artist's conception, you're talking about life.

ON CHANGES IN PHOTO EDUCATION

Every species tends to reproduce itself and with the boom in education, teachers tend to reproduce teachers. In photography that means we have more faculty with MFAs and fewer and fewer working photographers. The nature of what we teach changes when faculty are theorists. Theorists teach the theory of photography: they teach everything about photography except what to *do* to make a good photograph.

ON A TEACHING PHILOSOPHY

I encourage students to work instinctively, rather than to illustrate concepts. All over the world cameras are basically the same. What's going to be the difference between your work and everybody else's? It's not going to be technique. It's what you feel. Shoot what you feel strongly about. Look, you like ice cream. Take a picture that shows how that sundae looks to someone who loves ice cream.

As our brains evolved, we started to think we needed laws, rules: "Cross at the green, not in between." In New York, where jaywalking reigns? I think the result is we've lost our trust in instincts; we're trained not to trust them but control them—to reduce life to a set of rules, concepts. But in art, in making things, there are no rules. If you think you know a rule, try breaking it. You might take a great or at least an original photograph. In a way, my teaching is about freedom. I think that's the great seductive metaphor of what all art—dance, music, poetry, painting, and photography—is about, both for maker and viewer.

CHARLES HARBUTT is well known as a documentary photographer, working mostly through Magnum Photos, of which he was president twice. Since 1980 he has pursued more personal interests, extending the boundaries of journalism into the realm of the everyday, as well as the exceptional. His photographs have been widely collected and exhibited at major museums, including the Museum of Modern Art in New York; the Corcoran Gallery in Washington, D.C.; the Art Institute of Chicago; the Bibliothèque Nationale and the Maison Européene de la Photographie in Paris. His work also has been published in three books, the most recent of which, *Departures and Arrivals*, was published in 2012. He holds a BS in Journalism from Marquette University.

I like pictures that boggle the mind, when they expand the notion of what is real.

Patrick "Pato" Hebert

Associate Arts Professor
Tisch School of the Arts, New York University,
New York, New York, United States

www.patohebert.com

The way that a photographer uses the frame and an awareness of time, light, and space to create this two-dimensional encounter that the viewer is going to have is very special.

ON WHY PHOTOGRAPHY IS SPECIAL

It's special because it creates a focus and a kind of attentiveness. And the act of composing is just orgasmic because it requires a heightened sense of play, listening, and discovering. The way that a photographer uses the frame and an awareness of time, light, and space to create this two-dimensional encounter that the viewer is going to have is very special. Photography is also relational. If you understand that everything in the world is interconnected, then what photography does is accentuate that. Framing the world makes me more aware of that moment of encounter cum exposure. The photo becomes a marking of that moment, and for the viewer it is an invitation back into awareness, back into that 1/60 of a second. The image is a kind of echo that harkens to that moment of attentiveness that happened at exposure, while perhaps also making us, the audience, more attentive to the moment of our viewing. The exposure is often intentional for many photographers, but some photographs are incidental or accidental. Yet even then, the photograph itself becomes an opportunity for attentiveness.

ON THE MOST SIGNIFICANT CHANGES IN PHOTOGRAPHIC EDUCATION IN THE PAST DECADE

The most obvious is the emergence of digital because that impacted academic infrastructures as some schools had the money to invest in digital facilities and others did not. The second change would be between 2005 and 2007, when everyone walking around with a phone or digital camera became a daily photographer. That shifted the conversation about photography. So my students at Art Center who were paying a lot of money to become credentialed photographers were asking why should they be paying to learn photography if everybody was making pictures. That conversation begs the very real question of: What makes a good photograph if everyone is a photographer?

ON WHETHER THE COST OF A PHOTOGRAPHY EDUCATION IS GOOD VALUE

When anyone asks me if they should spend $60,000[18] a year to learn photography, I always first candidly wonder aloud if maybe

> But I think any photo discourse, or photo program, that is not aware of or having a conversation with video and multimedia is selling itself and its students short.

they shouldn't. But I think the real analysis should be about the cost of college as an investment and that includes the less quantifiable investment in your own growth. Although we don't need to be in a school to have a community of image makers or to learn, I tell my students that the space we create together and the focus they will get in the four years in college may never again be available to them in the same way. We should be willing to make significant investments in what really matters to us, but why should education cost so much?

That's a question we should all be asking at every level of society. So why study photography? A camera phone in the hands of someone like Nina Katchadourian[19] generates dynamic results because attentive-

> ## So I tell my students that their gear can't be the endpoint or the excuse because if it is, at some point they will stop making images.

ness, inventiveness, and practice matter. And that is why you study photography and art. At a formative point in your growth, you have an engagement with the practice in concert with others, which is difficult to consistently access anywhere else.

ON WHETHER VIDEO AND MULTIMEDIA BELONG IN A PHOTO PROGRAM

I do understand photography's sense of historically being the unwanted kid in the visual arts, so I understand photography's yearning to carve out autonomy. We have had such a small window in the history of photo education where we had an educational foothold and even those years were tense as we debated whether photography should be independent of the fine art and design departments. All those conversations were percolating and then the digital moment blew it all in another direction so now we're afraid that we are going to be enveloped by the moving image or multimedia departments. But I think any photo discourse, or photo program, that is not aware of or having a conversation with video and multimedia is selling itself and its students short.

ON THE GREATEST CHALLENGE THAT PHOTOGRAPHY EDUCATION FACES

The major challenges that students face are the cost of education and figuring out how to maintain a practice when they leave college. If you want to keep images alive in your life, what do you need? If your work is only film based, what is your strategy going forward? Where will you get your film processed or where will you print? Does a film practice end up becoming urban only? If you shoot digital, how will you continue making images on a regular basis? Could you make art with just your iPhone? With digital, the pressure on photo education

programs is to stay on top of the technology and not let that distract us from making images. And how will individual photographers afford $10,000 to replace or continually update their digital infrastructures? This creates an unhealthy pressure on photography education, faculty, students, and image makers in general. So I tell my students that their gear can't be the endpoint or the excuse because if it is, at some point they will stop making images. From an institutional perspective we must seriously grapple with the question of what the high cost of digital infrastructure means to education over the next fifty years. Departments used to be able to make an initial investment in the cameras, darkrooms, and people, and then the budget was about maintenance and strategic augmentation. Now the technology is transitioning much more quickly and that has huge implications for infrastructures and funding priorities on a rolling basis, as well as staff skill sets.

PATRICK HEBERT is an intermedia artist, cultural worker, and photo educator with more than twelve years' experience teaching college-level photography, including six years at Art Center College of Design in Pasadena, CA. He is currently an Associate Arts Professor in the Art and Public Policy Department at Tisch School of the Arts, New York University. In his photographs, Hebert explores the aesthetics, ethics, and poetics of interconnectedness. He was awarded a 2010 Mid-Career Fellowship for Visual Artists from the California Community Foundation, and in 2008 he received the Excellence in Photographic Teaching Award from Center in Santa Fe, NM. His work has been supported by the Rockefeller Foundation, the Creative Work Fund, and the Durfee Foundation. He holds a BA from Stanford University and an MFA from the University of California, Irvine.

Paul Hill

Visiting Professor
De Montfort University, Leicester, United Kingdom
University of Derby, Derby, United Kingdom

hillonphotography.co.uk

Photography has to be taught in art faculties, as it is the most important art form of the last two hundred years.

ON TEACHING PHOTOGRAPHY

Photography *has* to be taught in art faculties, as it is the most important art form of the last two hundred years. In one year we now make more photographs than have been made in the whole history of photography. The challenge today is that with modern technology, everyone can take a passable photograph, whereas not everyone can draw or write. Photographers know that photographs may be easy to make, but people who create lasting images are very few and far between. If we think of a photograph as an artifact that invites engagement with the world, then as a teacher we must assist students in making that engagement more effective. I try to do that by helping students think with their eyes, to see photographically—camera-vision, in other words. Most people can produce at least one decent photograph in their life, but can they produce one substantial body of work? Almost certainly not. So, that's what I say they should be aiming to do, because it's a privilege to be able to make a mark on the world by leaving something behind for posterity. It's a great buzz just to have that notion, to think, "Ah! I am immortal now." We also need to teach adaptability because it's not easy to find work as a professional photographer today, but then we shouldn't focus too much on future employment either. Of all the students who study English, how many become playwrights or poets? We need to think of photography the same way.

ON THE PROLIFERATION OF PHOTOGRAPHY PROGRAMS

When there were only a few courses that taught photography at an advanced level, you did attract a very dedicated group of students, by and large, because they felt they were different and special. They were the chosen few and that dedication usually resulted in the production of excellent work. Today students see photography differently because they're using their camera phones all the time through social media, particularly. Therefore, it has the same sort of currency that text had before.

> If we think of a photograph as an artifact that invites engagement with the world, then as a teacher we must assist students in making that engagement more effective.

ON WHETHER PHOTO PROGRAMS SHOULD SEPARATE COMMERCIAL AND FINE ART COURSES

There should be useful cross-fertilization in the curriculum at the BA level, not separate courses. The multiplicity of new visual platforms is immense nowadays. That presents a lot of creative opportunities for making work, as well as job opportunities. When I listen to my undergraduate students talk about how they use photography, how they communicate with each other, I'm enthralled by what they tell me and excited by their enthusiasm. The challenge is trying to channel that enthusiasm, to sustain that sense of being alive and engaged. We have to engage with all of creative possibilities and that includes the commercial world. So when the commercial world opens

itself up and offers interesting possibilities for photography graduates one should embrace it. If it doesn't, then use every device to criticize and subvert it!

ON THE CURRENT TREND OF TEACHING "ART," NOT TECHNIQUE

Technique should be taught, of course, but in the service of ideas. Good technique can mask some pretty thin ideas, and great ideas can't really be communicated if poor technique obscures them. Good ideas can come out of experimenting with technical aspects of the medium, but you have to ask: What are you trying to say? Photography is a stand-alone art form. But it has to interact with other disciplines in order to broaden its scope and present students with exciting prospects. It should not be ghettoized.

You have to engage students' curiosity—obviously you can't teach curiosity—and create that spark that mostly leads to innovative outcomes whether they are obviously "photographic," or conspicuously "art." If photo education becomes too academic, intellectual, or theoretical then you can extinguish that spark. Some students naturally gravitate to criticism and theory, and that's fine, but I think if we're talking about the practice of photography, you have to make pictures, not just read about them. That has to be at the core. Although I am advocating the primacy of the photographic image, it is obviously essential that students place their work within a wider critical framework and really *study* the medium.

We live in the real world. This is all we've got, so let's make the most of it by making pictures of that, whether we think of ourselves as photographers or artists. I tell my students, "You're storytellers; think about

PAUL HILL has been a major influence on British contemporary photography for more than three decades. His active photographic practice was described in *The Guardian* newspaper as tackling "life's big subjects" but with an approach that "is oblique, evocative, always pointing beyond … If a camera could capture poetry, this might well be what it would look like." He is known for, among other achievements, founding one of the first student-centered higher education photography courses when he taught at Trent Polytechnic in Nottingham, United Kingdom; establishing The Photographer's Place, the UK's first residential photography workshop; co-founding the Derby Festival of Photography (now FORMAT); and writing a seminal text on photography, *Approaching Photography*. He was course leader of the MA photography program at De Montfort University until 2010. He was named a Fellow of the Royal Photographic Society in 1990, was awarded an MBE[20] by the Queen for services to photography in 1994, and he received an Honorary Doctorate of Fine Art from Derby University in 2011 and DeMontfort University in 2012.

> We live in the real world. This is all we've got, so let's make the most of it by making pictures of that, whether we think of ourselves as photographers or artists.

it." This is how we communicate; this is how we learn things when we're young, through stories. It's not a difficult thing: Stories have a beginning, a middle, and an end. Just like life…

Matt Johnston

Lecturer, Photography
Department of Media and Communication,
Coventry University, Coventry, United Kingdom

#phonar, #picbod
www.mjohnstonphotography.co.uk

As a faculty you can recycle seminars and lectures every year, but if that is the case, you are out of date because the world we occupy as storytellers and content producers is changing so fast.

ON INNOVATION IN ONLINE EDUCATION

At Coventry we run two open classes, Picturing the Body (#picbod) and Photography and Narrative (#phonar) that meet on site but also are open to the global online community. We are really interested in the relationship between the online students and those who attend the class on site. As an open educator I want to change the structure of the educational experience for both types of students. Rather than putting myself front and center of the experience, I want our students to be the ones who are visible online. By putting them at the "front," our students went on to become mentors to many of the remote students. In doing this, and making other changes in my approach to open teaching, a truly engaged community formed, a community that would support itself in feedback, critique, and inspiration. It also resulted in our students inviting online participants to submit digital files, which they then printed and exhibited alongside their own at our end-of-class show. This collaboration was expanded up when a very involved group of online students from Santander, Spain invited our students to send the entire exhibition to Spain. Five of our students traveled with the work and took part in a twenty-four-hour #picbod festival. Our students now see the value of connecting to a global online community when they realize how many people are seeing and interacting with their images, how they can be supported by a larger peer group, and of course the possibilities of international collaboration.

ON CHANGING THE HIERARCHY OF THE CLASSROOM

I want to put the students front and center and create an environment where they work the same way they will need to work after graduation to be successful and sustainable. I can certainly see why people are hesitant to do things the way we do them here because it can look daunting, both from a digital literacy angle but also in putting your own material online, for free, and to be judged. I think these worries need to be put in context. I don't think of myself as an online teacher because I don't think that online is the answer to everything. The question for faculty has to be: Are we doing the best we can do to teach photography in the twenty-first century? Is what we've been doing for the past thirty years still appropriate? For example, I'm planning to run a class where we work openly with local communities that are already established and embed our students within these groups. This won't be online but will be open within a geographical area; it will include more fieldwork and maybe me delivering lectures and seminars to the students when they are embedded in their community. Maybe I will get on my bike and deliver a lecture or seminar that's catered to that community and group of students, rather than expecting that one lecture is going to be appropriate for these different elements. I know that some faculty will read this and think that this is extra work. It's not necessarily extra work; it's *different* work. As a faculty you can recycle seminars and lectures every year, but if that is the case you are out of date because the world we occupy as storytellers and content producers is changing so fast. If an institution is training students the same way it was doing it even five years ago, that's just not going to work for the world that they're entering. Maybe it takes a slightly different kind

of person to do things like we do here, but teaching should be fun. You also have to want to learn to teach like this. I can't wait to get on my bike and ride around these different communities and meet loads of interesting people and deliver different lectures rather than recycling last year's lecture.

ON THE CHALLENGES FACING PHOTO EDUCATION

Let's hope the heads of departments are reading this because these new ways of working benefit hugely from their support. It is not to say open classes cannot be a one-person operation, but putting all your effort into the students' experience is more worthwhile than fighting a system that doesn't get why you might even think of putting a lecture online, for free! I am lucky to have support from my department. I also think we need to realize that "online" and "open" are very different things. I'm interested in exploring what sort of certificates and accreditation we can do online, but I am more interested in how our version of open changes the experience for the students. I believe that the students in Spain who worked with ours to put on an international exhibition have a better accolade and greater experience than someone who completed an online ten-week course and received a piece of paper for it.

ON THE BENEFITS OF OPEN COLLABORATION

I am very interested in the design and function of the photo book, a medium that, in partnering design, text, and images, becomes more than a collection of photographs. A photo book is a project in its own right where everything—paper, image sequencing, text, etc.—has been considered. So I started a global project called the Photobook Club (photobookclub.org) to promote and enable discussion around the physical photo book, in particular looking at old, rare, and influential photography books from the twentieth century onwards. Anyone can join. Currently it consists of twenty-six global communities from Auckland to Bangalore, who meet on site, like a traditional book club. I strongly believe that one of the reasons for the success of the community is, like in #picbod, ensuring that the personalities of these different branches are seen rather than just my own. The result is twenty-six different branches that interact and discuss things in vastly different ways rather than a formula to be copied for each location. I also have

selected a box of books that is traveling around the world to these local book clubs. The members of the local book club write comments in a notebook that accompanies the books and will travel to subsequent events, acting much like the #picbod G+ community but fixed in location and given weight.

MATT JOHNSTON is a photographer and educator based in the U.K. He has worked for a large number of corporate and private clients including Channel 4, Ocean Media, Build-It magazine, and the Institute for Sustainability. A selection of his non-commissioned work is represented by Getty Images. Since 2009, he has also worked as a social media and audience consultant to a number of photographers, artists, and educators, seeking to better understand and leverage audience engagement habits. At Coventry, he has developed innovative, open, and connected teaching methods and platforms within the Photography BA program including the world's first photography class run as a Google+ Community and an iPhone and Android class app. The open classes #picbod and #phonar, co-developed by Johnston, have received numerous plaudits from photography- and education-based peers, including a speaking engagement at the Open Education Conference 2012 held in Vancouver, British Columbia. He holds a BA (Hons) in Media Production from Coventry University.

Svea Josephy

Senior Lecturer in Fine Art (Photography)
Michaelis School of Fine Art
University of Cape Town
Cape Town, South Africa

www.sveajosephy.com

We aim to educate artists and critical thinkers who happen to use lens-based media in order to express their ideas.

ON THE VALUE OF A PHOTOGRAPHIC EDUCATION IN A WORLD WHERE SO MANY PEOPLE HAVE CAMERAS IN THEIR PHONES AND ARE "PHOTOGRAPHERS"

In South Africa, only 10 percent of people have regular access to the Internet and a much smaller percentage in rural areas. However, cell phone technology has penetrated nearly 100 percent of the adult population. Since many of these phones have cameras this has changed the way photography operates in South Africa. Previously, photographic specialists claimed the high ground and the right to image, now this has become increasing easy for anyone to do.

I think what a photographic education at a university can offer is perhaps a more skilled person than the average cell-phone shutterbug. We are concerned with the development of the student as a person with a critical mind. We are interested in sharing some knowledge of precedent, of both art and photography, which might (but not necessarily) distinguish our graduates from amateurs. At Michaelis, photography is taught as part of a program in fine art (BA in Fine Art) so we aim to educate artists and critical thinkers who happen to use lens-based media in order to express their ideas. In a historically divided country, such as South Africa, it becomes quickly apparent that there is no universal language and while the medium is available to most social classes in some form, it is activated and evoked in a variety of complex different ways. Teaching photography here lies in the value of growing a community of thinking, literate, and visually literate people, who aim to understand the world we live in and the imagery around us in relation to histories and contexts both local and global.

ON THE IMPORTANCE OF TEACHING TECHNICAL INFORMATION

Technical skills may be more important in South Africa because here students have to do things themselves. We are not an institution with first world resources. This changes things. Also few of our students are going to "make it" as artists because it's harder for a photographer in South Africa to be successful as an artist, so the rest are going to go out and work in the film industry, as web designers, journalists, fashion photographers, wedding photographers, etc., so they have to

> Teaching photography here lies in the value of growing a community of thinking, literate, and visually literate people, who aim to understand the world we live in and the imagery around us in relation to histories and contexts both local and global.

have technical skills. So we teach them analog and digital processes in the first two years and we add videography and other specialized techniques in the third and fourth years. We do believe that analog processes are important. In a post-apartheid context, photographers now use digital techniques, but the analog processes help us understand our past as it was recorded. Also with the cost of film and printing, the analog process forces students to understand the photographic craft and to pay attention to light, color, tone, form, and content.

This assignment, done for Svea Josephy's assignment, Untitled Film Stills, is itself untitled from the *umaskhenkethe likhaya lam* series. Umaskhenkethe likhaya lam is isiXhosa for "the bag is my home." This refers to the tartan-patterned red, white and blue "China Bag" that is the subject of this series.
Image courtesy of Nobukho Nqaba

With digital, students can sometimes adopt a "spray and pray" approach, where they shoot three hundred images in the hope that they'll get ten good ones. In analog this is not an option. That said, the technical learning at Michaelis is secondary to the academic or intellectual process. We stress teaching students how to think about and look at images critically. All of this will (hopefully) enable the student to critically engage with the images they face and produce. For us in South Africa, it is important to keep up with debates around the visual arts, both from Africa and internationally.

That being said, many black students wish to pursue this area. My colleague Jean Brundrit and I are very consciously trying to grow our numbers of black students and so we make a variety of interventions to

> Life in South Africa is richer and more vivid than anything that a computer can produce: reality here is often stranger than fiction and the computed image can often disappoint.

provide them with the resources needed: material bursaries for those who can't afford to buy materials, counseling services, orientation programs, mentorship programs, and the organization of food security for those of our students who literally cannot afford to eat. We also have to be mindful of the gap between the privileged and the underprivileged when we assess work because a student who is able to afford high production values should not be at an advantage over a student who cannot afford them. The responsibility of the educator becomes much more complex in these circumstances and one has to take historical and moral questions into account before one can enter a classroom and teach.

ON THE CURRENT DIALOGUE ABOUT WHETHER IMAGES TODAY ARE "COMPUTED" OR "TAKEN" AND WHETHER THIS "COMPUTATIONAL PHOTOGRAPHY" SITUATES PHOTOGRAPHY IN AN UNPRECEDENTED HISTORICAL THRESHOLD[21]

I am not too sure I would make a distinction between "taken" and "computed" as it forms part of the same photographic continuum. There is less emphasis on what might be construed as "computed" in our courses. Computers are used as digital darkrooms, but the overly and overtly constructed image has not really happened here to the same extent as it has in Europe and America. While I find these computational photographic modes very interesting, so often I find the images too clean and slick. Maybe this is my context, but I prefer images with the grit and dirt of "reality." Life in South Africa is richer and more vivid than anything that a computer can produce: reality here is often stranger than fiction and the computed image can often disappoint. That being said, when this type of technology is used to make interesting comments about the world then it is useful.

ON THE HIGH COST OF EDUCATION AND THE INEVITABLE SOCIAL DIVIDE THAT IT CREATES

A university education is undoubtedly expensive and especially in South Africa where the gap between the rich and the poor is more exaggerated than in the U.S. and Europe. Of all the disciplines taught at our school, photography is the most expensive. Thus it becomes almost prohibitive for previously disadvantaged students to pursue a course in photography.

ON WHETHER FINE ART PROGRAMS SHOULD RESIST THE ENCROACHING COMMERCIAL WORLD

There is more than one commercial world at work here. There is the world of commercial photography: magazine work, weddings, fashion, editorial work, journalism, etc. These do encroach in the sense that our students do this for money and sometimes it is hard for them to distinguish between what is "good" in these spheres and what makes sense in the world of the academy and "fine art."

Then there is another more slippery commercial world, which we need to consider, and that includes the world of the commercial art gallery. At our graduate show, galleries and collectors come to check out the talent. Students are aware of this and with this in mind sometimes shift their methods of working and presentation to be more appealing to these commercial gallery spaces. This means that work which is highly experimental or process-driven is sometimes seen as less "saleable" than work on the wall in a white frame, which buys into the conventions of the collector and the commercial art gallery.

ON THE MOST SIGNIFICANT CHANGES IN PHOTOGRAPHIC EDUCATION IN THE PAST DECADE

The obvious change is that we teach digital processes. When I arrived at the school ten years ago there was no digital photographic equipment and no digital teaching in the curriculum. Apart from the technical, there have been huge changes in South Africa on political and social levels over the last two decades, shifts that continue and are not resolved. These have altered the face of South African photography. These include the re-inclusion of South Africa into an international art world after the cultural boycott, a transformation of the South African art market, and shifts in technology. In the last twenty years there has been a movement from the language and iconography of the struggle against apartheid towards very different and much more creative practices.

SVEA JOSEPHY, who holds a BFA from the University of Cape Town, a MFA from the University of Stellenbosch, and a Postgraduate Diploma in Business Studies from the University of Wales, focuses her work and research on the politics of post-apartheid photography, particularly as it connects to the politics of the land and its representation in relation to identity. She is interested in "new documentary" forms that have emerged in post-apartheid South Africa, in particular those that relate to the representation of the land and structures. Her work has been exhibited nationally and internationally in exhibitions such as *Crossing Boundaries: Contemporary Art and Artists from South Africa in Qatar*; Format International Photography Festival: Photocinema, UK; The Position of South African Photography Today, Germany; and DAKART 2010 9th Biennial of Contemporary African Art, Senegal, where she was a prize winner in 2010.

We also have to be mindful of the gap between the privileged and the underprivileged when we assess work because a student who is able to afford high production values should not be at an advantage over a student who cannot afford them.

Susan Kae Grant

Professor, Photography and Book Arts
Texas Woman's University, Denton,
Texas, United States

www.susankaegrant.com

Photography has certainly taught me how to slow down, be quiet, listen to my heart, and have the courage to let my intuition guide me.

This image is a page spread from a blurb book produced in response to the theme "Night Dreams, Day Dreams and Hypnogogic Hallucinations" given by Susan Kae Grant in a class focused on experimental techniques.

Image courtesy of Heather Roses

ON TEACHING PHOTOGRAPHY

As an educator, I essentially teach two things: the psychology of being an artist and the physicality of creating art within the context of the history of the medium. I think it is crucial to create a balance between theory and practice, so I incorporate discussions addressing technique, vision, history, and theory in every assignment. This is done utilizing a variety of methods such as technical demonstrations, readings, image presentations, and group critiques. I believe the technical side of photography is extremely important and should be taught in

unison with assignments that encourage creative thinking. Therefore, technical requirements are intentionally integrated within creative assignments so students learn to develop a balance between form and content.

It's important to teach students to see, both from their external world and their internal world. Without guidance and vision, most students experience raw emotions with very little understanding. Through the lens of artistic training, students learn to look at their lives and experiences with new perspectives. It is also important that we teach the history of photography by emphasizing who significant photographers are and how they work. This helps build a context by which students view their own and each other's work. It's also key that students learn to write and speak about their work. I believe one of the reasons art is underappreciated in our culture is that artists have not been successfully trained to articulate the issues in their art. Every project I assign has a creative writing component so that students are looking with both their vision and their heart. No matter what style of photograph is being made, the heart is involved in some way. Writing exercises consist of a series of one-minute questions that are designed to get students in touch with their inner thoughts, observations, and feelings. I find the writings inspire and clarify what the students are passionate about and provide insight into creating art from those passions. Through the writings they come up with amazing realizations.

ON A CRITIQUE METHODOLOGY

It is effective and crucial to lead critiques where all students and myself have an equal voice. At a basic level, my intent is to teach students how to be citizens of the art community by speaking and thinking objectively about their own work and their peers. Creating a structure is important. Students want and deserve constructive and honest feedback. I believe an empowering and successful critique is one that communicates feedback honestly without a student feeling attacked or disempowered. I strive to create a space that is safe because criticism must be presented with a sense of community, appreciation, and integrity. I discuss this with the students and emphasize that the critique is not a personality contest. I invite everyone to remember that we are looking at and talking about photographs not the people who made them. When a student's work is being critiqued, the student's

requirement is to be a committed listener and she is not allowed to interrupt or defend the work. When someone else's work is up, a student's requirement is to be a committed speaker with an obligation to share insights responsibly. Feedback and insights that are difficult or could be perceived negatively must be communicated with integrity and respect.

All critiques are held in our gallery. After a student's work is leaned up against the wall and everyone examines it, students have eight minutes to write anonymous answers to five questions I pose. The questions are generally related to each specific assignment. For example:

1. Emotional impact: Describe this work emotionally using three different words.
2. General subject meaning: Describe what you think the photographer intended to communicate in this work.
3. Memory and context: Describe the connections you experienced while viewing this work and what or who you are reminded of. Include elements you attach personal significance and/or emotion to.
4. Strengths and improvements: Describe three strengths you notice when viewing this work and state three examples of "action steps" that could be taken to improve the work.
5. Technical execution: Describe the technical execution of this work and list ways to execute it differently.

After everyone has written answers to the five questions, the student whose work is being critiqued gives a brief talk about the underlying issues in her work and any technical achievements she wishes to share. Then, I ask someone to volunteer to read the insights they wrote to question number one. We sit in a semicircle so the students are looking at each other and the work being critiqued. The first question is easy because it's short, and serves as an icebreaker to get the process going. Then we move counterclockwise and the next person addresses question number two. We continue until everyone has contributed by discussing one question. Next, I ask if there is anything that was left unsaid. Some hands always go up and those students contribute their observations. Lastly, I ask the student whose

work is being critiqued if there is anything else she wants feedback on. During this time she can ask for additional feedback but once again she is not allowed to defend, justify, or explain her work. The intent here is to gain more feedback about an issue or concern that didn't get mentioned or needs clarification. This process is intended for everyone to learn to listen objectively and to see their work through the eyes of their peers. Through this style of critique, students begin to gain confidence in discussing their work and learn to respect the viewpoints of others. They also discover the wonderful opportunity it is to have fourteen people discuss what the work means to them with neutrality and objectivity. If a student has a certain intention in their work, they can measure that intention against those fourteen points of view. After the critique process, each student receives the stack of anonymous written critiques from their peers to read at their leisure.

> Studying photography teaches focus, discipline, resourcefulness, and the ability to work on simple or complex projects that have self imposed parameters.

ON WHY STUDENTS SHOULD STUDY PHOTOGRAPHY

Studying photography teaches focus, discipline, resourcefulness, and the ability to work on simple or complex projects that have self imposed parameters. These skills translate to other jobs. Through photography, I believe students discover new ways of seeing and bringing the images that are in their imagination into fruition in ways that successfully communicate intention. They begin to realize that they have a gift; they see the world very differently and through their photographs, they can show their visions to other people. Additionally students are in an environment where they learn to articulate their vision and place their work into a historical context. Students learn by experimenting and taking risks. I teach them to look for threads of interest in their work that can be developed and nurtured into larger projects. Photography has certainly taught me how to slow down, be quiet, listen to my heart, and have the courage to let my intuition guide me.

SUSAN KAE GRANT, who says she wanted to be a teacher since childhood, has been teaching photography at Texas Woman's University since 1981. She has twice received awards for teaching excellence from the Society of Photographic Education (SPE) and once from the Santa Fe Center for Photography. Known both as a photographer and bookmaker, Grant has produced thirteen limited-edition handmade books and she has conducted bookmaking workshops worldwide. Her work has been exhibited nationally and internationally and is in the permanent collections of major museums, including the Tokyo Museum of Photography in Tokyo, Japan; the Victoria and Albert Museum National Library in London, United Kingdom; the J. Paul Getty Museum in Los Angeles, CA; and the Museum of Fine Arts in Houston, TX. She holds an MFA in Photography and Book Arts from the University of Wisconsin-Madison.

Dennis Keeley

Chair, Photography and Imaging
Art Center College of Design, Pasadena,
California, United States

www.denniskeeley.com

We need to flatten out this antiquated vertical positioning of teacher over student.

ON TEACHING PHOTOGRAPHY

Here are the two polarities: 1) Teaching students how to be artists is a difficult and complicated undertaking; 2) The real artist almost seems to be born leaning towards art. Somewhere between these two dissonances, we teach photography. I think that the practice of teaching works better when you create an optimum environment for learning. I've told my entering classes for the last nine years that they could finish every assignment, read every book, show up to class on time, and still not learn how to become a photographer. Learning takes a different measure of time, practice, and commitment from each student, but everyone, including teachers, has to be more interested in exploring the questions and the long-term process than in the simple memorization of other people's answers.

> I've told my entering classes for the last nine years that they could finish every assignment, read every book, show up to class on time, and still not learn how to become a photographer.

The whole institution of education must begin to rethink itself. We are teaching in a new time with unprecedented opportunities and even higher expectations. The overwhelming influence of technology has made people imagine a mythical future where no one will actually have to know anything. The reality is that even though I still believe that the most important, most direct, most productive conversations will occur face to face, I also accept that the new context for discourse, investigation, and access is that all information is now readily available on the Internet. Today, students are learning in many more ways and places than in the classroom, but many educators are still passively witnessing and surrendering to education's failure to recognize that new tools and environments are already offering students a valuable connection to knowledge which will inform their future.

ON THE CHALLENGES OF TEACHING PHOTOGRAPHY IN THE TWENTY-FIRST CENTURY

Today, the challenge is to keep pace with what even our less privileged students have access to at home, in their car, even in the school hallways. The snail's pace that education has utilized in the past to implement technological improvements is now undercutting the established sense of security and eroding the confidence that students want to have in their institutions. We have to be much quicker to identify and employ new and effective methods of delivering information. Time really is moving faster and students' enthusiasm about engaging information has to be met with an invitation and competency to explore almost anything. Our challenge as educators is to create a discernable balance between what is traditional and timeless and what might just be a popular trend. We need to be able to challenge all their assumptions about art, culture, history, technology, and knowledge.

Students continue to arrive at education's doorstep from more diverse backgrounds than we ever prepared ourselves for. Language

is only one of the surface obstacles. The necessity for education to engage, reflect, and address diversity is a formidable one. A person who has never been out of Burbank, California shows up with a very different perspective than a student from China—yet both are a contrast to someone who has lived all over the world. The students with less life experience always seem harder to reach. We encourage them to question some of the things they know and to try new approaches, ideas, investigations, and practices. Students who come with more experience already know that they don't know everything and can be a little more open to exploring the complexities of studying art. While we now have more students who are not from the U.S., we still don't have enough international teachers.

Teaching is now in a position of trying to solve some problems that just can't be solved in this upside-down circumstance. In private art and design schools like Art Center, we have some of the most privileged kids I have ever encountered and sometimes I think they are practicing to become better negotiators, rather than students trying to learn how to become artists. With this generation of entitled students, some want to be treated like the customers in a supermarket of education. Last year when I taught in India, I met students who came from much less privileged backgrounds. They seemed to see more clearly that access to education and knowledge was an extraordinary opportunity and that making a commitment to the work assured them a brighter future.

While art students today might want everything qualified for them, teaching students to make art places them in a world built on the photographic exploration of uncertainty, serendipity, irony—and, sometimes, even magic. For example, Atget's[22] mysterious work might seem to be simple, quiet, thoughtful or even too subtle. He seemed to see the poetic interplay of relationships, and in his work in Paris shows us a magical, silent place. You might have to expend a little effort to enjoy or understand his photography. To me, the work authenticates or represents that the quieter moments of life are as critically important as the busy or so-called "photographic" moments. There are more of the less dynamic points of intersection than there are of the so called "iconic" moments, or the heroic, "right place at the right time" decisive moments. Teaching might argue that one would not necessarily be more valuable than another.

ON THE VALUE OF STUDYING PHOTOGRAPHY

I think that the importance of a visual education is more obvious now than ever before. We are in the midst of a visual explosion of images in art, politics, journalism, and advertising. An individual's access to photographic devices has never been more ubiquitous. Deeply and

> Deeply and specifically interrogating all the acts of looking, seeing, observing, producing, and publishing images and attempting to resolve the visual questions will be an increasingly critical skill for informed citizens.

specifically interrogating all the acts of looking, seeing, observing, producing, and publishing images and attempting to resolve the visual questions will be an increasingly critical skill for informed citizens. There is never a downside to learning because the engagement and questioning that takes place in the classroom is really one of the most important pieces in trying to solve the human puzzle. We make it so complex for teachers these days. It's a wonder that anybody still wants to teach. The current public education system is simply broken and we need to fix it. TED prize-winner Jamie Oliver said that kids should graduate from school knowing how to make ten healthy recipes. I would say that kids should graduate with ten good ideas about how the world works. If we could do that we could begin to change the world.

ON A TEACHING PHILOSOPHY

My role as chair is simply to build the optimum environment for teaching and learning. I want everyone to share in that process and to benefit from the result. I believe that the most important role that teachers play is in the strategic facilitation of student learning rather than the dispensing of facts or even the expertise in sharing their own knowledge. We need to flatten out this antiquated vertical positioning of teacher over student. I learned a great deal about teaching from Alison Knowles, an instructor I had in college. She taught each person,

not the material or the "students." She didn't just teach the head and address what she thought I should be. She encouraged me to take the time I needed and consider what I could be.

I love teaching photography. Even with all the theory, it is still about an individual considering all the implications of making something. Some center their knowledge and practice in the academic, while others approach image making from a more intuitive or experiential approach. Image making is different from a number of the other arts because with photography, the process can always be connected to moment or a process that intersects with the immediate. I think that immediacy is potentially one of its most beautiful and poetic qualities. In the arts you always have a process of refinement or process, but with photography, you also always have that one moment when gesture, intuition, decision, and capture intersect. It exists in the critical point between you, subject, humanity, chaos, and an order between what is and what one sees. With technology today, it's easy to make a lot of pictures, so one of the most important new concerns becomes selection and a lot of what I try to share with students is about that. I task students to look closely at their photographs and try to uncover what they notice first. Which way are they leaning? I challenge students to consider what they might learn about their own character by looking at their own and other's photographs.

In the past, I taught classes with author Norman Klein. Our first assignment was to make one hundred pictures. Considering how our students had learned to respond to assignments, we were not surprised by their need to know and the question, "Of what?" We replied that we didn't know. We told them that the learning experience is sometimes about decision, informed investigation, a journey, or sometimes it is just quantity. "You say you're a going to be a photographer,

I also try to mix it up. I give long-term assignments and exercises that act almost as fast-paced quizzes: "Make a picture this afternoon and email it to me by midnight tonight." I want them to become familiar with disruption, uncertainty, and decision for the different environments that they will face in the future. I hope to teach a class incorporating an interesting assignment that another instructor shared with me. They are given one sheet of 4 x 5 film and in twenty-four hours they have to return with an arrestingly original printed image.

ON A TEACHING TECHNIQUE

I don't want my students to feel any separation between technology, technique, and content. I want them to explore that whirlpool of choice and balance in their own decisions about the process of making often and regularly. This is what separates us from the fine art and design departments at Art Center in a very clear way. We try to teach things together: technology, technique, composition, and conceptual image making. Even business, presentation, research, and history is integrated in some way in each course. We mix the work and approaches from commercial photography with the abstraction and concepts from fine art. I don't think we've ever seen a successful artist who doesn't have some business skills. The idea of a successful commercial artist who is unfamiliar or uncomfortable with the development of a concept is almost unheard of.

ON CRITIQUES

I don't even try to critique everything in a class. I spend more time in a critique discussing what might be the very good work and addressing the trials of the very bad work because I think that provides the most benefit to the majority of students. Identifying some of the obvious traps that lead to failure is an important lesson for an artist who wants to build towards a career. "Okay, this work is a less effective response than

> I want them to become familiar with disruption, uncertainty, and decision for the different environments that they will face in the future.

so go make one hundred pictures." One student made one hundred pictures and assembled them all to make one. It was a remarkably beautiful solution. She figured out how to take our simple assignment and transform it into something she actually wanted to make.

what everybody else did. How do we think this works and what decisions went into making this look this way?" Sometimes we learn more from that work because art is about approaches, trials, and failure. The life of an artist is about making things that don't work, even with all the

prompts and theories that they know. The people who are exploring territories that are less valued, more treacherous, and messy are often your new geniuses. It's also true that some people really are stupid at times, and yes: there *are* even stupid questions.

I vary my approaches to critique methods because I never want students to think that there is one best way to evaluate work. I try not to have two critiques in a row that are the same. There is one thing I tend to do more often than anything else. I bring someone students don't know to sit in on the crits, because I don't want to become the sole consistent and judging voice in the negotiation of their assignments. Over time students begin to know what I like, what I'm interested in, and what questions I'm likely to ask. I often question a work's motivations; its visual tensions, weight, and balance. I like the conversations that interrogate the way a student intends a piece to function. I want students to learn how to articulate their intentions. The one thing I never permit in a crit is a student to base the worthiness of their work solely on their personal preferences for the piece. I assume that they like the work they made, and if they don't, then that's something I *really* want to talk about.

> The one thing I never permit in a crit is a student to base the worthiness of their work solely on their personal preferences for the piece. I assume that they like the work they made, and if they don't, then that's something I *really* want to talk about.

DENNIS KEELEY is an award-winning photographer who has integrated the career of artist, photographer, teacher, and writer for more than twenty-five years. His images grace hundreds of album and CD covers and his client list includes Sony Music, Atlantic Records, *The New York Times*, and *ID* magazine. His photographs in the 1992 book *Looking for a City in America: Down These Mean Streets a Man Must Go* (Getty Publications) won numerous awards, and in 1998 he was engaged to document the creation of the J. Paul Getty's Central Garden by Robert Irwin. As Chair of the Photography and Imaging Program at Art Center College of Design, Keeley has become one of the most well-known educators in the U.S. This year, he was a recipient of a research grant from the Annenberg Foundation. He is a frequent speaker on photography and education and is currently on the board of the Angel's Gate Cultural Center in San Pedro, California. He holds a BFA from the California Institute of the Arts.

John Kippin

Professor in Photography
University of Sunderland, United Kingdom

www.johnkippin.com

We are looking for people to use the medium to say something about themselves, culture, or society that is meaningful and contributes to knowledge.

ON TEACHING PHOTOGRAPHY

We teach photography through an appreciation and interrogation of pictures. We consider images as fine art or contextualized through fine art. We are looking for people to use the medium to say something about themselves, culture, or society that is meaningful and contributes to knowledge. Therefore, our focus is on supporting critical individual practice. I don't insist on a particular style or way of doing things. Typically I suppose I use what one would call a fine art methodology, but in our program we're also very well aware of the commercial potential of photography and its position in helping people find careers. I want my students to take control of the photographic process so they will feel confident in practicing photography and understand the reasons why they are making images. But I always stress an understanding of how photography and images form our ideas of the world. I emphasize thinking like a photographer, which involves understanding the ideological construction of things, how representation works, how

> It is important also to focus on the actuality of the photograph, its physical presence and qualities, particularly when viewed in the digital ecology that we exist within.

images will be applied and are applied through new media, how they're communicated and understood within the culture of the image, and how images define so many aspects of our lives and our history in the information culture that we have today.

We do teach a range of key technical skills in the first year, but our program is distinguished by the significant history and theory component, so our program provides a liberal education in a sense, but one that deals with pictures, photography, or arguably the language of images, as a way to have a more general education experience. It is important also to focus on the actuality of the photograph, its physical presence and qualities, particularly when viewed in the digital ecology that we exist within.

ON CHANGES IN PHOTO EDUCATION

In the U.K., in the past twenty years, we've moved from a handful of photography courses, some of which were perhaps located within fine art courses as discrete strands, into numerous undergraduate and postgraduate programs. Studying photography is very popular now because I think that it's seen as an alternative to fine art and students think they might get a job with a photography degree. I think that's a logical fallacy because we couldn't possibly support the number of photographers we produce so I think it's important that our students understand that we're interested in the practice of photography and what it means to be a photographer, rather than training them to necessarily practice as a photographer.

These alternative-process images were produced in a module that aims to explore and expand the students' technical, aesthetic, and creative skills and encourage an experimental and innovative approach to image production.

(top left) Image courtesy of Tori Best
(top right) Image courtesy of Steffi Kanneier
(left) Image courtesy of Elena Teleaga

ON THE VALUE OF STUDYING PHOTOGRAPHY

Even though governments would love everybody to study math and sciences there are a whole range of people for which that is just not appropriate. I think of photography as being like teaching philosophy or history, but with the additional elements of understanding the construction of pictures and thinking about visual images. We produce quite critical students who are confident because they're capable of producing images, but who are also flexible thinkers. Those skills are transferable. Often, though, at first, students are interested in studying photography because it is exciting and perceived as something that they can easily get the hang of, but it's only as they move through the program that they realize what a difficult subject photography really is.

ON THE CHALLENGES OF TEACHING

I think it becomes more difficult every year, quite frankly. We don't have a fluid culture anymore where there are lots of galleries showing work, and that discourse is so essential to teaching photography. So it's a challenge for faculty to find new ideas or new ways of thinking about what photography might be, or the way that individuals might develop practices that are relevant to them. We have to work against the fact that so much image making today is quite derivative. What's also happened in this country is that art education has been privatized by the current government and it's not as subsidized as other disciplines. We've imposed fees of 9,000 GBP,[23] so we risk changing who can afford to study photography. I fear that eventually only the most privileged students will be able to study and that harkens back to the Victorian age.

ON COMPUTATIONAL PHOTOGRAPHY AND THE IMPORTANCE OF TECHNOLOGY

There are factions, I have to say, in this business who talk about the photographic industry as though they were shipbuilders or something on that scale. They're most interested in technology. I don't think we would want to go that way. I think there's something to be said for Flusser's idea that every photograph that has or ever could be taken is embodied within the design of the technology that produces it. The new interest in computational photography is just an extension of that. And while I think there's some truth to that, it's also too easy to be fooled into thinking that it's a solution or truth for photography education; but like everything, it's only partially true. Photography has always been influenced by technology and this is no different, no more earthshaking. It's like the invention of oil paint or canvas. Every human activity is conditioned by the things we invent or discover.

JOHN KIPPIN is an artist and photographer who lives and works in the northeast of United Kingdom, largely within the broad context of landscape. Many of his works integrate texts and images in ways that challenge the realist paradigm that traditionally underpins a range of documentary and realist practices. Kippin's work pays allegiance to the conventions and traditions of pictorial landscape while foregrounding issues within contemporary culture and politics. In addition to works made for the gallery, he has produced a number of public artworks and publications. His work has been widely exhibited both in the U.K. and overseas and is in many collections. He has contributed to numerous conferences and symposia and is currently Professor in Photography at the University of Sunderland. He holds an MA and a PhD.

Mark Klett

Regents Professor
Herberger Institute for Design and the Arts at
Arizona State University, Tempe, Arizona, United States

www.klettandwolfe.com

The idea of even trying to figure out what a good picture is and how images interact has to be rethought.

ON TEACHING PHOTOGRAPHY

First, photography is not a universal field. We teach it based on who we are and what we were taught to be. At Arizona State we certainly teach fundamentals, and the how-to-do-it part, but we also teach working process, maybe more so than at other schools. For me, that focuses on the relationship between conceptual and intuitive processes.

I think the biggest change in teaching today is dealing with the new digital realities because it presents both challenges and opportunities. One of my former students, and now my colleague, Byron Wolfe,[24] who works on some of the projects we do with Rephotography,[25] started a project in the early 2000s, photographing every day with a digital camera, eventually publishing a book called *Everyday*.[26] I thought that was inspirational and I've taken a digital photograph every day now for eleven years. I also started this class that was initially called Every Day with a Digital Camera, but later we changed it to Digital Camera Photo Editing. What interested me was how having a digital camera available at all times actually changes how students think about photography. When they used a film camera what usually happened was that they would go out with the mindset to purposefully make a picture. When they have a digital camera on them at all times even the most inconsequential thing can be a subject of a picture. So, that was the idea behind the whole class: that you have a camera on you at all times, so you can photograph in a very intuitive way. That liberates students in terms of thinking about what constitutes proper subject matter. But the downside is that they end up with hundreds of pictures a day and they don't know what to do with so many photographs, so the meat of the class becomes about editing. There's that old Ansel Adams quote: "Twelve significant photographs in any one year is a good crop."[27] That doesn't fit with this new technology. The idea of even trying to figure out what a good picture is and how images interact has to be rethought. Students who are used to shooting digitally don't value each image in the same way we valued the individual image when we shot film. If I look through a year's worth of digital images, I can see patterns and recurring themes that have metaphorical meaning. This becomes a very intuitive way of shooting. That's very different than a conceptual film-based model where you devise a methodology and a project and then you produce it.

ON WHY STUDENTS SHOULD STUDY PHOTOGRAPHY

That's an interesting question, particularly here at Arizona State. Since we're an art program, we're upfront in saying that we're not training people to go into an industry. The skills that people learn might be useful in the industry, but we're not teaching them to be commercial photographers. We're trying to teach them to develop a strong vision, a photographic voice. I think that's what they're going to need if they do want to go out into the world and make their way because a strong vision is so much more useful and much more important than just learning technique. If you're trained as an engineer, that's all you know how to do and if there're no jobs for engineers, you're in trouble because that's all you know. I feel like our students know how to adapt and they know how to make things work. When they graduate, they can take their understanding of visual language and roll with it at little bit. Even if they end up going into some other field they would still have some appreciation for photography and art. Actually, the job prospects for creative people are pretty high, especially for photographers. It's not

the same kind of photography that people have done in the past, but there is a need for image makers and people who understand design and web-based work.

ON A CRITIQUE METHODOLOGY

I listen very carefully so I can understand what motivates the student, what influences them, what is being said, but also what's not being said, what excites them, and what doesn't excite them. I listen and I look at their body language: are they open or are they closed off? I take a different approach to every student, and I am very conscious of the group dynamic. If I think that they're not working, then I push them. If I think that they're making the same picture over and over again, and I think there's a block there then I want to know what their fear is. I try to get them to move beyond where they are, but I want them to determine the direction. I'm trying to get a sense of the difference between what they're saying and what they're doing. A lot of times what they're saying is one thing, and what they're doing is completely different, and I'll point that out.

Sometimes if you dig down a little deeper, you'll get something that's pretty hidden and it can be dangerous. But, I've been doing this a long time so I'm sensitive to that. If I think I'm getting close to something, I may pull it back and meet that person individually when there aren't a lot of people in the room and try to explore the issues.

One of the things that I try to do is create a level of trust in the classroom. I'm also trying to create a level of professionalism because I want them to understand that what they're entering into is a profession. I expect professional attitudes. So, I don't allow anybody to get snippy or to get personal. I'm the moderator: I do a pretty good job of making sure that things run properly, and if things go too far in one direction, I'll pull it back. If I see things getting out of hand, I'll stop it. On the other hand, if there's criticism and they need that, and it's appropriate criticism for the work, I'll let it go. I'm going to watch that very carefully, but it's just been years of experiences of seeing it happen.

My first experience with a critique was kind of funny. I was a graduate student at the Visual Studies Workshop, and I was teaching my first class to members of the community. It was a small class but I remember three students in particular. One guy was deaf, and he wore two hearing aids. He could hardly hear anything, and he just seemed kind of angry all the time. Then I had this housewife, and she just wanted to make better pictures of her kids and she loved to photograph flowers. And then there was this one guy, who was really intimidating for me because he was this professional color printer in town, who had come out of New York; he just wanted someone to look at his pictures, but he knew way more than I did. I remember one of our first critiques: the housewife brings in pictures of flowers and stuff and then the professional printer brings in these photographs, and they're just these big, gorgeous color prints of these kinky things he's doing with his girlfriend. The housewife looked at it and was like, "Whoa, oh my god!" And the deaf guy was just like, "What?! What are you saying?!" And I was just thinking, "What am I going to do or say? I have no clue, nobody has taught me how to do this." So I just had to work it out. I think the community classes were the hardest classes I ever taught. I learned a lot about how to get different people with different perspectives to work with each other, how to respond, how to structure a conversation around the work. It was trial by fire and that has helped me all these years.

MARK KLETT, who has been teaching at Arizona State for more than thirty-one years, is an award-winning photographer who studies the intersections of culture, landscape, and time, using the photographic technique of rephotography, which refers to the act of making a new photograph on the same spot where an earlier photograph was made. His interest in the land stems from his earlier education as a geologist. Klett has received fellowships from the Guggenheim Foundation, the National Endowment for the Arts, the Buhl Foundation, and the Japan/US Friendship Commission. His work has been nationally and internationally exhibited and published and it is featured in more than eighty museum collections worldwide, including the Art Institute of Chicago, the Whitney Museum of Art in New York City, and the Tokyo Metropolitan Museum of Photography in Tokyo, Japan. He is also the author of fifteen books. He holds a BS in Geology from St. Lawrence University and an MFA from the Visual Studies Workshop in Rochester, NY.

Bao Kun

Guest Professor, Photography
Tianjin Academy of Fine Arts, Tianjin, China
Part-time Professor, Photography Department
Zhejian A and F University, China

baokun.blshe.com/blog.php

My philosophy on photographic education is that I use photography as a starting point, and train students to become elites in the understanding of history and reality.

ON THE VALUE OF STUDYING PHOTOGRAPHY

Because of the ubiquity of digital technologies and the many photographs made today, the value of a photographic education on an undergraduate level is to teach students to express themselves and create a relationship with society. Photographic education on a graduate level should focus on the cultural research of photography and media, such as photography history, visual culture, and art history; this is to increase the student's ability to analyze photographic work.

A photo education informs students that our society today is in a visual era and we communicate with a visual vocabulary. Imagery directly impacts the society more so than ever and our understanding of our surroundings and culture largely comes from visual imagery. The making, spreading, and reading of the visual language are important areas of study, so we need photographic education to continue advancing the world of photography. The photography profession was developed at a time when photography was not so ubiquitous, which formed a power structure among photographers. Having more photography graduates will allow this relationship to maintain its balance. If there are no more photography graduates, this power structure will collapse, and so will the photo industry.

ON TEACHING PHOTOGRAPHY IN THE TWENTY-FIRST CENTURY

The main goal of an educator is to teach the students how to think independently. A photograph today includes thousands of different messages: historical, political, economical, and cultural. Therefore, photographic education should focus on the studies of humanities, and the analytical aspect of photography. The students should use photography as a medium to confront this complex world from different angles.

Even though technique is important to a photographic education, in this digital age the importance of *teaching* technique is decreasing. The teacher only needs to teach the basic direction and reasoning of the

> Therefore, photographic education should focus on the studies of humanities, and the analytical aspect of photography.

techniques. It is the student's responsibility to further explore the different software and editing programs—and because students today come from a computer generation, they can learn these things themselves. The teacher should focus more on the philosophical language behind art and photography. In other words, what the media industry really wants today is an intellectual conversation. When it comes to education, the educator should lead the students to think outside of classical and modern art history, and find their ability to communicate with the reality today. Of course art history is important, but the educator should teach the students to understand why the images were successful,

and not just expect the students to blindly worship the past. Traditional photography has a stronger artistic influence. This means that the photographer had a much more complex and long-term relationship with his medium, and this experience is very important to the creative mind and the communication to the world. This needs to be maintained and passed on in photographic education today.

ON THE PHILOSOPHY OF TEACHING PHOTOGRAPHY

Photography is very different from traditional fine arts. The beauty of photography is its unlimited exploration of imagery, which closely involves our everyday lives. My philosophy on photographic education is that I use photography as a starting point, and train students to become elites in the understanding of history and reality. This kind of training will make students confident, independent, and driven.

ON CHANGES IN PHOTOGRAPHIC EDUCATION

The biggest change is the democratizing of photography that has occurred because of digital technology being so available. The ethics of digital media are something that photo education must adjust to. What worries me is that on a social level, journalistic photography has completely collapsed. This has made it difficult for photography graduates to find jobs. A lot of schools focus too much on teaching digital technology. To me that lacks philosophical meaning. Digital technology can take care of almost all stages of photographic production, but it seems irrelevant to the meaning behind a photographer "taking" a picture. The students who come out of these programs become technicians, not photographers. In China, we describe this phenomenon as universities becoming "vocational high schools."

These images are part of a series produced as a thesis project under the guidance of faculty Bao Kun.

Images courtesy of Xiang Yu Zhou

These images are part of a reportage series on aging in China produced
as a thesis project under the guidance of faculty Bao Kun.
Images courtesy of Lan Mei

Digital technology does provide us with a different dynamic of the medium, but the fundamental meaning of "photography" doesn't change. A lot of the digital postproduction software has similarities to traditional painting mediums, and this allows a new way to structure photographic-based art, but this is no longer photography, rather an art form that uses photography as an element. Ultimately, maybe we need to explore the possibility of using digital techniques to create new philosophical thinking and theories.

ON CONTEMPORARY ATTITUDES TOWARDS AUTHORSHIP

This idea has two dynamics. First of all, authorship is traditionally defined by the relationship between the creator and the work, such as the personal experience and philosophy of the creator embedded in the work. This is further defined by the structure of the artistic world and the publication world. These structures have collapsed in the digital age. The Internet allows a kind of freedom for creation, and a huge quantity of work can now be published online. The second aspect of authorship is the need for power and control provided by copyright, intellectual property, or even privacy. Under these circumstances, the author's "ownership" not only doesn't change, it is sometimes enhanced. Photographic education should focus more on the second aspect.

Digital technology does provide us with a different dynamic of the medium, but the fundamental meaning of "photography" doesn't change.

BAO KUN is a renowned Chinese photographer, art critic, curator, educator, and award-winning author based in Beijing. Active in Chinese photography, he joined the Chinese Photography Association in 1983 where he continues as the Deputy Director of Theory and Criticism Committee. He was voted the most influential person in Chinese photography in 2009 by *Pixel* magazine (UK). He is a frequent judge at major photography events and festivals. His work has been widely exhibited in China and he writes an active photography blog, baokun.blshe.com/blog.php. He holds a BA from the Beijing Capital University of Economics and Business.

Heike Löwenstein

Course Leader for BA (Hons) Photography
(Contemporary Practice) and MA Photography
University for the Creative Arts, Rochester, Kent,
United Kingdom

www.heikelowenstein.com

People say designers solve problems and artists ask questions, and I think there's a place for educating photographers as designers who solve problems but in the way they do that, ask questions.

ON PHOTOGRAPHY

For me photography has always been more about the process than the image. I can't ignore the significance of the image itself on all sorts of levels, but the function photography has for me has been what it has enabled me to do: a way to engage with the world and feel alive; it requires me to be alert and in the moment in order to notice and see. When I was nineteen it also gave me a reason to escape the narrow world that I felt my family inhabited. Photography has given me a license to do things that otherwise may have been more awkward or impossible. Over the last ten to fifteen years my connection with photography has slowly but steadily shifted. Teaching photography has been part of this process, as I think and talk more about images now than make them—for good or for worse, I couldn't say. My relationship to photography has become more complex, and the deeper I go the more questions arise. Generally the two most beautiful things about photography are that nobody owns it and that it can mean very different things to different people.

culture and a photography education provides a supportive, collective, and collaborative framework to do that. Photography programs also educate students so they're able to differentiate their images from the millions of images that are taken by just anybody. Knowing how to use technology appropriately and knowing the craft of photography is one aspect that separates professionals from amateurs. Beyond craft skills a photography education teaches students conceptual skills, and the culture and context of how photographs function today, in the past, and possibly in the future. Finally, and maybe most important, is that studying photography teaches students how to develop ideas. People say designers solve problems and artists ask questions, and I think there's a place for educating photographers as designers who solve problems but in the way they do that, ask questions. If we stopped educating photography students we would lose the skill, experience, knowledge, and history of photography as a means to explore life, culture, history, and politics. Photography education impacts society in a way because all of the photo graduates who may chose to, or have to, go into other types of jobs bring an education in visual literacy into those environments. Being a visually literate person is of value in today's society that is more and more visually

Generally the two most beautiful things about photography are that nobody owns it and that it can mean very different things to different people.

ON WHY STUDY PHOTOGRAPHY

The question is why study photography when everybody is a photographer these days, and even on a professional level anyone can claim to be one. Photography is a very relevant tool to investigate life and

dominated. Finally a photography education teaches a sort of discipline and persistence, if taken seriously by the student. Photographers normally don't take no for an answer because to get or make an image, you have to work to get through the no and turn it into a yes somehow.

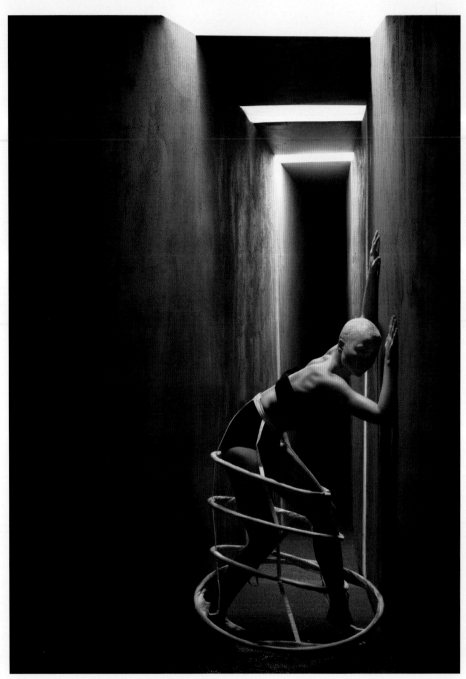

Image courtesy of: Jareth
Fletcher-Miller, Jade Perry,
Annie-Rose Peddie, and Hazel
Thompson

That skill is very useful anywhere, though I feel it may also be what makes photography educators seemingly more difficult faculty than those from other disciplines in the university environment, at times when the institution demands compliance.

ON TEACHING PHOTOGRAPHY

Nurturing creativity has become one of my things, because although some people think that creativity can't be taught, there's a lot of research that contradicts that notion and suggests that creativity is a method. The more you produce, for example, the better the outcome will be. That's most true in education. Our students in the middle who have potential don't produce enough, and their level could be raised significantly if they increased their volume of production. The research on creativity also suggests that it's important to be open to unexpected things and that ability can be enhanced consciously if you employ methods like "beach combing"—wandering on a beach not looking for anything in particular. You approach the world with an empty and open mind so you can be receptive to the unexpected. If you are creative then you look at culture, context—everything that's around you. I have been surprised to find students can be quite resistant to this idea. Recently I asked my students to write up all of the photographic ideas they had for the unit we were embarking on. I encouraged exploring all of their ideas for the first half of the period. It appears that there is a human tendency to work on one idea early on and just work on that, which most of the time is an idea one had already successfully worked on before, thus going back to what we know. That is why it is so important to be open to all influences around us. If one explores multiple ideas alongside each other initially and focuses in on fewer and eventually one, aspects of the other ideas will enrich the one final idea; and there is also something to fall back on if one project isn't working out.

ON CHANGES THAT IMPACT PHOTOGRAPHIC EDUCATION

Certainly digital technology has impacted photo education as much as it has impacted society at large because all of the advances in technology can be reflected in a photo curriculum. I tend to include more complicated technologies such as CGI[28] and 3D that have seemingly little to do with photography when coming from a fine art perspective.

I think I am a bit more open to these ideas and possibilities than other colleagues because I have a background in media and publishing as well as photography. I think it is important to introduce students to the possibilities of making images without a camera and the technologies as well as concepts to merge the real with the virtual in their images. This represents a massive change in how images are made, read, and used. The shift that has taken place over the last five to ten years is as fundamental I think as the development from painting to photography had been. All methods in photography should be explored, not least to explore the history of photography in practice, but also for those who feel or discover that the tactile, analog way of developing work is instrumental to their photographic work.

The commercialization of arts education in the UK may lead to barriers to studying photography in the future. I hope that will be mitigated by the new thinking about open learning platforms and the potential to change the nature of photo education in terms of how it will be delivered. I am not necessarily talking about MOOCs here, rather variations of open classroom models and platforms that I am curious to explore further in networks with colleagues from Coventry University, the States, and further afield.

HEIKE LÖWENSTEIN has been a photographer for more than twenty years. Her current research employs panoramic photography to explore the meaning of place and representation of identity. Her work has been represented in books and featured in solo and group shows in Europe, the U.S., and China. Before becoming a photo educator and artist, Löwenstein worked as a commercial photographer with a client roster that included *Stern,* Otis, Dorling Kindersley, and BMW. She earned an MA in Hypermedia Studies with merit from the University of Westminster in 1996.

Niko Luoma

Visiting Professor
Aalto University School of the Arts, Design,
and Architecture, Helsinki, Finland

nikoluoma.net

In my own view the most interesting photos are not taken, but made.

ON TEACHING PHOTOGRAPHY

As teachers we should be the source of inspiration and curiosity so I believe that active working artists are the best and most innovative teachers. I studied at the Museum School in Boston in the 1990s. We didn't pick any major or minor field of study and all the disciplines were together. Watching how a sculptor, who usually thinks and works in 3D, put ideas together into a 2D piece was so innovative and when I, a photographer, did my first bronze cast, realizing volume for the first time, that was inspiring. I think that this kind of cross-discipline thinking is very innovative, particularly now, and this is something I am personally trying to include in all of my courses.

ON WHY STUDENTS SHOULD STUDY PHOTOGRAPHY

The idea that everybody today is a photographer because of digital technology is true and in a way the distance between amateur and professional has blurred, but that's why education is important. I think that the most important thing that the students should get from the university is to learn how to edit, how to be critical, how to rationalize their selection, and how to give and receive feedback. It is the best place to learn about the meaning and context of images, how context determines why some images work better than others.

ON THE VALUE OF TEACHING ANALOG PHOTOGRAPHY IN A DIGITAL WORLD

Digital and analog are two different processes with different materials and different results. I think it is a shame that many universities are rushing to get rid of the analog processes. It is one process among the others and should be available at least in smaller scale. Films and photographic papers, apertures and shutter speeds, cyan, magenta, and yellow dials will always remain. Even though the end result can be very similar in analog and digital processes, the process itself is different so if you think about "entering" into these two processes to break them into the parts and manipulate them, you will see how marvelously different these processes are and how they are definitely not exclusionary! Think about for example Alvin Lucier's[29] sound piece "I am sitting in a room" for voice and electromagnetic tape (1969). You could achieve the similar result both in analog and digital but if the interest is in the process itself, as it is in Lucier's case, it is a whole different conversation.

> As teachers we should be the source of inspiration and curiosity so I believe that active working artists are the best and most innovative teachers.

ON A PHILOSOPHY OF TEACHING PHOTOGRAPHY

For me it is three main things: content, content, content. Then experimentation, focus on process, always questioning. I like Sol Lewitt's sentence number 32 from his *Sentences on Conceptual Art*: "Banal ideas cannot be rescued by beautiful execution," but also the words of John Cage: "Do not try to create and analyze at the same time. They are different processes." I teach photography as both a discipline, since it has its own way of thinking, but also as a medium since it has its own specific materials. I always try to remember what I learned from my first photo professor David Akiba because he taught me to see and read between the lines and from my last professor Timothy Persons who taught me how use what I saw and read.

ON THE IMPORTANCE OF TEACHING TECHNIQUE

In my own view the most interesting photos are not taken, but made. So even though a photograph is all about content in the end, it is essential to follow the latest developments in techniques so students know all the possibilities. And even though my own work is completely analog, I think that since photography is an amazing combination of math and physics, the "technical" is the content sometimes. The camera as apparatus can be a tool and the subject matter at the same time. The questions of "film" as material and exposure as content will become more of its own branch of photography.

For me it is three main things: content, content, content.

NIKO LUOMA is an internationally exhibited photographer. Using studio-based analog photography and influenced by mathematics and geometry, Luoma works only with light and light-sensitive materials to create abstract images that appear to have no direct reference to the surrounding visible world. He is as interested in the process as he is in the finished image. He holds an MFA from the University of Art and Design, Helsinki, Finland.

Michael Marshall

Associate Professor and Area Chair, Photography
University of Georgia, Athens, Georgia, United States

mmars.myweb.uga.edu

All the technical information is out there. They just have to know how to find it. For example, I always remind my students that there is a page two to a Google search.

ON THE VALUE OF STUDYING PHOTOGRAPHY

As a culture, we are communicating more with photography than with writing today. Students who study photography acquire the ability to understand visual communication, so that is a direct benefit. They also acquire the skills of creative thinking, problem solving, and abstract thought. Studying photography also teaches key skills about creating relationships and how to look at a broader world rather than a narrower one as we tend to see in the sciences. These ancillary skills will be increasingly valuable in the twenty-first century.

ON CHANGES IN PHOTOGRAPHIC EDUCATION

Students are still trying to figure out who they are and what they're passionate about, but how they go about that has changed and this impacts education. Students today are very used to looking through a digital viewfinder or a screen and most have no film experience. Conceptually I think they are different too because the way they engage the world is different: their social interactions and communication are digital. They're certainly more adept at media, but the downside is that although on the surface they may be more used to seeing photographs, I'm not sure they're more adept at understanding how images function and how to make them most effectively.

One other area that impacts photo education is all the technical information available online. In our program, we are integrating self-guided learning rather then spending so much class time teaching technical information. We are teaching students how to teach themselves because that will be a critical skill for the world they are entering. All the technical information is out there. They just have to know how to find it. For example, I always remind my students that there is a page two to a Google search.

ON ANALOG PROCESSES

We still teach film because we are interested in exploring the range of image-making. The film and darkroom experience gives students a different understanding of the physical process of making an image. It slows them down. I see a deliberateness in how students make images after they have worked with film and that improves their digital work, too.

ON TEACHING VIDEO

Video should be a part of a photography curriculum because the moving image is increasingly part of our visual communication. In our program, we give students the flexibility to go in the direction they choose. If I were offering a special topics class in landscape, for example, I would be totally fine if one student shot with a view camera and another with a video camera because that's just part of photographic language.

There is so much interesting mixed-media work being created today. I would love to see photography not as a separate program. The

> We are teaching students how to teach themselves because that will be a critical skill for the world they are entering.

resistance to integrating photography and video or media is traditional: older faculty don't want to make changes and younger faculty are interested in cross-media work. We are trying to break down these barriers by creating classes that are concept-based, not media-specific.

ON ONLINE LEARNING

We aren't doing much here about online learning except talking about it. We know it's coming, but we have all been very hesitant. The source of my hesitancy is that so much of what I love about teaching is connecting one-on-one with students and I'm so used to experiencing that in the classroom. I'm trying to be open to the idea that there are ways of using social media now that will facilitate that same kind of connection in an online teaching structure rather than a physical classroom structure.

to community activists working on issues of food and food insecurity who all said that communicating their message was hard for them. Well, that's what photographers do well, so I divided the students into groups and they worked with the non-profit groups.

> Video should be a part of a photography curriculum because the moving image is increasingly part of our visual communication.

ON A PHILOSOPHY OF TEACHING PHOTOGRAPHY

I am giving students a language, and a set of skills to use that language to engage their ideas. That means I have to know what their interests are so I have all my students fill out a questionnaire. I ask them questions about what they like to do. What did they like to do when they were a kid? What do they do with their free time now? What books do they read? What section of the newspaper would they read first? They fill this out in class.

I also think it is important for them to connect to the local community, because I think that digital technology actually makes students more insular. The live in this little technological bubble and they have no concept of what's around them in terms of the community and the places they live in. I've started to integrate community-based assignments to give them the skills and confidence to go out in the community and make connections, make work about the community, or even use photography as community service or to help others. For example, I taught a class called Community Engagement where I picked community food issues as the topic and connected my students

MICHAEL MARSHALL is an artist from Athens, Georgia. His recent projects have spanned from explorations of the spiritual landscape to natural history museums. He is currently chair of the Photography Department at the University of Georgia, and chair of the Executive Committee for the Society of Photographic Education. His work has been widely exhibited in solo and group shows. He holds a MFA from Arizona State University where he worked with Mark Klett on the Third View Project.[30]

Arno Rafael Minkkinen

Nancy Donahue Endowed Professor of the Arts
University of Massachusetts, Lowell,
Massachusetts, United States

www.arno-rafael-minkkinen.com

I tell my students that art is risk made visible.

ON WHY STUDY PHOTOGRAPHY TODAY

Students should study photography for the same reason they would study literature and poetry, or listen to music: to think about the lives of other people and to appreciate their stories, their wonderments, achievements and heartaches, the way their minds work—in short, to become less self-centered you could say. To learn how to see means seeing the world others also see, find beautiful, strange, or fearsome. Photography is about everything. To study photography means being open to the whole visual world in which we live. It means developing the thinking capacities of our minds and the feeling capacities of our hearts. Just as there will be a need for writers, musicians, and philosophers, there will be a need for people who understand photographs, who can analyze, interpret, and evaluate lens-based imagery. Surely there will be important roles in society for people with such capacities.

ON THE CHALLENGES FOR PHOTOGRAPHIC EDUCATION

The challenge we face as teachers is to provide concrete learning experiences so that students can pack along such examples to use throughout their careers. This means instilling a respect and thirst for experimentation and the accompanying risk it takes so they can remain teachable throughout their lives.

If we can convince our students that they have unique contributions to make as visual artists, they can be inspired to expand the medium. With fearless experimentation and tireless energy, they can join the continuum of contributors whose names never stop being added to the list of photographers we already know. Just think of someone whose work was not known five years ago and is suddenly a reference point in critical discourse. It happens. And it can happen for our students too.

ON TEACHING PHOTOGRAPHY

Imagine Jacques-Henri Lartigue in Photo I, before he became a photographer. He shows the teacher a photograph he took with a camera that had a vertical rising focal plane shutter. He was panning a Grand Prix race car when he suddenly realized he would miss getting the bystanders to keep up with the car. So he slows down the pan not realizing that the simultaneous action of the rising shutter curtain would play havoc but create magic in the image. In the print, the wheels of the car are elongated like a 1950s cartoon while the bystanders are hilariously holding on for dear life, as if blown backwards in a wind tunnel created by the speeding car.[31]

The teacher is impressed. Visibly proud of himself, little Lartigue asks if this makes him a great photographer. "I'm afraid not," the teacher replies. "It's a great image but you're not a great photographer." Lartigue snorts, as the teacher looks him in the eye: "Listen Jacques, make me another and you'll one day be Lartigue."

> Just as there will be a need for writers, musicians, and philosophers, there will be a need for people who understand photographs, who can analyze, interpret, and evaluate lens-based imagery.

Zooming out the door with his camera in tow, the teacher shouts after him. "Remember the trick: keep it the same, but make it different!"

Day two, Aunt Bichonnade is flying down the staircase, caught in mid air, as if she is falling.[32] "Terrific! You did it!" his teacher exclaims. "It's the same picture you made yesterday—just as funny, about science, gravity, and speed—but it's entirely different!" Lartigue is ready to high-five the teacher. "Not so fast." The teacher yanks back her hand. "Do it again."

Day three, Anna La Pradvina is strolling down the Avenue du Bois de Boulogne. All wrapped in furs, she is dressed to kill, a beautiful oval hat, and a couple of dogs with really skinny legs to add to the glamour. A car comes into the frame from the left and a horse-and-buggy carriage exits the frame on the right.[33] "Congratulations, Jacques Henri Lartigue," the teacher exclaims. "Now you're a photographer—and one day will be a great one—because you produced three totally different photographs that are all the same. We have the idea of speed, gravity, horses giving way to horsepower, glamour out of step with the march of time, and astonishingly, all with great humanity and humor."

I call the assignment The Power of Three. Anyone can make one good picture. With two you are always comparing them for which is better. It's only when you get that third image that a pathway becomes visible. Now you can see thirty images, three years ahead, maybe a lifetime.

The limitations and opportunities are suddenly apparent in the skeletal matrix of the concept. I customize the assignment based on what the students show me. The subject can be anything: portraiture, landscape, fashion, autobiography, it doesn't matter. As the Lartigue example demonstrated, the content and intent of the images is just as critical for continuity as the visual style and graphic look.

Students need to trust that photographs matter. There is a difference between audiences they know—like their peers, friends, and family members—and audiences they will never meet. You will always satisfy the former because they know you and want to encourage you. The audiences that you will never meet are the people who walk into galleries and never sign the guest book.

A good way to take the creative temperature of your work is to prepare a portfolio of some twenty images and lock away somewhere on a slip of paper a list of five of your favorites, meaning the images

This image comes from the series that Andrew Williams produced in response to the Billy Collins poem, *On Turning Ten*, part of an assignment that Arno Minkkinen gives to his students.
Image courtesy of Andrew Williams

that truly matter the most to you because of their content, intent, and visual style. Then show this portfolio to five people you don't know, and ask them to pick out the best pictures, maybe by marking on the back their favorites with a pencil. It means no peeking until all five people have had a turn to vote. These votes tell you what the general public sees and likes best in your work. The composite of winning images can come pretty close to defining what your work is about. Then, find five experts in the field whom you respect—teachers, other photographers, and artists you know—and are willing to look closely at the same portfolio, marking their favorites in the same way. This may take some time but it will give you a good sense of your strongest work from the perspective of people who understand the nuances of artistic practice and have some knowledge of past traditions.

When done, arrange the images from those with the most marks down to those with none. Then comes the moment of truth: dig out that slip of paper you locked away with your favorites. If your picks match, your work is likely on target. If the images that mattered the most to you were essentially ignored, your work has yet to communicate what you wish to express. It's time to start over. It's a big temptation to suddenly agree with what others like, but students fall for that way out all too often.

I tell my students that art is risk made visible. We need to see the risk you are taking in your work. But we also need to know that the best of your work contains the best of your intentions. If that is not happening, it takes courage to start again; and that's another form of risk taking we should never forget.

I want my students to discover their own working methodology. What is it that they do and how does that factor into what they get? Some of my students work intuitively; others plan everything before they shoot. Some work at the last minute, others keep up a daily pace. Keeping their antennae up for those nuances is important because methodology also defines our work. If you keep changing the way you work, soon you will become ten different photographers.

ON A TEACHING PHILOSOPHY

I believe that everyone and anyone can become a photographer and create a unique and interesting body of work. But my students ask how they can be original when everything has been done before. I know what they mean. It happens all the time. You show your work to a gallery director, and it doesn't take long before they hand you a book by someone who has already done the work you are showing. So you leave and start something brand new, and three years later you show the work, let's say to a publisher this time, and bingo, it's the same reaction. Another book plops on your lap by someone who's been there and done that. What to do?

> If the goal is to communicate with audiences you will never meet, separate becoming famous from making your work famous.

My answer is called the Helsinki Bus Station. It's been one of my most effective metaphors for encouraging students to create and realize an original body of work, and it goes like this: the central bus station in Helsinki is lined with many bus platforms, from each of which a dozen buses leave the center of the city along the same route. For example, from platform #1 you can pick up bus numbers 63, 20, 49, 18, or 21. Leaving the center of the city, each bus takes exactly the same route. The metaphor is simple: After three years of hard work you're told you've been traveling on the Eggleston bus. So you hop off and head back fast to the Helsinki Bus Station to pick a different platform with a whole different working methodology. Three years later, it's the same story. Your houses shot at midnight cry out Todd Hido, your cadavers twitch like those by Joel-Peter Witkin, and your bathers pose before the camera from the same awkward age as those facing Rineke Dijkstra.

So it's back to the Helsinki Bus Station once again, by taxi now, as you are getting older. And for a lot of folks, this will become the creative pattern for the rest of their photographic career—until you zoom back on the Google map and see what really happens in Helsinki. About three kilometers out of town (about two miles), bus 63 turns left as buses 20, 49, 18, and 21 continue along. Soon each bus finds its way out of town; no bus is on the same route anymore and

with a dozen of kilometers to go, a whole career of work is waiting to be seized and with such great originality that, decades later, critics will declare your genius was visible from the very start! The motto is easy to remember. Stay on the bus. Add an expletive before bus and it works even better. The great Italian photographer Massimo Vitali made a lot of images from high viewpoints along beaches. So did Richard Misrach. To find the convergence, where the buses find their own routes, just look at the pictures. Callahan was there too, much earlier, with startling differences. It was Moholy-Nagy before him with Nadar, from his balloon, the first to get that aerial Google map viewpoint nailed.

If the goal is to communicate with audiences you will never meet, separate becoming famous from making your work famous. I tell my students to work on the work, not on themselves. Once that happens, they can only become their work's caretaker. They no longer own it. Yes, fame is the painful side of art. Not to worry, I tell them. For the longest time that side will always tell you you're not good enough. Just stay on the bus and you'll show them.

ON A CRITIQUE METHODOLOGY

I begin with the premise I learned from Harry Callahan. He taught from excellence, from pictures that worked, pictures about which he had important things to say. He zeroed in on the ones he liked and often told us why. Sometimes you got his blessing just from looking at his eyes looking at your work. If he didn't find anything particular to say, we moved on to the next student. Influenced by Harry, I tell my students to listen for my enthusiasm. I will also speak about photographs I find less successful and often go deeply into their positive attributes, but when I get to images I feel surpass the norm or reach beyond what the student has done before, my sentences get longer, the history books come out, my hand gestures become animated, hovering like a helicopter over such images; my enthusiasm just builds and builds and everyone can sense it.

ARNO RAFAEL MINKKINEN is a Finnish-American photographer, author, curator, and educator best known for his unmanipulated nude self-portraits in the natural landscape. He started his career as an advertising copywriter and developed a passion for photography when working on the Minolta camera account. His work has been exhibited and collected extensively both nationally and internationally in many of the most important venues that display photography, including the Centre Pompidou and Musée d'Art Moderne in Paris, the Musée de l'Élysée in Lausanne, the Tokyo Metropolitan Museum of Photography in Japan, and the Museum of Modern Art in New York. Seven monographs of his work have been published, along with entries in hundreds of books, journals, magazines, and online sites. In addition to being a Professor of Art at the University of Massachusetts, Lowell, Minkkinen is also a docent and visiting professor at the University of Art and Design in Helsinki. He has previously taught at the École d'Art Appliqués in Vevey, Switzerland; the University of the Arts in Philadelphia, Pennsylvania; and MIT in Boston, MA. He holds an MFA from the Rhode Island School of Design, where he studied under Harry Callahan and Aaron Siskind.

Colleen Mullins

Photographer and Educator

colleenmullins.net

The best part of being an educator is that your students can exceed you.

ON WHY STUDENTS SHOULD STUDY PHOTOGRAPHY

Photography students gain a lot of technical skills that can be applied to other activities. They learn to communicate visually in one of the most challenging languages that everyone who takes a picture thinks they understand, but doesn't. A good photograph is a complex conversation and students who can create those conversations have skills that are transferable to many industries.

ON TEACHING PHOTOGRAPHY

I believe that the act of research in art is vital to the classroom. Everything I do in my career I bring back to the classroom. I tell my students this is what works for me, and I suggest it might work for them. If I weren't so active in my practice, I don't think I would be as effective as a teacher. It's key that faculty remain relevant, pay attention to the community, and understand that we can't just be the ivory tower, the place of higher learning where people just go to be educated. We have to teach practicality. How are you going to manage your business when you get out of here? I know that no one wants to use the word business anywhere near a BFA program, but it's time we did because if we arm our students with the ability to write and understand the business side of our profession, they will be better equipped to make fabulous art.

ON THE CHALLENGES OF TEACHING PHOTOGRAPHY IN THE TWENTY-FIRST CENTURY

Most photo programs have a struggle between the fine art students or faculty and the commercial photography students or faculty. That struggle doesn't need to happen in the twenty-first century. I always told my students that I don't teach fine art photography and I don't teach commercial photography. I teach photography. Regardless of the genre, all photographers need technical skills, all photographers need to understand the language of photography, and they all need to know how to write. I believe that we should give all students all the tools they need to do whatever they want to do and stop having the debate about art versus photography. I understand that this debate is historical

> Most photo programs have a struggle between the fine art students or faculty and the commercial photography students or faculty. That struggle doesn't need to happen in the twenty-first century.

and comes from when photographers were fighting to be taken seriously by the art market so we called ourselves artists not photographers. The problem now is that we place a value only on the artist, not the photographer. So we have faculty in photography departments who are artists who use photography but they aren't photographers and they are not grounded in the mechanics of the camera and they don't understand the optics of a lens. This is changing the educational dialogue.

This image was created by NYU student Elena Mudd as a response to the Big Picture assignment given by Colleen Mullins, which Mudd admits was much harder than she thought it was going to be.

Image courtesy of Elena Mudd

ON PHOTOGRAPHY

Photography is a medium where the process itself dictates how the end product looks and functions. Photography allows me to edit the world differently than if I were using another medium. With photography I can show you something that you wouldn't see even if we were both looking out the same window. It is the purest way of saying, "Hey I am looking at the world this way. You look at it this way too." It's like pointing a finger at something to get someone to pay close attention.

ON DIGITAL TECHNOLOGY

What I find interesting about using digital technology as a post-production tool is the relationship that I have with an image when I am working in Photoshop at 100 percent enlargement. I get to know the image more intimately than I ever did in the darkroom. I find things in my pictures that I didn't realize were there. For example, I've been struggling to make a good picture of a particular beach in my current project, and I've been making the same photograph for four years now. I went back to some of my earlier negatives and in examining them at the intimacy of 100 percent on my computer screen, I saw a person crying, rocking back and forth, and a number of other small dramas playing out on the shore. This picture has given me pause to think about when a print might be better large—a reason not dictated by fashion or market, but by content.

COLLEEN MULLINS, who currently lives in Minneapolis, MN, has been a college educator for more than twenty years. Formerly the director of BFA Photography at the Art Institutes in Minneapolis, Mullins is currently working on a project in her native California on regions north of San Francisco with deep personal connections to her family's history. Her work is in the collections of the Ogden Museum of Southern Art, the Southeast Museum of Photography, and the Weeks Gallery Global Collection of Photography. She has been the recipient of two McKnight Artist Fellowships for Photographers, four Minnesota State Arts Board Grants, and a Women's Studio Workshop Project Grant. She holds a BA from San Francisco State University, CA, and an MFA from the University of Minnesota, Minneapolis.

Photography is a medium where the process itself dictates how the end product looks and functions.

Joyce Neimanas

Artist
University of New Mexico, Albuquerque,
New Mexico, United States
(retired faculty)

joyceneimanas.com

A lot of people forget that the camera is one-eyed; it doesn't see the way we do.

ON WHY STUDENTS SHOULD STUDY PHOTOGRAPHY

Why do people study anything? The answer to me would be to expand their minds. You don't study photography to learn techniques. You get a photography degree to learn how to think, then take that information and apply it to any subject. Thinking is not confined to one medium. Studying photography also gives you access to the lexicon of art and provides insight into art history. When I go to a museum and see a show, say by Gerhard Richter, I might not fully comprehend everything since the only way we can approach art, or life, is through our own experiences. I might need someone to assist me with his language, to tell me how he is moving through his work because I don't have sufficient language to understand it. People think they understand photography because it looks like a shrunken version of the real world. But as I tell my students, if they think photographs are real, then why doesn't a picture of a glass hold water? Photography is an abstraction and people must be taught how to produce and comprehend abstraction. A lot of people forget that the camera is one-eyed; it doesn't see the way we do.

ON TEACHING PHOTOGRAPHY

Photography education was more innovative in the past before there were so many administrative requirements. When I was a graduate student at the School of the Art Institute of Chicago, studying under Ken Josephson, the photography program was new and we had no rules or constraints. It fostered a very open and inventive time period for the medium. Today there are so many requirements, including supplying a syllabus that you are expected to follow, that any flexibility in the classroom almost becomes secretive. It really stifles innovative teaching.

ON A TEACHING PHILOSOPHY

It was interesting to me to find the uniqueness in a person so I could better understand their work. It's easy to say that students should photograph what interests them but sometimes they are too young to know that, so I had tricks to help. I made them actually go to the library to find a book to bring into class. Searching the library stacks, they had to explore lots of unfamiliar books to find artists who interested them. Then they would come back and tell the class what they liked about the work. I think it's important for students to know what photographic "tribe" they're from. History plays an important role in the development of ideas. Artists do have a tribal history. I want to know about the artists who impact my ideas. For example, Annie Leibovitz is a great photographer, but she's not from my tribe. It's important for students to research the history of their photographic tribe. It's as important as what they end up making themselves. Another trick I had was a game where people would find the most interesting YouTube videos. I gave out

> Photography is an abstraction and people must be taught how to produce and comprehend abstraction.

prizes for the most interesting videos, selected by the students. It's always a challenge to get into their brain, but this made it easier.

Getting to know them individually also helped me devise strategies for each student. If a student was afraid to get close to people I would suggest that she put herself in a situation where being close to people was normal and wouldn't immediately identify her as a photographer observing people, such as in a revolving door or standing in line at a movie theater. I sometimes assigned performance pieces. I had one student who was scared, so I suggested he make his performance about being scared. He came in with a sheet over his head and wrote backwards with a magic marker on the inside of the sheet, with the words revealing themselves one at a time "I-am-scared-to-death."

ON THE GROWTH OF MFA PROGRAMS AND HOW THE REQUIREMENT FOR A MFA IMPACTS PHOTOGRAPHY DEPARTMENTS

When I went to graduate school there were only three or four programs in the country offering MFAs. The growth of these programs created a greater need for MFA degrees, because if you offer an MFA everyone on the faculty has to have an MFA. Let's face it, MFA programs are money makers. If the degree is required, people have to come and get it and the schools make money.

ON A FAVORITE CLASS

I taught a class on mapping. The students were required to look up the definition of the word "map" [34] and then figure out what it means to them. Mapping forces you to think conceptually about 3D space. What is a map and what does it mean to use a map? Everyone approached it a little differently. Some students went on a trip to find something; others "mapped" a little piece of ground. That was fun and they learned a lot about how an idea (or 3D space) is transformed into a 2D image. The observers of the work journeyed from a source to a destination through the use of visual narrative.

ON A CRITIQUE METHODOLOGY

I've tried a million things, but one that worked well was to have each student write down a few words or sentences, something really short about the exhibited work. The statements were anonymous. I collected

> Today there are so many requirements, including supplying a syllabus that you are expected to follow, that any flexibility in the classroom almost becomes secretive. It really stifles innovative teaching.

them, shuffled them up, and gave them to the artist to read. They had to read them and then ask questions about the comments and so began the dialog. The student being critiqued kept the statements throughout the semester. Having students write things down really helps the ones who are afraid to speak up in class.

JOYCE "JOY" NEIMANAS joined the faculty of the Art and Art History Department Photography area at the University of New Mexico (UNM) in 2004, having previously taught at The School of the Art Institute of Chicago. She retired from UNM in 2010. Her work is in the permanent collections of major public museums and she has had shows at illustrious museums such as The Museum of Modern Art, New York; The Art Institute of Chicago, IL; and the Tokyo Metropolitan Museum of Photography, Japan. She received three National Endowment for the Arts grants, and a Pollack/Krasner grant. In 2011, she was named honored educator of the year at the annual conference of the Society of Photographic Education. In 2007, she began making videos with QuickNoise, a dance collaborative in New Mexico. She holds an MFA from the School of the Art Institute, Chicago.

Lorie Novak

Professor, Photography and Imaging
Tisch School of the Arts, New York University,
New York, New York, United States

www.lorienovak.com

I feel strongly that it is our responsibility as educators to lead discussions on issues of race, class, gender, and sexuality, even if, or when, it makes students or us uncomfortable.

ON CHANGES IN PHOTO EDUCATION

Issues definitely recycle and content changes, but questions always seem to center around the question: What is photography? When I became chair in 1999, our department changed its name to Photography and Imaging to signal that our view of photography was more expansive and included the range of possibilities afforded by digital and new technologies. I remember when I started teaching at NYU,

I am most interested in the discussion about the afterlife of the image— what happens to photographs when they enter our culture?

a big question was: Should we require color? Then it shifted to digital photography and new media. What complicates the question now is that, in a sense, everyone is a photographer and photo-based media takes many different forms. One of the current challenges is how to get young photographers to see their practice as open and not categorized by being digital or being analog.

ON TEACHING DIGITAL PHOTOGRAPHY AND MULTIMEDIA

There are both philosophical and practical questions raised by the facts that with analog photography we are dealing with light on film and with digital it is ones and zeros. What is produced with the digital image is not an object or a thing. When light is translated to ones and zeros it renders the image differently. I am most interested in the discussion about the afterlife of the image—what happens to photographs when they enter our culture? For me, that is where the

conceptual difference between the digital and analog becomes more interesting for the study of photography. It raises questions about the truth of a photograph. We have been able to manipulate images since the birth of photography, and that ability to manipulate gets more sophisticated and easier. We can create an image that look like a photograph when it was produced with computer graphic software and was not created with a camera. So the interesting question is: Is something photographic if it has not been created with a lens? Maybe that image isn't a photograph, but a photo *something,* and we need new terms. Although we know the extent to which photographs can be altered or created without our ever "being there," we seem to still have a tendency to believe what we see.

Teaching the moving image, how to deal with image and sound, and possibilities for putting work on the Internet, are part of the contemporary practice of photography. Time-based media is not this "other thing." We see more photographs on the screen than in any other form. Usually this engagement is in a sequential slide show, a video, or some interactive or non-linear format. Students must become conversant in these forms and have the flexibility in their thinking and practice to adapt to new ones. Technology is always changing, so our definition of what it means to be technically proficient is always in flux. I focus on giving students confidence to teach themselves, learn from each other, and collaborate.

ON WHY STUDENTS SHOULD STUDY PHOTOGRAPHY

First, I believe in the importance of education for education's sake and the need for visual literacy and a critical eye. At NYU students get a good liberal arts education in addition to their extensive photographic studies. Studying photography can be like studying humanities because being visual literate and being able to read photo-based images are important skills to understand culture and history. There is too much pressure now on universities to focus on job training and that pressure seems to be greater on fields like photography. The world students will enter when they graduate is not the same as the one that existed when they started college. They must invent possibilities for themselves. Regardless of the student's reason in choosing to study photography, I think that the degree provides students with many possibilities because students learn how to see and think, to communicate ideas, how to tell stories, find their creative voice, be original, and take responsibility for what they do. Being an image maker or working in our field as photo editors, curators, writers, designers, community-based teachers, etc. are not the only career paths.

For example, I have a former student who is applying to medical school. She told me that our program prepared her well for her current job as a researcher in a cancer research lab because the critique skills she learned help her question what she is doing and present and defend her research. Another student who was working as an EMT before applying to medical school told me he thought studying photography prepared him for that job because he could go into a chaotic situation and quickly make visual order. And since he was a documentary photographer, he learned how to interview people and draw them out, the same skills he will need as a doctor.

ON A CRITIQUE METHODOLOGY

I have two basic mottos for my own art-making process and teaching studio courses: content determines form, and make visual decisions visually. I start a critique with the students speaking first about their intent so that discussion focuses on their intent and how and if their images are communicating their ideas. There is often disparity between what we see and what the student tells us, and this becomes a basis for feedback and discussion. I discourage the use of terms such as "this is a good picture" or "this works" without saying why

> Regardless of the student's reason in choosing to study photography, I think that the degree provides students with many possibilities because students learn how to see and think, to communicate ideas, how to tell stories, find their creative voice, be original, and take responsibility for what they do.

because I find these terms too vague and dependent on traditional ways of seeing to be useful comments on their own. Critiques are a place to learn how to talk about images and articulate ideas. I try to connect theory and practice as well as process and product. We also work on artist statements. Beyond an initial presentation of their project concept, I don't let students just verbally present their ideas if they don't have something visual to show. I encourage students to think about what kind of feedback they need. I never speak first so my opinion does not dominate the conversation. I will, however, insert myself if someone says something really extreme and no one responds to that comment. I assure the students that I will talk about everyone's work but by not speaking first, I emphasize the importance of establishing a community of their peers. In my classes where the critiques have been the most exciting and interesting, I feel that, in a sense, I don't need to be there because they are truly engaging with each other.

ON A TEACHING PHILOSOPHY

I like to think of the studio classroom as a laboratory—a safe space for students to experiment, expand their thinking, give and get feedback, connect theory and practice, focus on process as well as product, and understand how their work is being received. Students need to take responsibility for the content and the context of their work. I feel strongly that it is our responsibility as educators to lead discussions on issues of race, class, gender, and sexuality, even if, or when, it makes students or us uncomfortable. I try to make the classroom environment

non-threatening so that we can have substantial and honest discussions. We must make sure that students in the class feel that they can bring up difficult issues as well, and recognize that we as educators have our own ways of looking and particular gaze. If students want to make something that many read as being sexist or racist, for example, it is their decision in the end, but they must understand the underlying issues and histories that affect the reading of their images. A common example is that there is a lot of misogynist/fashion-related work that's being made (by both women and men) and the misogynist undertones don't always get discussed in classes because, unfortunately, it is so much a part of our culture. Writing is also important. I don't believe that a photograph can necessarily speak for itself. Photographs often need text, particularly in documentary work, to give them context and specificity. There are many students who feel their photographs shouldn't "need" text. Once images are in the world, it is not just about the image being well seen. Not everything can be communicated visually and if images need context, image and text (be it written or oral) must work together, and this cannot be just an afterthought. On the other hand, text cannot be a substitute for what is not in the image. If there is openness, grappling with all these issues in classroom discussions is exciting. I love learning from and being surprised by my students.

LORIE NOVAK has been teaching for more than twenty-five years. As Chair of the Photography and Imaging department at NYU from 1999 to 2006, she was an innovator in shifting the thinking from the photograph as a single object to a discipline that included digital technology and time-based media. Her web project *collectedvisions.net*, exploring how family photographs shape memory, was one of the earliest interactive storytelling sites. Her current work employs various technologies of representation to explore issues of memory and transmission, identity and loss, presence and absence, shifting cultural meanings of photographs, and the relationship between the intimate and the public. She has had countless national and international group and solo shows and her photographs are in permanent collections such as the Art Institute of Chicago, IL, the Museum of Modern Art, New York City, and the Victoria and Albert Museum in London. She is also the founder and director of Future Imagemakers/Community Collaborations, a participatory photography project offering free digital photography classes taught by NYU students to NYC high school students. Novak holds an MFA from the School of the Art Institute of Chicago and a BA from Stanford University.

I feel strongly that it is our responsibility as educators to lead discussions on issues of race, class, gender, and sexuality, even if, or when, it makes students or us uncomfortable.

Catherine Opie

Professor, Photography
Department of Art, University of California,
Los Angeles, United States

www.regenprojects.com/artists/catherine-opie/#1

I don't know if I can teach anyone how to be a great photographer, but I think that I can teach them to understand the historical ramifications of photography, how to see, and what it means to look.

MB: WHY SHOULD ANYONE SPEND FOUR YEARS STUDYING PHOTOGRAPHY?

CO: Why should anyone study anything? We study something in depth to learn the language of that subject. Photography is no different. It is a learned language, based on referring to its history and what it is to see in a critical way. I don't know if I can teach anyone how to be a great photographer, but I think that I can teach them to understand the historical ramifications of photography, how to see, and what it means to look. Almost everything has already been photographed, so how do we think of images in a new way? To me, this is about *looking* in relationship to understanding how a photo operates. Looking is understanding the relationship between how images are constructed and the underlying ideas in the images. I can help students expand their ideas, and I can help them move beyond clichés—and we have a lot of those in photography—sunsets, kittens, puppies, children.

MB: ARE THERE THINGS THAT CAN'T BE PHOTOGRAPHED ANYMORE BECAUSE WE'VE PHOTOGRAPHED THEM SO MUCH?

CO: It's all open territory. Anything can be photographed, but you have to be able to understand critically if you're bumping up against a cliché. And you have to argue for it in relation to why your idea is fresh in terms of you representing that potential cliché.

MB: WHICH THEORISTS DO YOU REFER YOUR STUDENTS TO READ?

CO: I always try to have them read a lot of Rebecca Solnit. I'm interested in her book *A Field Guide to Getting Lost.* I like her ideas about wandering. And if I'm doing a landscape class, I appreciate the way that she begins to talk about landscape and the history of landscape.

> Anything can be photographed, but you have to be able to understand critically if you're bumping up against a cliché.

I also assign Susan Sontag, especially *Regarding the Pain of Others.* It's an interesting book to talk about in relationship to the idea of how documentary photographs operate on the political level.

MB: DO YOU THINK THE IDEA OF A BFA WHERE STUDENTS STUDY JUST PHOTOGRAPHY IS TOO NARROW TODAY? IT'S THIS LITTLE FUNNEL AND THE HOLE IS GETTING NARROWER AND NARROWER BECAUSE AT MOST ART SCHOOLS STUDENTS JUST STUDY PHOTOGRAPHY WITH A VIDEO CLASS TOSSED IN HERE AND THERE.

CO: Quite honestly that's not how the art world is operating anymore. Painters, sculptors, and mixed-media people are using photography within their work. Photography has filtered in through all the other genres. It's interesting that the other genres are not filtering into photography.

CO: The problem is that I don't really understand these categorizations. It just goes back to this older position of photography not being art. It's always been a quandary with me because although I am a photographer's photographer I was funneled into the art world as an artist, not as a photographer. So historically the photography department at MoMA would not show my work, but the painting department at MoMA would. It's only now that the photography department is interested. I think it's just because I didn't start out showing at photo galleries so the title of photographer was never stuck on me. The converse is true for anybody who's doing commercial photography and is starting to move into the art world; she is often only considered to be a photographer, not an artist.

MB: HOW DO WE TEACH STUDENTS TO DIFFERENTIATE THEIR IMAGES WHEN WE SEE SO MANY IMAGES AND EVERYONE WITH A SMARTPHONE IS A PHOTOGRAPHER?

CO: First, I think it's an issue of learning how to edit, and teaching them to be good editors is really the place that a lot of us are in right now. I had a long conversation with a student last quarter about his use of

> We need to think about the relationship of the physicality of the object as a photograph, not just as an image.

cell-phone images because he would just print them out in these huge grids in the same way that they would be tiled on his phone. He didn't know how to edit. He, like other students, thought that because he could record all the minutiae of his life on his phone, that the images were interesting. I was pushing him to understand that he had to contextualize his photographs so that there was some sort of criticality in the edit. It doesn't matter whether the images are smartphone images or taken with a different camera; the question will always be whether photographs, regardless of how they are presented, can hold my interest in a room. It's going to be interesting for photography to figure that out today, because we are beyond the idea that if you make it big,

it's going to work out. We need to think about the relationship of the physicality of the object as a photograph, not just as an image. I think that's why we see so much experimentation with exploring the relationship between abstraction and photography. It's the same kind of crisis that painting went through. With the invention of photography we no longer needed to have the painting act as our document; now with the invention of digital we no longer need the photograph as object, so we're beginning to really use abstraction in relationship to the image, but also hanging onto analog processes. It's a very curious time and I find it actually very exciting.

MB: SINCE THIS CURRENT GENERATION MAY BE THE FIRST TRULY DIGITAL ONE, ARE YOUR STUDENTS THINKING ABOUT PHOTOGRAPHY DIFFERENTLY THAN PAST STUDENTS DID?

CO: I don't think that they're as informed about the history and I think that they're really thinking of photography as a grab-bag of techniques. If I taught in a photography program, it might be different, but because I teach in an art school that includes all mediums, I think students feel photography can be used however they want to use it without really understanding its history. I'm wondering if we're facing a generation of people for whom history is irrelevant because when I show them images they only look at them in relationship to the here-and-now. I can get them interested if I make them stand in the darkroom, experiencing that process, because it gives them a relationship to the physicality of the process. It's like watching tennis versus playing tennis. I worry that if analog completely disappears, the history will disappear as well.

MB: WHAT IS YOUR CRITIQUE METHOD?

CO: I critique from different places. It depends on the work being shown. I really view myself as an educator in the position of a mentor. My job is to guide and interject. The student can choose to focus on certain questions that they might have, but sometimes I might say, "Don't speak at all; let's just interpret the work and see if we're on the right track of what you're trying to convey with your work." I'm

not into the mean critique; I allow criticality but I don't allow anyone to just dismiss work. If someone is being jerky in the critique then I'll call him or her out on it, because that's not a valid way to critique. I try to really invoke a sense of ability with language in the class, and often I say: "Well, just pretend that I'm an art historian or curator and I'm coming to your studio to look at your work; you have to lead me through the work."

CATHERINE OPIE'S work has been exhibited extensively throughout the United States, Europe, and Japan in solo and group shows in many of the world's most prestigious galleries and museums, including the Guggenheim Museum in New York, which exhibited her work in 2008 as a mid career retrospective titled *Catherine Opie: American Photographer.* Before moving to Los Angeles, she was a professor of Fine Art at Yale University. She holds a BFA from the San Francisco Art Institute and a MFA from the California Institute of the Arts.

Timothy Persons

Director of Professional Studies and Senior Lecturer
Aalto University School of Arts, Design,
and Architecture, Helsinki, Finland

gallerytaikpersons.com

I hope to put on my gravestone that if I did anything, at least I introduced students to content, poetry, and the courage to find their own way.

ON TEACHING PHOTOGRAPHY

When I was first asked to evaluate the various programs at Aalto,[35] in the early 1990s, I saw it as a blessing and a curse, since no one wants to be the one to criticize another's department. Yet, it was through this process that I discovered the photography department and the talent that resided there. In those days the students came to me for portfolio reviews with their contact sheets in plastic bags, no written statements, and very poor presentational skills. Looking back now it seems ages ago, yet I'm still touched by the ideas I saw then and the depth of the content they represented. The problem was there was no teaching platform at the time which supported a sustained vision to harness these skills and to help those selected MA students realize their ideas into finalized works. I was appointed the director of professional studies and began what has now been twenty years in developing new approaches in how to teach the photographic process as a conceptual tool.

My philosophy was to use the camera as a means to realize conceptual ideas. Consequently, we began a program that incorporated not only how to think with the camera but how to use the process to find solutions to the whole picture. To do this, we created situations where these selected MA students had the opportunity to experience first hand how to produce, build, curate, and visualize their own works in an exhibition atmosphere. In a sense, we took the class out of the classroom by exposing them through a series of pop-up exhibitions throughout the Helsinki region. What began as an educational model eventually transformed itself into the cornerstones of what the Helsinki School was built on: content, originality, and no compromising.

We basically built a program that focused more on content than commerciality. Critics of our system will gladly point out that the name Helsinki School represents a branding of art, not an idea. However, we didn't originate the name but merely used it to associate our more successful students with a sustained system of teaching that blended different generations of artists through dialogue, critique, and mutual cooperation. The Helsinki School doesn't exist as a school but as an educational opportunity for those selected MA students from Aalto University. One of our goals as an educational institution is to help our students find the process for approaching and solving problems they will face in their professional careers. It's more than just teaching techniques. Our aim is to create an educational environment where ideas can be debated, criticized, and shared. We encourage students to push beyond the borders and to take chances. No institution can teach intuition but it can be nurtured and used as any other tool for harvesting knowledge and information.

ON THE CHALLENGES OF PHOTOGRAPHIC EDUCATION

The greatest challenge for any type of art education is to not push the students too fast. Each generation needs time to develop and find its own voice. As educators we must be careful not to push a student too hard in one direction, as we stand a greater chance that plagiarism will become the norm, not the exception. There is no measurement for artistic maturity. It takes the time it needs, as everyone is different. We at Aalto in the photographic department have created a system for exhibiting our selected MA students with our various graduates and professors. This serves several purposes. First, it affords the younger

generation the time to invent themselves while giving the former graduates a new platform to work from. It's all about harnessing the enthusiasm of one group with the experience of another. Secondly, it acts as a catalyst that binds the older with the younger by association and through a shared experience. The result of these combined generational exhibitions is a rejuvenation that can be found in the dialogue between artists in their works as well as in the teaching.

To realize this, Aalto University through its Professional Studies Program established Gallery Taik (1995) to promote, teach, and curate through pop-up exhibitions, art fairs, and museum shows. What began as a virtual school gallery twenty years ago in Finland has now become known as Gallery Taik Persons[36] and is one of the leading independent photo galleries for young artists in Europe today.

ON THE RELATIONSHIP BETWEEN ANALOG AND DIGITAL TECHNOLOGIES

Digital technology offers the artists different opportunities to study the photographed image in ways the analog process never could. However, while some may argue there is the lack of depth or roundness to the digital image, in my opinion it is only a matter of time before this will no longer be an issue. Most of Aalto's MA students still photograph with film but research prior to the final shooting with some sort of digital camera. We have to think of photography in the twenty-first century as the ultimate soufflé: You have to know your ingredients and how to use them at the right time. Photography will always have a magical quality to it whether we work it in a darkroom or on a computer. It is like life's mysteries: there is no end to them.

ON WHY STUDENTS SHOULD STUDY PHOTOGRAPHY

Teaching photography in the twenty-first century will be more about defining new ways of interpreting what we see. The visual image is essential in every part of our daily lives; therefore we should be teaching the contextual ways of thinking visually. Whether it is painting, sculpture, video, or a combination of all the above, photography will be the medium that defines how this century will look, think, and visually interpret itself. Content is the key as well as the lens. Photography will be more about closing your eyes to see and using the camera as a tool to think with. Studying photography should teach the students how to use the medium as a vehicle to explore and integrate into the environment you surround yourself with both mentally and emotionally. Our goal at Aalto is to create and sustain those platforms for experimentation by keeping the borders of thought open and ever changing.

TIMOTHY PERSONS, who currently resides in Berlin, is a renowned educator, curator, and artist, known as the founder of the "Helsinki School,"[37] which grew out of the photography program at Aalto University School of Arts, Design, and Architecture. Along with his positions at Aalto, Persons is one of the artistic curatorial advisors to the Kulturhuset, Stockholm, Sweden; a member of the selection committee of Paris Photo; senior curatorial advisor to the Royal Library, The National Museum of Photography Copenhagen, Denmark; former senior advisor to the Borås Art Museum, Sweden (2006–10); and former senior curatorial advisor to KIASMA Museum of Contemporary Art Helsinki, Finland (2007–10). He has curated more than forty international photography exhibitions, written numerous books, and exhibited his own work worldwide. He holds a MFA from Claremont Graduate School, CA.

Jonathan Shaw

Associate Head, Media Department
School of Art and Design, Coventry University,
Coventry, United Kingdom

#phonar #picbod
jonathan-shaw.com/blog

*If we do genuinely try to learn together as
a community, connected environment, then
surely we should all learn more.*

MB: WHY IS THERE LITTLE INNOVATION IN ONLINE TEACHING?

JS: A lot of it is historical and a human resistance to change. At Coventry, we had the opportunity to be innovative because we were setting up a new course specializing in photography and the only absolute was that it would not be a fine art photography program because we had one of those already. We approached it by thinking of what photography could be and will be, not what it was. We're more interested in understanding photography as a practice, but not one that is inward looking, one that is more outward and trying to embed what that means. Our program approaches teaching photography as something that will seek to give students the ability to earn a living in photography.

At the time we created this course, most photo educators in the U.K. were talking about digital versus analog, whether universities should still have color darkrooms, and things like that. It seemed to me they were missing what was going on in the world, which was the

> We're more interested in understanding photography as a practice, but not one that is inward looking, one that is more outward and trying to embed what that means.

exponential growth in image production and making, maybe not for commercial purposes, but photography was huge. It was more than a means of representation; it had become part of the conversation and a fluid form of communication.

MB: WHAT KIND OF PRACTICE DID YOU HAVE?

JS: I used to drill holes in cameras to pull them apart so I could create a camera that would allow me to photograph the passage of time by recreating our perception of movement. In a sense I took contemporary photography back to the earliest days of invention where we had Muybridge providing us with what we now see as "bullet time."[38] Digital technology has released my practice, so to speak, because I can create work that before was impossible. I am not longer confined by the limitations of the traditional darkroom.

MB: YOU AND YOUR COLLEAGUE, JONATHAN WORTH, ARE WELL KNOWN FOR YOUR OPEN ONLINE COURSES #PICBOD AND #PHONAR. HOW DID THESE COME ABOUT?

JS: On reflection there were a number of events that led to the evolution of the open classes; at its heart was the desire for a different mindset and philosophy for the course, but I think a key moment occurred from a symposium we ran in 2008 with colleagues at Goldsmiths Creative Media Forum, called Photographic Mediations where we set to explore and debate photography as a mediated form. To free that symposium from its physical location in the U.K., we made the material available online, and suddenly rather than the intimate thirty participants, we now had thousands of engaged participants—to date the collection now has had over a million listens.

In the second year of our program, we realized that our students weren't looking outside the four walls of the classroom. Pedagogically, we saw that as problematic. So we decided that if our students weren't going to engage with the photographic community, we would invite the community into the classroom as a way of nurturing and supporting our students and to "force" an interaction with the community. We used the similar strategy as we did with the symposium: we invited the global photographic community into the classroom through social media in our class on picturing the body, which is now known as #picbod. What set out as an initial experiment and an exploration is now firmly at the heart of our practices.

MB: WHAT ELSE DISTINGUISHES YOUR PHOTOGRAPHY PROGRAM FROM OTHER MORE TRADITIONAL CURRICULAR APPROACHES?

JS: We used that as a starting point and in developing our new program, we didn't take anything for granted. We questioned everything, including the value and experience of a lecture hall in which the lecturer faces the audience. As a consequence we eliminated lecture halls, computer facilities, video editing suites, and instead we needed to reflect reality and decided to enable our students to be mobile with laptops so everything in the "classroom" can be facilitated 24/7. In #picbod and #phonar, our lecturers use microphones, students are photographing them and tweeting notes and sharing comments through a variety of networks.

MB: YOU'VE CREATED AN ATMOSPHERE WHERE STUDENTS MUST BECOME ACTIVE LEARNERS.

JS: Yes, but it is not only the students, the teachers also become active learners; for us, we start with the premise that we don't have all the answers—and rather than seeing that as negative, we posit that our job is to seek out the most appropriate and important questions. The open classes can be seen as a resource, a moment in time that we've recorded, so we can't let it become stagnant; we have to keep adding new layers of knowledge, asking new questions.

If we do genuinely try to learn together as a community, as a connected environment, then surely we should all learn more. If somebody is guarded and not willing to share ideas, they will not get a place on our course, which has become the most competitive program in the entire university. In fact, we've even changed our admissions process. We interview students as a group because we are looking for students willing to share their ideas and help each other.

MB: THE CRITICISM OFTEN VOICED BY FACULTY IN A MORE TRADITIONAL PROGRAM IS THAT AN ONLINE COURSE LIKE YOU HAVE DESCRIBED IS MORE WORK THAN A TRADITIONAL CLASS.

JS: The question faculty should be asking is not so much about workload, but our relevance as educators in the twenty-first century. The university traditionally existed from this idea that we have this one book of knowledge and our job as teachers was to transfer that information to students. Today information doesn't exist as a single source. It is distributed and accessible from anywhere. We understood we didn't have that book of knowledge anymore and if that information is available for

> The question faculty should be asking is not so much about workload, but our relevance as educators in the twenty-first century.

free online, why on earth would students pay thousands of pounds for the privilege of an outdated and potentially bad version of that same education?

We're living in an entirely different world. To be relevant we can't and mustn't just teach how we were taught. We need to question and think of our role, perhaps if we see ourselves as curators of experiences, we can achieve a shared ambition of creating transformational opportunities for learning to take place. This hierarchy of staff and student has got to go. We can't continue to assume that the traditional classroom is the only space in which to teach and more importantly learn from each other, we have known for years the success of learning out in the field. For education to succeed I believe we need to apply the best that both the digital and physical worlds have to offer. We

must utilize all of the effective channels of communication modeled through digital and social media so we shouldn't think of it as more work, but as different work.

JS: We expect that our students will develop the ability and skills to be reflective and critical of what's taking place in the world and on social media. Our approach to the open classes is exploratory; we are constantly analyzing and changing what doesn't work. We expect our students to have the full breadth of photography skills, digital communication skills, and even the ability to read and write some computer code. We talk about releasing ourselves from the history of the print as artifact to enable us to be a bit freer about how we think about photography. With technology now that allows us to make images without a lens, and a photograph is not necessarily made by a person standing behind a piece of metal apparatus, we need to rethink the classic semiotics of what an image is and how it functions. We need to stop distinguishing between still, video, or film and think about the idea of the image as being active. If we can remain open to the fluidity of ideas about photography and images, it's a very exciting time for photographic education!

MB: WHAT ARE YOUR NEWEST PROJECTS OR ITERATIONS OF YOUR CLASSES?

JS: My new project is called *New Landscapes of Photography: Explained, Explored, Questioned and Discussed.* It is a book project that offers a starting point for a journey through uncharted territory—the new landscapes of photography. This is a metaphor in recognition of what is really exciting at this moment in time: the vast array of opportunities for photographers to free themselves from self-imposed conventions and for governing institutions to adopt new mindsets and see photography as a much wider, new landscape of possibilities.

We are attempting to offer to new and emerging audiences simplicity rather than simplification of the terrain, an opportunity to understand and engage rather than just passively know. At present, I do worry that institutions, whether they be cultural venues or educational establishments, at times lapse back into old assumptions, methodologies,

and references. We all need more than ever to consider our relevance and our value proposition, so perhaps—as George Baker stated in his summary for San Francisco's Museum of Modern Art's *Is Photography Over?* Debate—this affords us an opportunity to return "to the forgotten potentials of the medium before its industrialization"?

We see this new project as a way of understanding what skills tools, and perhaps more appropriately, using the analogy of the explorer, what compass we need to navigate our way through this new and rapidly forming educational landscape. Rather than seek to draw conclusions, the project is seeking to draw together differing perspectives, examples, and experiences across a breadth of people working within the broad field of lens-based media. This new journey seeks to continue the mission we started with our #picbod and #phonar classes, offering a new open platform focusing upon accessibility to these debates, questions and explanations to new and emerging audiences, digital natives and digital immigrants alike.

JONATHAN SHAW uses the camera, usually designed, built, or customized by him, as an instrument of both scientific record and aesthetic exploration. Prior to his post at Coventry, Shaw maintained a robust commercial and fine art career that included commissioned pieces for Volkswagen UK, the Manhattan Loft Corporation, and a 2003 book project with Nigel Coates, *Guide to Ecstacity* (Laurence King Publishing). Also in 2003, a Dewi Lewis publication, *Time/Motion,* placed Shaw's work alongside photographic pioneers Eadweard Muybridge and Harold Edgerton. At Coventry, Shaw and his colleagues introduced a new way to think about open online education by opening two site-based classes, now known as simply #picbod and #phonar, to the photographic community at large. Shaw has a BA in Photography, Graphic Design, and Computer Graphics from the University of the West of England, and a MA from the University of Central England. He is also a Fellow of the Royal Society for the encouragement of Arts, Manufactures, and Commerce (RSA) and the Royal Photographic Society, and an Adobe Education leader.

Stephen Shore

Susan Weber Professor of the Arts
Director of the Photography Program
Bard College, Annandale-on-Hudson, New York, United States

www.stephenshore.net

Painting as a craft is inherently synthetic and photography as a craft is inherently analytic.

MB: IN THE MORE THAN THIRTY YEARS YOU'VE BEEN AT BARD, WHAT CHANGES HAVE YOU SEEN WITHIN PHOTO EDUCATION AND THE EXPECTATIONS OF STUDENTS?

SS: The students we get here now are much more aware of the art photography world. I can come into a beginning class and have discussions about Jeff Wall with students. Twenty years ago, if I were to ask a student about an art photographer, he would answer with Ansel Adams or occasionally Robert Mapplethorpe and that would be about it.

MB: WHAT CLASSES DO YOU TEACH?

SS: I teach a variety of classes. This semester I'm teaching a view camera class and a 100 level class in visual literacy. In the Fall I always teach a basic photography course. When I came here originally in 1982 I was a friend of Garry Winogrand, and he was moving to the Hudson Valley. I asked him if he would be interested in teaching. He said yes, but under the condition that it be a 100 level class. I said, "I don't mean to *embarrass* you Garry, but you're one of the greatest photographers around. Why a 100 level?" He said, "That's the most important class." That's been the philosophy of this program ever since.

MB: DESCRIBE HOW YOU TEACH VISUAL LITERACY.

SS: It's a studio critique class called Photographic Seeing. I use my book.[39] In fact the book grew out of this class. I had been using John Szarkowski's book *The Photographer's Eye*, but I thought that the chapter on Vantage Point was off point. So I rewrote a new chapter for vantage point, and eventually I ended up writing a whole book.

MB: IN YOUR BOOK YOU SAY THAT THE WORLD DOESN'T HAVE A FRAME; THE PHOTOGRAPH FRAMES THE WORLD. THAT GOES TO WHAT PHOTOGRAPHY DOES SO WELL: IT PUTS A FRAME AROUND A VERY BRIEF MOMENT IN TIME. IN YOUR BOOK YOU ALSO CALL PHOTOGRAPHY AN ANALYTICAL DISCIPLINE. I HADN'T THOUGHT ABOUT IT THAT WAY.

SS: This is actually something I learned from Szarkowski, who did write about this. Painting as a craft is inherently synthetic and photography as a craft is inherently analytic. I don't mean collaged photographs or Photoshopped photographs, but what we would call straight photography made with a camera and printed directly from a negative. It goes to exactly to what you are saying that photographers are placing a frame around the world. We're putting an order around something that's pre-existing, which is essentially an analytic act. Painters go in the opposite direction. They start with a blank canvas, and with each mark they build complexity. So a painter starts with a blank *nothing* and synthesizes an image, and a photographer starts with *everything* and selects from that.

MB: WHAT IS THE STRUCTURE OF YOUR PROGRAM HERE?

SS: During the first year everyone takes a beginning class, no matter how much they've studied before. Then they take a second semester class that doesn't have a major technical component, whether it's Photographic Seeing or a class called Light, which Larry Fink teaches. The second year, all students take one semester of color and one semester of view camera. In the first semester junior year students take a digital class, and the second semester is an advanced class, offered by different teachers so students find the teacher who's going in the direction

that they want. In all of our classes the technical component doesn't last more than a third of the semester; the remaining time is spent on critique. I've sat in on digital classes in other institutions where the instructor spends fifteen weeks going through every Photoshop menu and sub-menu. When we teach a digital class you get five weeks of Photoshop, which is basically taught as a printing technique, and then ten weeks of critique. I don't believe in just imparting the technical information. We ask students to take this new expanded technical vocabulary and integrate it into their aesthetic practice.

MB: IN A SENSE YOU ARE TEACHING STUDENTS HOW TO TEACH THEMSELVES BY INTEGRATING TECHNIQUE WITH PRACTICE. YOU DON'T TEACH DIGITAL UNTIL THIRD YEAR. WHY?

SS: A number of reasons. I first started thinking about it a couple of years ago when I had a visiting professorship at an art school in Switzerland, ECAL.[40] I worked with a group of eighteen to twenty students who were very talented and very committed and in many ways are more advanced than students here. The second year I taught there I noticed that everyone's prints were poor. And not only that, although they were all working in color—they didn't see color. They were taking pictures that happened to be in color, but they weren't thinking in terms of the color space or the balance of the palette of the picture. I tried to figure out why an entire group of these very talented, very serious students would all have a similar problem. I discovered that none of them had ever been in a darkroom. This was the marginal year where everyone used only digital. It convinced me that something

> It convinced me that something essential is learned through traditional film-based processes that may not be learned, at this point at least, through digital.

essential is learned through traditional film-based processes that may not be learned, at this point at least, through digital. If you go into a darkroom and make a print and think that this doesn't communicate the experience of light that I saw, and so I have to make it 5 percent lighter, maybe change the contrast a little to communicate what the

sunlight looked like on this day, and if you do that enough, you may start seeing light differently when you take a picture. If you learn to color balance a print, how to hold it on the wall and study it, and then think this needs five points less magenta—and then go back, make another print—it may sensitize you to seeing color in the world. A particular film will have a particular palette. You learn that palette and you learn the limitations. It gives you a boundary; a limitation that you have to learn to deal with while making good work that takes advantage of the given palette. With digital, it can be anything and for students that may actually present too many options. Understand that I have nothing against digital. Most of the photography I do for myself is with a digital camera. All the prints I've been showing for the past ten years are digital C prints. All of our students learn digital. But as a teaching tool I think there's something to be said for, at least to some degree, mastering black and white and color film first.

MB: YOU STILL TEACH VIEW CAMERA AS A REQUIRED CLASS. MANY SCHOOLS, INCLUDING MINE, DON'T DO THAT. WHY IS VIEW CAMERA IMPORTANT IN THIS DIGITAL AGE?

SS: I'm convinced that it is the single most important class that's taught here because it is the class that causes the greatest evolutionary jump in students. Even if they never go back to the view camera, it doesn't matter. Taking the view camera class is the big change because it forces them to confront the decisions they make as a photographer, and they can't hedge it. It's not like when you're holding the camera and if you breathe, the frame changes. You either put the camera here or you put the camera there. Which do I want? Both are equally valid. What do I want the picture to be? That's something interesting to confront. And if you were to interview a student before they took view camera and ask them if they were framing their work consciously, they would say yes. After taking the Photographic Seeing class they would say they saw a big change, that they really were conscious. But if you were to interview them four months later after the view camera class, they would say I thought I was consciously framing my work, but now I see that I wasn't. It takes them to a new level.

MB: IN ADDITION TO THE VIEW CAMERA, WHAT ARE THE ESSENTIAL CLASSES, TECHNIQUES, OR THEORIES THAT YOU THINK AN EDUCATED PHOTOGRAPHY STUDENT SHOULD LEARN?

SS: I know this doesn't sound very aesthetically sophisticated, but I think cameras make a big difference because cameras change the vocabulary. Everyone used to come in with an SLR. Now they come in with a DSLR. But we have a large collection of cameras, so when they take color, they always study with a medium format camera or a 4 x 5. We have enough medium- and large-format cameras to give every sophomore, junior, and senior their own camera for the entire semester. That makes a difference. I also believe that all students should study photo history. Our students take both a survey history of photography class and at least one advanced history of photography class either from Laurie Dahlberg or Luc Sante, who isn't strictly a historian but has his own take and teaches a class a year that he's interested in. Our advanced history courses change every semester so some students who are interested in the history of photography will take a different history of photography class every semester.

MB: COLLEGE IS SO EXPENSIVE TODAY, PARTICULARLY AT PRIVATE SCHOOLS LIKE BARD. WHY SHOULD SOMEONE STUDY PHOTOGRAPHY AT THAT PRICE?

SS: The answer here, at least, is that they are not just studying photography. That may not be the answer at a fine art school, but here students get a strong liberal arts education. You asked earlier about essential courses. Here, that might be a class in human rights. We have a great human rights program at Bard. So maybe taking another human rights class or two is better than taking a second photography class. Photography's role in a liberal arts college is not just to produce photo majors. It's to teach a visual language and to see with conscious attention. But I always feel a little funny promoting college as someone who doesn't have a college education.

MB: DID YOU GO TO COLLEGE AT ALL?

SS: No. I dropped out of high school in my senior year when I began photographing at Warhol's Factory.

Renowned photographer **STEPHEN SHORE**, the Director of the Photography Program at Bard College, has been teaching there since 1982. His work has been widely published and exhibited, including at the Museum of Modern Art, New York City; Hammer Museum, Los Angeles, CA; Jeu de Paume, Paris, France; and the Art Institute of Chicago, IL. At age twenty-three, he was the first living photographer since Alfred Stieglitz to have a one-man show at the Metropolitan Museum of Art in New York. He has received fellowships from the Guggenheim Foundation and the National Endowment for the Arts. His series of exhibitions at Light Gallery in New York in the early 1970s sparked new interest in color photography and in the use of the view camera for documentary work. Shore's work has been published in several monographs and he wrote *The Nature of Photographs*, published by Phaidon Press, which addresses how a photograph functions visually. It has been translated into six languages. His work is represented by 303 Gallery, New York, and Sprüth Magers, London and Berlin.

Steven Skopik

Professor and Chair, Media Arts, Sciences, and Studies
Ithaca College, Ithaca, New York, United States

www.stevenskopik.com

Photographers have always known that photographs are only versions of the truth; now everyone knows it too.

ON TEACHING PHOTOGRAPHY

Students today often come in thinking they know more than they do because digital cameras make it so easy for them to make a technically adequate photograph. I spend a lot of my beginning level classes in a tactful, diplomatic way getting students to understand that they need to take two steps backwards and reconsider what they know. So I'm slowing them down and asking them to look at the photographs they took prior to the course with a more critical eye.

Our experience in the world is mediated by images and the extent to which you understand this positions you to be an informed, critically thinking citizen.

ON THE VALUE OF STUDYING PHOTOGRAPHY

First, the goal of a college education in general is to learn to think about thinking. We all understand that the vast majority of photography graduates will not become professional photographers. But photographs are so pervasive in our culture that a visual arts education has real value. Our experience in the world is mediated by images and the extent to which you understand this positions you to be an informed, critically thinking citizen. In a photography program, we're educating both image makers and audiences for those images. As someone who makes photographs, I want people who can receive images in a thoughtful, meaningful, and analytical way.

Although there is an institutionally pragmatic sense in which photography has to be a major, because that's how colleges and universities gauge the economic success of a program, photography makes a lot of sense as a minor, or as an element of a interdisciplinary or cross-disciplinary point of study because understanding photographs is an element of basic literacy these days. I don't just mean understanding how to read a single photograph, but understanding how images work with other images and other modes of communication. We almost never encounter that idealized, lone, perfectly autonomous photograph that was often the focus of photographic education, so that idealization of the pristine image is less relevant and pervasive today. Today images are surrounded by other images, or text, or as a lead-in to a video, so teaching students context and an understanding of how that changes the meaning or the ways that ideas circulate through the culture is an urgent educational task, and for the students, a professional skill that they have to have.

ON THE IMPACT OF DIGITAL TECHNOLOGY IN PHOTO EDUCATION

We're in a messy, complicated, unsettled moment. Much of the discussion in the past ten years has focused around the transition to digital. I used to think it was a bigger deal than it's turning out to be. I'm increasingly persuaded by the fact that photography is not so

much a technology as it is an idea that the culture has about itself—a representational need we have. The actual technology we use is less important than what we do with it. The big thing with digital is how it begins to erode the reporting or truth-telling function of photography. I'm persuaded by Max Kozloff's idea about the photograph not as objective document but as witness. Photographers have always known that photographs are only versions of the truth; now everyone knows it too.

We eliminated analog completely from our introductory level class a few years ago and made it an upper-level elective with great trepidation because we were concerned that the ease of digital would encourage sloppy image making. If I can burn through seventy pictures in five minutes without having to think about much, is that thoughtful, careful image making? I believe that there is value to creating a space

This image was taken by Steven Skopik's student to answer the prompt to produce a beautiful image from something considered ordinary or even ugly.

Image courtesy of Jeremy Coman

for students to be slow and deliberate about making images. I recently taught a basic black and white analog darkroom photo class offered as a junior level elective and I was worried about the course evaluations, because in the class there were literally tears of frustration from people who have done mostly digital. The course evaluations were surprising. Even those whose comments ran along the lines of, "I never want to set foot in an analog darkroom again," conceded that learning analog was "really helpful to my image making."

> We almost never encounter that idealized, lone, perfectly autonomous photograph that was often the focus of photographic education, so that idealization of the pristine image is less relevant and pervasive today.

I also had a recent experience with a student taking a portrait of me for a school publication. She shot seventy images of me in a couple of minutes and when I asked her if she wanted to look at them, she said she'd do that later. I realized that this was about process. Maybe the thoughtful, critical moment of looking was not when she was *taking* the pictures, but when she was *editing* them. She would get to the same place, but using a method I wouldn't use or encourage my students to do. I realized this may be the time for people like me to recognize that digital technology shifts the moment of careful attention to a different place in the process.

ON WHY PHOTOGRAPHY

I may be old-fashioned in the sense that my attraction to photography has to do with using it as a way of thinking about being in the world. It represents the familiar as something a little bit strange but still recognizable. Photographs are always inhabited by this oddness because they are cut off from time. They have a built-in melancholy and lyrical feel that forces me to slow down and think about my experience in the world. Photography is a way to organize experience and structure how one thinks about the world, while simultaneously recognizing that there's no structure to the world. It's an impossible task to make sense of the dichotomy, yet we do it anyway. We don't have any other choice.

ON A CRITIQUE METHOD

I have some basic rules of the critique game. The student who is presenting always wants to declare the meaning of the photograph, so I require them to just listen first. Since I'm teaching undergraduates, I try to get away from simple intentions of like or dislike. I am interested in drawing out the thought process behind valuing work, getting people to understand the context in which they're making work and how context is an element of evaluating its success or failure. The task of a photojournalist is different than that of the photo artist exploring some arcane avenue of art philosophy, and whether they're succeeding or coming up short is based on your knowledge of the cultural conversation in which they participate. We have to think about that, take one step back and be aware of ourselves being aware. That's what it means to be a human being and from that realization comes many other implications: intellectual, ethical, and political. If I can think about myself thinking, I can think about you thinking. That is the point of a critique: being aware of ourselves being aware of these images, which is different than simply being aware of the images. That's the crux of what I try to do in a critique.

STEVEN SKOPIK is a photographer, author, and educator. His work has been exhibited in numerous solo and group exhibitions throughout the U.S. His articles, essays, and reviews on photography have appeared in such publications as *Exposure, Afterimage,* and *History of Photography.* He has been awarded an Artist's Fellowship from the New York Foundation for the Arts, and has twice been a recipient of a photographer's grant from Light Work in Syracuse, New York. He holds a BA from the University of Delaware, a MFA from the Rhode Island School of Design and a MA from the University of Wisconsin, Madison.

Amy Stein

Photographer and Educator

www.amystein.com

To make really engaging work, students need to understand the relationship between photography and something else.

ON WHY STUDENTS SHOULD STUDY PHOTOGRAPHY

If you hope to become a good photographer, I believe you need to have a deep understanding of materials and processes, have a strong sense of the historical and contemporary context of your work, be informed about how your work will live in the world, be able to defend your work and intelligently critique the work of others, and have access to the wisdom of people who have failed and succeeded down the same path you are taking. It has never been easier to access this information and create these relationships outside of a formal educational setting, and some people have the capacity to make it work, but an undergrad arts education is still the most effective way to learn these lessons in concert and maintain the ascetic focus necessary to be a better photographer. I'm not saying an arts education will make you a great photographer, but if the school includes a curriculum that values the five priorities I mentioned above and continues to evolve its own understanding of those priorities, formal study will teach you the discipline and practice that can push you towards greatness.

The technical elements of photography can be learned in a year, to the point of being competent. To make really engaging work, students need to understand the relationship between photography and something else. With a few notable exceptions, the best work is not solely about photography; it's about the human experience and how we live in the world. I'm a true believer in a fine arts education but I feel it's best applied when it's complemented by the study of something else. Philosophy, politics, history, economics, and anthropology are fine examples, as are a myriad of other subjects.

ON TEACHING PHOTOGRAPHY

As a teacher of photography, I recognize my role is to excite interest in photography, inspire students to have their own point of view, and to train them in the discipline necessary to carry on in their post-academic life. You would think students in a photography program would be brimming with a love and curiosity for all things photographic and throw themselves into the process of forging their own vision, but that is usually not the case. Many beginning students have a preconceived idea about photography and what it means to be a photographer that isn't far removed from the layperson on the street. I hope that I can excite their passion for photography so they will pursue their own vision and make work that is truly unique and meaningful. I also taught seniors and their needs and concerns are radically different than first-year students. I feel a true kinship with these students. I know their challenges well. While they're often the most challenging to teach, they are the most rewarding. My job is to prepare them to function the best they can during those first difficult years after graduation. Besides strategies for simply getting out of bed, getting themselves to the "studio," which may also be in their bedroom, and making work, I'm a big believer in teaching the approach that one's own work is rarely enough to sustain long-term, deep engagement with photography.

ON TEACHING VIDEO

I am a photographer, not a video artist. I enjoy video and I think all students benefit from a multi-discipline approach, but I'm constantly puzzled why video and photography get lumped together. Both utilize a lens-based medium to make art, but that's where the similarities end.

Because their processes and materials are quite different, occasionally it feels awkward to have both video and still photographers in a critique class. However mixing these two approaches raises the awareness of all students to the possibilities and constraints of the other medium. This awareness will hopefully strengthen their own work and their broader engagement with all lens-based arts.

ON THE UBIQUITY OF PHOTOGRAPHY

One of the more interesting aspects of the ubiquity of photography conversation is how often it's happened in the history of photography. From the Brownie to the Polaroid to disposable cameras to the advent of digital, each innovation in the consumer camera market has been met by debate about the proliferation of photos and what it means for photo artists. In my mind, the conversation is inextricably linked to the struggle for artistic legitimacy that has been present in the photo world since the Photo-Secessionists and the self-doubt that all photographers carry with them because of it. We, more than anyone, seem to be constantly spelling the end of our medium as a means of artistic expression.

In viewing the ubiquity of photographs through the "threat lens," much of the conversation misses the bigger and more exciting transformation that is happening. Despite the accelerating proliferation of imagery, many photographers are making images as they always have. They understand that their art is something entirely different from the

> We, more than anyone, seem to be constantly spelling the end of our medium as a means of artistic expression.

legion of online snaps and Facebook "selfies." There's been intense discussion about how the democratization of photography is eroding the power of the image as special, primary, and unique. But most artists I know still feel that their work has these qualities and feel no direct threat from the online explosion of imagery. Some use film and analog cameras. Some have embraced digital cameras and other technologies, but generally most artists have continued to focus on their own means and language of expression.

Another group of artists has chosen to embrace our changing relationship with images and the role the Internet is playing in this transformation. Artists like Penelope Umbrico, Mischa Henner, and Doug Rickard obtain images from online sources such as Flickr, Craigslist, and Google Maps. They recontextualize public and corporate imagery to create art that challenges our relationship to vernacular imagery.

In an artist's talk at Parsons last year, Mishka Henner, whose work is sourced from Google Maps, stated that he felt no need to make images when such a wealth of material is available online. His comment was addressed to a room full of faculty and students who are heavily invested in the process of making images. His visit sparked debate among the students and challenged the notion of what photography should and can be. I personally find Henner's work to be some of the most provocative and intelligent art being made today precisely because it challenges my own ideas about making photographs.

ON THE LOVE OF PHOTOGRAPHY

Initially my reaction to photography was like that of music: an instant jolt of recognition followed by an intense engagement and emotional response. The most important early images for me were of the American hostages coming home from Iran. These images showed the former hostages stepping off the plane while their waiting families ran across the tarmac. Perhaps those images had such an impact on me because they were the first photographs I ever really "saw." They struck me as very important: politically and personally and as documents. Over thirty years have passed since I first saw those images, during which time I've probably looked at millions of photographs. I've been moved by many, but I can't remember having that intense feeling since. It would be nice to think that I may again.

I grew up around photography, but not around image makers. My mother was the director of the U.S. State Department's photo library, so I grew up around stacks and stacks of black and white press photos. These photos were sent all around the world for the purposes of education and propaganda. These early experiences taught me to appreciate images as objects, but more importantly to recognize that their true content and purpose isn't always readily apparent.

I lost my job as a dot-com executive in 2002, and within a month I knew I wanted to become a photographer. While there hasn't been a day that hasn't been challenging, photography has been the best thing that ever happened to me. While I make a fraction of what I used to in the tech world and work harder than I ever did when I had a day job, I feel a strong sense of gratitude that I'm able to spend my days thinking about and making photography and sharing my love of it with others.

AMY STEIN is a photographer and educator based in Los Angeles. Prior to moving to Los Angeles, she taught for several years at Parsons The New School for Design and the School of Visual Arts, both in New York City. Her work explores how people today are increasingly isolated from community, culture, and the environment. She has been exhibited nationally and internationally and her work is featured in many private and public collections such as the Philadelphia Museum of Art; the Museum of Contemporary Photography, Chicago, IL; the Nevada Museum of Art, Reno, NV; the Nerman Museum of Contemporary Art, Overland Park, KS; and the George Eastman House Photography Collection, Rochester, NY. Her first book, *Domesticated*, released in fall 2008, won the best book award at the 2008 New York Photo Festival. Her second book, *Tall Poppy Syndrome* (Decode Books), a collaborative project with Stacy Mehrfar, was published in 2012. She holds a BSc in Political Science from James Madison University and an MSc in Political Science from the University of Edinburgh in Scotland. In 2006, Amy received her MFA in photography from the School of Visual Arts in New York. She is represented by ClampArt in New York and the Robert Koch Gallery in San Francisco.

Terry Towery

Associate Professor, Photography
Lehman College, City University of New York,
New York, New York, United States

www.timedia.com

Students should drive the needs of education, not technology.

ON THE VALUE OF TEACHING PHOTOGRAPHY TODAY

I think that's like asking what the value of teaching writing is. Writing is a language that you can use to be a poet, a journalist, or you can write copy for aspirin bottles. Photography is a language and your use of the language is what is important and why you study photography. I am not sure we can teach creativity, but we can absolutely nurture it by creating environments that encourage it. The goal of an art school education is to learn how to be creative and our job as educators is to spark a passion for lifelong learning and lifetime creativity.

ON THE CHALLENGES THAT PHOTO EDUCATION FACES

The challenge is staying current with digital technology because the complexity of the software has grown exponentially. We used to be able to teach a new software package in three months max and then make interesting things with the tool. Now, with the "Adobefication" of photography education we're constantly chasing every new feature that Adobe adds to its software and students need to spend the whole year just learning the software. Students rarely make anything interesting with the tools; instead they just learn software. I don't think photo education should be that way. Students should drive the needs of education, not technology.

This image was produced by Terry Towery's student in response to an assignment in which students explored various ways to make a self-portrait.
Image courtesy of Carmen Casado

ON WHETHER VIDEO SHOULD BE TAUGHT IN A PHOTO PROGRAM

Maybe I am a traditionalist, but I think that photography is a still subject. Just because DSLR cameras have digital video capabilities these days doesn't mean that photography programs should refocus their goals. I don't think still photography programs should pretend to be film programs. Motion is a totally different skill set. If an artist needs to use video, by all means, let's help them learn it, but to make a general statement that every art student should use video is absurd to me. What I see is that photo students are generally not integrating camera motion into their videos; they're basically treating video like still photography where the activity moves in front of the camera. Photo programs think they should be adding video because everyone else is. If students want to be videographers, they should go to film school.

TERRY TOWERY's teaching experience is broad and ranges from community-based programs, to community colleges, to private art schools. Currently he is a full-time tenured associate professor at Lehman College CUNY and a part-time associate professor at Parsons The New School for Design in New York. His work, which is experimental and often focused on new uses of alternative processes and digital media, has been widely exhibited in group and solo shows and is included in the permanent collections of the Victoria and Albert Museum in London and the Museum of Modern Art in New York. He has a MFA from the University of Florida where he studied under renowned photographer Jerry Uelsmann.

> Maybe I am a traditionalist, but I think that photography is a still subject. Just because DSLR cameras have digital video capabilities these days doesn't mean that photography programs should refocus their goals.

Conrad Tracy

Course Leader, BA (Hons) Commercial Photography
Faculty of Media and Performance,
Arts University Bournemouth, Bournemouth,
United Kingdom

Photography has earned the right to stand on its own, to be celebrated as its own medium without having to be referential to historical arts practice.

ON WHY STUDENTS SHOULD STUDY PHOTOGRAPHY

Even if we take into account all the different jobs that involve photography—art director, agent, stylist, picture editor, studio manager, production manager, gallerist, theorist, writer, critic, subject librarian; all the things that make the creative industries what they are and also those that help us in society—I think the question is: Does the world need another 1,800 graduate photographers?[41] Maybe not, but what it does need is a new wave of really good contemporary photographers who will advance our practice, who will become the avant-garde for a new movement, style, or way of seeing. Without photography education, I'm not sure if that would happen.

ON CHALLENGES IN PHOTOGRAPHIC EDUCATION

Photography in the twenty-first century makes us rethink what photography actually is and what it can be. We have to reconsider what we are producing and what students expect from a photography degree. Ten years ago, students chose a photography degree because they had a real passion for a subject. It was a philosophical journey more than a vocational journey. Now, with digital technology, everyone can

make pretty good images so the medium is far more democratic. This forces us to rethink how we teach photography so that our graduates know they will gain a sensibility above and beyond the amateur with a smart phone. In the U.K., now that students pay 9,000 pounds per year

for a degree course, they have become more consumer-oriented and they want to know that there will be things that they're going to learn that they wouldn't be able to if they weren't on a particular program, so courses have to be distinguished from other courses. In a course like mine, which has always had a commercial focus, we emphasize the importance of looking outward, through bringing in art directors, picture editors, stylists, all the people that you would either work with or be commissioned by. This doesn't dilute the more intellectual debates that we have about photography, but it does frame a different point of reference that other arts-based practice courses may not do, or value in the same way.

Getting students to look outward is a challenge for more fine-art-based programs. So much student fine art work is self-reflective. That can be successful if you are facing your demons. But when you're nineteen, you might not have that many demons to face because you might not have had that left-field or dysfunctional life to respond to within your work. When you're nineteen, you look at the influences around you so we see so many images that look alike. How many more photographs do I have to see from the more fine-art-based degrees with trees shot at night illuminated by the lights of a car, or with a young naked boy or girl looking a little depressed, harshly lit in their bedroom? The work is often so self-absorbed and inward looking, that the only real audience that cares is the originator of the work. Some students just don't get that by looking outwards, it is far more likely they will find far more interesting things to investigate.

I find the debate about photography versus fine art incredibly frustrating.

ON THE SCHISM BETWEEN FINE ART AND COMMERCIAL PHOTOGRAPHY PROGRAMS

I find the debate about photography versus fine art incredibly frustrating. Photography education deserves its place within the canon of arts education. I understand that photography is a new medium, still, and that some feel they have to justify the discipline through the historical weight of what has gone before. Is that immaturity because the discipline is young? Or is it that those who only know the world of education populate much of this world? And if they come from a liberal arts background, and they've been through an art school—which traditionally is a fine art background—then they've made work for a gallery exhibition and they've ended up teaching, often in the institute that they studied at. That obviously influences the way that students are taught. I've always thought that any course is only as good as the staff who teach on it. When you've got a team of staff who are all originally from the same program, you're going to get a situation with limited dialogue, and more likely monologues. In my course, although most of us have done our masters and exhibited work, we've also all been working photographers at a reasonably high level nationally. We understand the breadth of photography and have an expanded view of what photography is or potentially can be.

I find it strange that this conversation continues in America, because America was among the first countries to embrace photography as photography and not because it did some stuff that maybe painters had done before. It's reductive for photographers to feel that their work is only fully justified through its validation as fine art. Photography has earned the right to stand on its own, to be celebrated as its own medium without having to be referential to historical arts practice. Part of the problem is that we as a photographic community are asking the right questions to the wrong people. Why do we ask the art community to justify what we do? How many photographic art superstars are there worldwide? Maybe fifty to seventy? How many successful commercial photographers are there across the world? Thousands.

ON ONLINE EDUCATION

It works really well for some programs, like the model seen on the photography program at Coventry University.[42] Elements of online education should probably be included in all contemporary curriculum design, but I don't think it should be the main driver. For example, we are investigating how to embed more online methods into our courses, but we want it to enhance delivery, not become it.

I think the hybrid method at play within Coventry University is probably something that can be learned from. For some students a course with a free point of entry is fantastic, but the idea of how we as individuals interact with our students in a classroom is a key benefit of education. Adding online possibilities is secondary. Education is still stronger when students have actual contact with their tutors. I know that there is a trend to add social media to classes, but I think we're still at the stage where so much of what happens on social media is just noise; the content is limited and sometimes quite vacuous. I am not on Twitter, for example, and some colleagues tell me I am a Luddite. I'm not. I'm just not particularly interested in that dialogue at this moment and I don't necessarily want my students distracted with its content either. This doesn't mean it doesn't work well for others, or that a format such as Twitter won't be used within my teaching practice, it's just I think that there is a little too much surface and not enough depth of content if there is an over-reliance on one hundred and forty characters.

> It's reductive for photographers to feel that their work is only fully justified through its validation as fine art.

A student-centered approach will always be at the center of a successful teaching philosophy. You need to leave your ego out of the classroom and actually listen to your students. My job is to guide, help, and support them, but not in a passive way. You have to provide advice and constructive criticism to your students, providing not only what they want, but also what they need. That balance is the best way to teach.

My teaching has also changed with experience. I'm gentler than I was when I first started teaching; I say the same things but in a very different way. My people skills with young students are better than they used to be. I like to think I'm firm, but fair. Perhaps that's the father in me?

CONRAD TRACY is an active photo educator and editorial photographer. As Course Leader, Conrad has developed one of the most successful photography degrees in the U.K. He has been an active member of the Association for Photography in Higher Education (APHE), and is presently chair of the organization. Prior to his role at the Arts University Bournemouth, Tracy taught at several universities including Portsmouth University and University College of the Arts. He has also maintained an active professional life with a client list that includes the *Observer Magazine* and the *Saturday* and *Sunday Times Magazines*. Tracy's photographic work is represented by Getty. He has also exhibited in various group exhibitions in venues in Derby, Leicester, and London, and he continues to make documentary portraiture today. He is currently working on a long-term personal project, which sees him return to his interest in politics, class, and football culture through a portrait of a group of supporters who embody an alternative philosophy to that of mainstream football: the supporters of FC Sankt Pauli in Hamburg Germany. He has a BA (Hons) in Photography from Staffordshire University and a MA in Visual Communication from the University of Central England.

You need to leave your ego out of the classroom and actually listen to your students.

Type A: Adam Ames (AA) and Andrew Bordwin (AB)

Adjunct faculty
Parsons The New School for Design,
New York, New York, United States

www.typea.us

Photography doesn't do many things, but anything involving description it does very well.

ON CHANGES IN PHOTOGRAPHIC EDUCATION OR PHOTOGRAPHY STUDENTS

AB: Today's students are digital natives; they may be the first totally wired generation. The barrage of images that they encounter almost forces them to establish a value system, in terms of their work. So they assign a value scale to images that they not only encounter, but also that they create for themselves. They see a split between their art, their serious personal work, and everything else, including Instagram, Facebook, and anything online. We see more of them shooting film for their serious work, and just last semester we heard several heartfelt and cogent descriptions of how film is a shift in process that physically slows them down. For example, one student described himself as having a slutty finger when he shot digitally, meaning that he basically shot indiscriminately until he discovered film, which helped him shift how he approached shooting. These students are different than those who grew up with film, because we don't necessarily change the way we shoot based on whether we're shooting digital or film. But for someone who's a digital native, shooting film has a medicating effect and changes their response to the image and the value of the process. It's a way of dealing with this overwhelming tsunami of digital images that they encounter, make, and see.

ON CHALLENGES THAT PHOTOGRAPHIC EDUCATION FACES

AA: For photography education, the challenge is the photography programs and I would start by just getting rid of them as separate programs and making them part of larger art or multimedia programs. When you're talking about art, commerce, or commercial photography, you have to know more than just how to take a picture. At this point, if you're doing commercial photography, you need to know how to do commercial video or motion work as well. If you are an art photographer with a capital P, chances are you're going to have some

> For photography education, the challenge is the photography programs and I would start by just getting rid of them as separate programs and making them part of larger art or multimedia programs.

other kind of work in there as well. It's always rubbed me the wrong way when photography sets itself apart and distances itself from other media. I've always wanted to mix those things up and get people out of the protective bubble of photography.

AB: I always quote Joe Strummer[43] on this one ... he always said, "Output requires input," which basically means that if you're going to make work you have to feed your mind. That's not going to come from staying inside one department. It should only be a place you go to once you've figured out how you're going to integrate all that you want to say into some kind of visual statement that is well formed and compelling.

ON TEACHING CONTEMPORARY ART THEORY IN AN UNDERGRADUATE PROGRAM

AA: We should teach contemporary photographic art theory, and I usually start with Susan Sontag just to get a foot in the door, but I also bring new examples of photographers who are breaking new ground. In many ways I approach my undergraduate class, to a certain extent, as if it's a graduate class. Now I don't have any proof that this helps prepare them to be better photographers. I just think it's important.

AB: I think there's every reason to teach theory. You have to trust kids, you have to trust that the knowledge is getting through and it's contributing towards their education. Sontag is always assigned but I think there are other books to read. One book that I used this year is Fred Ritchin's book *After Photography*. Fred is a really great writer and he's saying a lot of things that are really up-to-date, specifically about the role of the image in 2013. It's really digestible and contemporary. When students read Sontag they're reading about a world that was written about before we were kids. As valuable as the ideas are, it does feel antiquated to them so I think it's important to introduce something that is much more of their time.

ON THE DEBATE ABOUT TEACHING "ARTISTS" OR "PHOTOGRAPHERS"

AB: The guiding principle at Parsons these days is that students should think of themselves as artists first and not photographers. I for one welcome it because ideas don't exist within a small box. Ideas exist on their own and they ask to be approached, tackled, and wrestled on their own terms, regardless of medium. If the way that photography functions is something that is central to your aesthetic and your working method then you're going to be a photographer. But I think that in order to form a wider community it's valuable to think of yourself as an artist. I just think it's an expansion of how you view the creative process, one that doesn't, first and foremost, bow down to the medium but actually just bows down to the act of making art and that shared conversation that's been going on in the world for so long.

ON WHAT DISTINGUISHES PHOTOGRAPHY

AA: I am going to be incredibly contradictory and hypocritical because on one hand, I think photography is stagnant, and yet I'm consistently drawn to it. Photography doesn't do many things, but anything involving description it does very well. If you want to create an image, and create a response in the person who sees it, then photography is very well suited for that. It's not necessarily well suited for telling a full story, being truthful, or any of those things. Also, I just get turned on by the aesthetics of it. I like the gear. I like talking about it. It's in my blood. I like the way things look when they're photographed. I like photographing things. I like what you can do with the tools. No matter how hard I try to quit, I keep going back to it. It's a cruel mistress.

AB: Initially when I was twelve I used to tell myself and everyone around me that the reason why I did this was because I thought the expression of language was a biological need, and that photography was a way of getting this expressed that other things couldn't accomplish. Again, like Adam said, it can do some things well and others not so well. One of the things it does well is offer up a completely blank slate for you to map yourself onto. It's just a series of triggers that elicit a response. The fact that it has the façade of veracity, that it has some connection to reality, or that description of reality, allows the person making it to have tremendous control over what's being done. You can make images that you can say are real, fake, or truthful. You have all those different ways of manipulating the trigger that you're putting up. You hope that people respond to it.

ADAM AMES AND ANDREW BORDWIN, working under the *nom de guerre* Type A, employ a variety of media to explore the ways in which humans compete, challenge, and play and the resulting social and psychological imbalance. Their conceptual collaborative work has been widely collected and exhibited in the U.S. and Europe. Both also maintain robust individual practices. Ames holds a BA in Communications from the University of Pennsylvania, and a MFA in Photography and Related Media from the School of Visual Arts. Bordwin holds a BA in Classical Civilization and a BFA in Photography from New York University.

Penelope Umbrico

Core faculty
The School of Visual Arts, New York,
New York, United States

www.penelopeumbrico.net

Trying to define photography is like trying to see air.

ON WHY STUDENTS SHOULD STUDY PHOTOGRAPHY

Studying anything gives you a kind of understanding that connects you to the history of it, and that can help you develop a language with it. I'm not sure you need to spend four years at an institution to be able to make a good photograph, but if your interest is photography obviously studying it will help you develop and have some confidence in what you want to say with it. The challenge for photography educators is getting students to understand that, sure, you can take a photograph, a good photograph even, but what are you trying to say about the world around you? If you don't have anything to say, that's fine, but you're not adding anything to the discussion, and in the context of a challenging program, you're missing out on the conversation. The good thing about a four-year program is that you learn how to say what you want to say—that is, if you have something to say.

ON THE DEFINITION OF PHOTOGRAPHY IN THE TWENTY-FIRST CENTURY

Trying to define photography is like trying to see air. It's everywhere, and of course there's so many different kinds of photography. Any definition hinges on what kind we're talking about. I think it's interesting that if I were a painter, you might ask me what kind of painting do I do? But you would know I don't house paint, or sign paint. You would assume I paint on canvases or at the very least make objects of art. We don't make those kinds of distinctions for most of photography.

In our lifetime it's always been a common medium for the most part. We are all photographers the way we are all writers. Photography has been part of my life since I was six when someone gave me a camera. I wasn't called a photographer just because I took a photograph, but I was called an "artist" when I drew something.

ON VIDEO, MULTIMEDIA, AND INTERDISCIPLINARY STUDY

Video, multimedia, digital media, are all part of a contemporary visual practice and if it's taught well, students will understand when a specific medium works best for what they're trying to say. In my own practice

> I would advocate for an approach that recognizes screen-based work to have a very specific kind of materiality, and that it belongs in a contemporary photography program along with everything else.

my work is defined a lot by context and use—how images are used and shared, and in the context of web-based platforms, the screen is as much a material object as a photographic print is. But we're not trained to think of the screen that way. Perhaps the problem in some photo programs is that it's hard to let go of the material object of a printed photograph. I'm not saying that we should, or that anything could replace it. I would advocate for an approach that recognizes screen-based work to have a very specific kind of materiality, and that it belongs in a contemporary photography program along with everything

else. I don't think this is radical. The entire history of photography is filled with drastic shifts caused by new technologies. Imagine the existential unease when we understood that the image made by camera obscura could be fixed and therefore severed from the body that made it. Perhaps digital images create an equal unease in how they can be infinitely reproduced, and can be anywhere simultaneously

ON A TEACHING PHILOSOPHY

Students are coming into an art program, so we assume they have a connection to the visual world. I try to help them develop that by figuring out where they are coming from, what their influences are, what interests them in terms of visual thinking. I encourage them to develop a critical relationship to photography that questions all the assumptions they came into the program with. And because the technological tools of photography are changing faster than we can speak, I think it's really important for them to have a good ground to stand on when it comes to the conceptual and theoretical aspects. Though you can't really separate the two, it's more important than ever for students to understand the socio-cultural relevance of what they are doing, and how it fits into a bigger picture.

So the undergraduate class I've consistently taught deconstructs photography to help students understand it as a conceptual tool as much as a formal or technical tool. It's mostly based on discussion and critique, with weekly assignments that forge a relationship to theory that is relevant and useful to their studio practice. I hope they come away with an understanding of how photography engages, or is engaged by, larger issues such as authorship, originality, truth, fiction, memory, archives, performance, surveillance, and so on. The funny thing about this class is that every year it changes. Sometimes the changes are based on new cultural ideas that suddenly seem very important, sometimes because the medium has changed and suddenly a previous way of doing something makes no sense. So for example, one exercise used to have the students go to the New York Public Library picture collection. Now, they do web image searches. But for an exercise on archives, I insist they use the library. It becomes a completely different exercise than it was, say, ten years ago, because they know they could find some images in five to ten minutes using the web—the very act of working slowly through the file folders at the library elicits a different response than it did ten years ago.

PENELOPE UMBRICO is an award-winning artist whose work is a radical reinterpretation of everyday consumer and vernacular images that she sources from consumer media, including print catalogs, Craigslist, eBay, and Flickr. Her work has been extensively exhibited nationally and internationally in both solo and group shows and is held in numerous public collections, including the Guggenheim Museum in New York City; the Museum of Modern Art in New York; the Museum of Contemporary Art in Chicago, IL; the San Francisco Museum of Modern Art, CA; the Tampa Museum of Art, FL; and the Metropolitan Museum of Art in New York. She has been awarded prestigious grants including a Smithsonian Artist Research Fellowship, a Guggenheim Fellowship, a New York Foundation for the Arts Fellowship, and an Aaron Siskind Foundation Individual Photographer's Fellowship Grant. In 2011, Aperture published her first monograph, *Penelope Umbrico (photographs)*. In addition to her post at SVA, where she has been teaching for more than fifteen years, she was the chair of MFA Photography at the Milton Avery Graduate School of the Arts, Bard College, Annandale-on-Hudson, NY. She has also held faculty appointments at the Rhode Island School of Design, Providence, RI; Parsons The New School for Design, New York; Harvard University, Cambridge, MA; Cooper Union, New York; Sarah Lawrence College, Bronxville, NY; Columbia University, New York; and the International Center for Photography, New York. She holds an undergraduate degree in Art from the Ontario College of Art and Design, Toronto, ON, and a MFA from New York's School of Visual Arts.

Wang Chuan

Vice Dean, School of Design and Professor, Photography
Central Academy for Fine Arts, Beijing, China

en.cafa.com.cn/wang-chuan.html

Digital cameras only make photography easy to use, not easy to understand.

ON WHETHER "COMPUTATIONAL PHOTOGRAPHY" AND DIGITAL POSTPRODUCTION SOFTWARE RENDER IMAGES COMPUTED, NOT TAKEN, AND HOW PHOTOGRAPHY EDUCATION SHOULD RESPOND

First we need to define what we mean by "photography" and "photograph." If we mean in a broad sense both traditional and digital images, then I would say that the role of postproduction software is the same as the traditional darkroom. We don't question if traditional pictures are "darkroomed," so should we question whether photographs are Photoshopped? I am quite interested in the difference between "digital photography" and "computational photography" because I think that absolutely the person behind the camera controls the image, not the camera, and it doesn't matter if it is a digital camera. The subjectivity of photography is absolute while the objectivity is relative. The reason is, once we use the camera, even with a release cable, we can't get rid of our subjectivity and how that impacts the photograph.

ON WHY STUDENTS SHOULD STUDY PHOTOGRAPHY

I think actually it's about the definition of "profession" in the new digital age. When technology allows everyone to take a photograph, it could put the masses on the same level as the professional photographer, but education will still allow us to revise and refresh the meaning of photography, and it will differentiate the professional because education provides a visual literacy that the masses don't have. Here in China it still means something for someone to be well trained and our school, CAFA, has acquired a reputation for teaching photography.

ON TEACHING PHOTOGRAPHY

A problem with the popularization of photography is the shift in thinking about identity, property, and the standard of photography in the age of the Internet. Digital cameras only make photography easy to use, not easy to understand. Students need to study photography to help them understand photographic visual language. We are not just teaching technique; we are teaching attitude, methodology, and

> We as educators deeply influence how our students think and that's why again and again we push the students to have more experience outside of photography to fertilize their photographic practice.

providing a shared experience. Our other role is to teach students to differentiate their images because today everyone can take a picture. I think the most important thing is to foster the sense and attitude and the full understanding of the diversity and complexity of the media and today that includes still image, video, and sound, and both analog and digital processes like video and HDR photography, because it's the basic knowledge needed. It's all part of the chain of image formation whether that starts as film and ends up digital or it's all digital. We as educators deeply influence how our students think and that's why again and again we push the students to have more experience

This image, from a series titled Salt, was part of a collaborative project that Wang Chaun gives his advanced students. Here Yang Chen worked with a graphic design student to investigate rumors of a pending salt shortage following an earthquake. They used the traditional Chinese custom of a spring couplet, but replaced all the Chinese characters of good will in the spring couplets with the Chinese character that means salt.

Image courtesy of Yang Chen

This image was taken as part of a collaborative project that Wang Chaun gives his advanced students. It shows the beginning stages of the project where student Leng Wen worked with a jewelry designer. Rather than simply photograph the jewelry, Wen created a series as if she were on an archeological dig by using pieces of old newspaper headlines, documents, travel tickets and then creating a story by shooting and reshooting, editing, and post-production to create the feeling of the past, as if the unearthed artifacts included the jewelry.

Image courtesy of Leng Wen

outside of photography to fertilize their photographic practice. This can't be the sole responsibility of photographic education, but it doesn't mean we shouldn't do it.

ON HOW TEACHING PHOTOGRAPHY HAS CHANGED

Digital technology has changed the content of what we teach, and it has changed how we teach: we can evaluate, view, share, and critique images immediately—right after we press a button. It's hard to say whether it is good or not. But digital is just technology. We are still teaching *photography* and here that includes film. In fact, CAFA is the

> Digital technology is quite interesting. On the one hand, it has popularized photography. On the other, it has made photography abstract.

only school that can provide students with the option to make color prints in the darkroom. A lot of students from Southeast Asia want to be here to experience the color print because they've only heard of it. They've never seen it. We struggled for years to keep this, because we think it's important, even as it got more and more difficult. Kodak stopped supplying chemicals, so we moved to Fuji once they opened a factory in China. But we suffer technically because our prints are high-contrast from certain environmental issues, including our water. But we still keep it because we think the history of photography is something important. We want our students to be able to go through the two-hundred-year-old history of photography and that includes film and the other processes, before they jump to digital. We want students to be able to use a light meter and understand all of the techniques. Although most people enjoy how easily they can work with digital cameras, if they don't understand how cameras work in general, or how to control exposure, any little problem or mistake in the work process will kill them. Digital technology is quite interesting. On the one hand, it has popularized photography. On the other, it has made photography abstract. With our fundamental courses we do analog and digital at the same time because we want to establish a link between the two, between the past and the present.

ON CHINESE PHOTOGRAPHY

Photography has interacted with our culture almost as long as it has with Europe. The Empress and officers of the Ch'ing dynasty had already enjoyed having their photographs made. The problem here is that by 1949 photography was controlled by the government and became more of a tool for propaganda. The 1970s was the beginning of what we called New Photography in China when our best photographers began using it for personal expression and to make political statements. The new generation doesn't have the same interest in politics, maybe because they are more interested in technology and in their own life and for them that life is about the self, not the commons. As a department we have tried to help students develop a sense of social responsibility and also to view their own experience from a common social perspective.

WANG CHUAN, who has been teaching photography at the Central Academy for Fine Arts (CAFA) in Beijing for nearly thirty years, has had extensive exhibitions of his work in China, the U.S., Italy, the U.K., and Australia. He is a member of the Pekin Fine Arts Gallery in Beijing, founded in 2003 as the first art gallery in China dedicated to photography. As a former book designer and illustrator, Wang Chuan approaches photography more as a constructed narrative than as a decisive moment. His work has incorporated photomontage to illustrate the desires of China's emerging middle class, set against the destructive element of modernization and loss of nature. Most recently, his work has experimented with various means of integrating enlarged pixels into an image, and considering the inherent beauty of the pixel, rather than dismissing it as an artifact of technology. He holds a BA in Book Design from CAFA and a MA in Visual Art from CAFA and Griffith University in South East Queensland, Australia.

John Willis

Professor, Photography
Marlboro College, Marlboro, Vermont, United States

jwillis.net

[T]he most fundamental criteria for teaching is a love of education ... at the point where students have finished with their formal education, they ought to have the excitement and knowledge needed so that they can and will continue to produce a work of evolving purposes.

ON WHY PHOTOGRAPHY IS SPECIAL

Photography is an art form, but it's also a way to explore the world, to see how we fit into the world, and to communicate that to others through aesthetically interesting images. I always try to balance the aesthetic and social and political implications of an image, which means I straddle the modernist and postmodernist worlds. I love the idea that an image can evoke so many different responses about the world around us, and that one image because of the relationship of things in the image, the moment it was taken, the light and the form, can be both metaphorical and literal. I also love the opportunities that being a photographer has given me. I've been invited into situations just because I have a camera. To me, that can be really magical. And there are times, in all honesty, when the camera gives me the confidence and the willingness to ask people whom I don't know if we might sit down and have a conversation, and share an experience or something.

ON A TEACHING PHILOSOPHY OR STYLE

I am open to different kinds of work, partly because I appreciate different styles, but also because I'm the only regular photo professor at Marlboro. I don't want students to do the kind of work that I do. I'm trying to help them figure out what they're drawn to and then find out how to communicate that. I stress from day one that I want my students to find out what they're passionate about because that's what they should be photographing, even if the passion isn't positive. You can be angry or frustrated about something, but that's still a passion. Sometimes—probably a lot of times—the best work comes out of people who don't feel like they have something that they want to preach to the rest of us. What they have is something they're really curious about, and they want to spend time with it, and it seems important to them.

My goal is to help the students figure out what they want to do with their work, not to tell them what work is the best.

ON TEACHING PHOTOGRAPHY IN A VISUALLY SATURATED WORLD

It's very exciting and challenging. It's easy to make and distribute photographs today, but it's also potentially easy to get bored. It used to be that you could go out and be somewhere that hadn't been photographed, and you could see nice single moments and make nice images, and they'd be very dynamic and profound. Today in so many places you'll see a crowd of people with digital cameras and telephones all making pictures. Students question what they are doing that really makes it worth spending the time, energy, money, and natural resources to make images. Why not just talk or write about experiences? Or look at other people's images that are already made? The teaching challenge is answering that question. Even before this proliferation of images, I told students that I'm not a big believer in originality in art. I just think that if we really do the research, we find other people in the past who have done similar stuff. But I also tell my students that if they work hard enough at any project, if they really understand it, and if they make strong in-depth work about it, their images will be different because we come to our subject matter with different life experiences.

ON CRITIQUE METHODS

My approach varies depending on the group dynamic. My goal is to help the students figure out what they want to do with their work, not to tell them what work is the best. I don't think I ever talk first and I don't let students explain the work first. They can only say something about the image that the class needs to know before we talk about it. I encourage advanced students to put up an artist statement. I try to get everybody in the class communicating about the work. I always tell students that, because they can learn more when listening to other work being critiqued because they don't have the ego and vested interested in what is being said as they do when it's their work.

ON THE VALUE OF A PHOTOGRAPHIC EDUCATION

Cost is a real issue today. The parents I talk to are concerned with how much debt their child might accumulate and I respect that. I believe in the value of a liberal arts education because what we teach is creativity, critical thinking, and problem solving. Major corporations and small innovative companies want people who are strong critical thinkers, who know how to teach themselves new skills, who have self-confidence, and who know the value of hard work. That comes from a good liberal arts education.

I agree with many of the critical arguments that postmodernism really starts to bring up: the knowledge that we really can't be objective, are not objective beings: we are not going to capture the world objectively: we're not going to present the world objectively.

ON WHETHER TECHNIQUE SHOULD BE TAUGHT ON PHOTO PROGRAMS

I'm being somewhat facetious when I say this, but today we probably could learn everything technical through textbooks and the Internet, so I don't know if teaching it matters to the same degree that it did in the past; but yes, students still need to learn technique. But they don't all need to learn the same thing. For example, I will teach the zone system to students who have interest; I don't teach it to everyone because you don't need it if you're working exclusively digitally. Basically, I want my students to understand that all these techniques and types of cameras just create possibilities.

I've taught at art schools, and it's a wonderful environment with wonderful energy, and all kinds of great things, and there is room for classes on technique like lighting or color, but I tend to think in the long run, it's good to learn more about life, and just general things you might make art about, instead of just learning about art all the time.

Education in this country is just absurdly expensive so I try to create opportunities outside the classroom for experiential learning, community engagement, and internships. These opportunities will help students learn what they can do, what their possibilities are, and will give them lines on their resume that will stand out differently than if they just get a degree in photography.

ON MODERNISM VERSUS POSTMODERNISM

I agree with many of the critical arguments that postmodernism really starts to bring up: the knowledge that we really can't be objective, are not objective beings: we are not going to capture the world objectively: we're not going to present the world objectively. As someone always interested in the political and social implications of an image, I'm thrilled to hear these conversations, and that awareness. At the same time, part of what drew me to photography was that it was a tool that got me out of my head, and out of the house, and into the world relating to others. I feel like people have taken the postmodern critical arguments so seriously that they are afraid to relate to each other sometimes.

JOHN WILLIS, an award-winning fine art documentary photographer, has been teaching and doing collaborative service in community-based settings since he was a graduate student in 1984. Today as the sole photography professor at Marlboro College in Vermont, Willis continues his engagement with teaching. He co-founded and remains involved with the In-Sight Photography Project (www. insight-photography.org/insight) that offers free classes to anyone between the ages of eleven and eighteen in Southern Vermont, to provide a way for teenagers to engage constructively with their communities. Willis is a Guggenheim Fellow and a recipient of several Vermont Arts Council grants. His work has been exhibited nationally and is featured in national and international public collections including the Tokyo Metropolitan Museum of Contemporary Art, Japan; the Bibliotheque Nationale de France in Paris, France; and the National Gallery of Art in Washington, D.C. In his images, Willis often explores issues of place, community, and history. Created primarily in black and white, and more recently in color, his work ranges from traditional documentary and portraiture, in images taken on the Pine Ridge reservation in South Dakota, to constructed and manipulated composite images produced from the Emperor's Palace and Tuol Sleng, a former torture and execution prison run by the Khmer Rouge and now a genocide museum in Phnom Penh, Cambodia. He holds a MFA in Photography from the Rhode Island School of Design.

Jonathan Worth

Senior Lecturer, Photography
Department of Media and Communication, Coventry
University, Coventry, United Kingdom

#phonar #picbod
www.jonathanworth.com

My role as an educator today has shifted from being this font of knowledge to being a curator and contextualizer who leverages social media technologies to extend learning beyond my knowledge base.

ON #PHONAR AND #PICBOD

Photography and Narrative (#phonar) and Picturing the Body (#picbod) are two classes at Coventry University that I created to understand new models for sustaining a twenty-first-century photography practice. Degree students at Coventry attend the on-site classes, but they also are open to anyone, anywhere on virtually every social media platform that currently exists: Twitter, Vimeo, SoundCloud, YouTube, App.net and Google+. A Wordpress blog functions as the class hub, aggregating the other social media environments, through links and blog posts. Our class RSS feed hosts my audio recorded lectures and interviews I conduct with notable professionals, special discussions, and class assignments. Online students do not receive a grade or credit, but they participate by adding #phonar or #picbod at the end of a tweet or tagging images. Coventry students share notes with real and virtual classmates with the same hash tags. In 2010, #picbod attracted 10,000 visitors from 1,832 cities in 107 countries,[44] and I launched the first free class application for the iPhone, #picbod.

ON MOOCS (MASSIVE OPEN ONLINE COURSES) AND OTHER FORMS OF ONLINE EDUCATION FOR THE TWENTY-FIRST CENTURY

I am always asked to talk about MOOCs, which is ironic, because I don't teach a MOOC. My Picturing the Body (#picbod) and Photography and Narrative (#phonar) courses are normal classes within a closed undergraduate degree, which I opened to anyone on the Internet. The degree students in my classroom get a very different experience from the people who tune in online. One of the criticisms leveled against industrial-scale distance learning, which is what MOOCs are, is that it is like an old broadcast model: there is no dialogue. What I do is very different; it is all about dialogue. The students tweet their questions or comments and if you're in the classroom or watching with us in real time, you will see those tweets, and participate in a real-time global conversation. I also store the tweets, so we get this global set of notes, which just get better and better as the week goes on and more people tune in.

My role as an educator today has shifted from being this font of knowledge to being a curator and contextualizer who leverages social media technologies to extend learning beyond my knowledge base. I draw on my professional network, interview "experts," edit my interviews into something watchable, and then I post them to watch together in class, or at anytime for those following us online. I also arrange a little window where the lecturers might come on and answer some questions at a cost to the online "student" of twenty GBP for twenty minutes, so for instance I've got a cluster of single mums from the north of England who can't afford to go to college, and they're getting one-on-one tutorials with award-winning photographers for twenty pounds. That's awesome, I think.

Another criticism of MOOCs in general is that people say that you can't ensure quality or know if students are learning or even if it's their work. I just totally think this is an outlook from the last century. When I have 35,000 people looking at my students' work, that is 35,000 opportunities for my students. We had a second-year student who ended up with a book edited and published by a Hong-Kong-based art director because he was following one of the classes and liked the

work. I now get people who come to the class to find distributed talent, such as Benjamin Chesterton, who is the director of Duck Rabbit Multimedia. He likes that he can look for class members (people in this "conversation" and with these skills sets) throughout the world.

ON THE VALUE OF STUDYING PHOTOGRAPHY IN THE TWENTY-FIRST CENTURY

When I meet with prospective students and their parents, I reframe the conversation around photography to one around visual fluency. I show them how transferable those skills are, and in our highly visual culture how essential they are becoming. We might look at Andreas Gursky's photo "Rhein II," which sold for $4.3 million in 2011 and I'd say that I'd expect a graduating student of mine to at least be conversant in notions of provenance and taste, because I'd expect them to be leveraging those same dynamics in their own work. I'd also expect them to understand why wedding photography is some of the most valuable photography that we'll ever inherit. Then I might show a CCTV image, or a phone image from "x" zone of civil unrest, or a staged photo-op from "x" war zone, and ask which if any are believable—I'd expect my students to know what questions to ask at that point. Visual literacy isn't just about reading the images; it's about understanding them too. Visual fluency isn't just about being able to speak a visual language; it's about being heard amid all of the noise and being believed.

Studying photography helps us not be fettered by old ideas and language. As Marshall McLuhan said, we always describe new media in terms of old media and so I think that's a real problem for photographers. Today photography is as much about ones and zeros as it is the artifact of the photograph. The artifact is fixed in time and it looks backwards, it has a provenance, but the digital image is unhitched from time and space and it looks out. It connects you to people. Artifacts and images are wildly different and students need to understand why. I go to universities as an external examiner and they say they teach digital photography. I ask what environments do they teach that in, and what do they mean by digital practice, and they usually list all the technical processes they teach and types of cameras they have. The problem with that is that it is just teaching how, but not why. That's just educating students to be suppliers. That is a losing strategy because someone somewhere is always going to supply it cheaper. If you're teaching digital practice, then you need to teach about the difference between the image and the artifact and how to leverage those environments. If students aren't being engaged in that dialogue, then they are ill equipped to deal with the contemporary world of the photograph and the image.

ON THE CHALLENGES FACING PHOTO EDUCATORS IN THE TWENTY-FIRST CENTURY

The challenge facing photographic education is to actually redefine the medium and not continue to frame it with old metaphors. If we really want to change the world then we need to start by describing it differently. We are currently going through the second paradigm shift for photography as the digital image breaks away from the artifact. The first one occurred when photography broke away from painting, a period we associate with people like the f/64 group.

Conversations such as those around whether photography is dead or not are tragicomic examples of this sort of "description-failure," when we think there are currently, what, 100 billion images on Facebook alone? With more images made in the last year than last century, how can the medium be dead? David (www.david-campbell.org) describes these people as mixing up the mode of information with the mode of delivery. In other words, they're talking about the deaths of last century's business models not the practice. The medium is thriving as never before.

> When I meet with prospective students and their parents, I reframe the conversation around photography to one around visual fluency. I show them how transferable those skills are, and in our highly visual culture how essential they are becoming.

ON ESSENTIAL SKILLS TO TEACH

We need to be artisans for sure but we need to be credible and connected witnesses, editors, and suppliers too. We need to understand

and be proficient with all of our tools in both analog and digital environments. That means we must learn code. We need to be able to use a camera manually, just as we need to get under the skin of a program beyond the old Photoshop darkroom metaphors. It's not so different from the first time we agitate the developer trays and see images appear from the chaos. Coding is like that. When you get down to the ones and zeros, sense emerges from the digital chaos. In fact, I can't think of anything more important with regard to the age of the image that we are currently entering. Learning code not only enables us to author our images more richly, but we can also comprehend and unpack the information embedded within other people's images. That leads to credibility and connectivity leads to being heard. So I guess the two essential skills to teach are the camera and code. Not sure about the order.

JONATHAN WORTH is a British portrait photographer and educator. His accolades include being named one of *PDN*'s "30 under 30" in 2000; as a commercial photographer, his client list included *The New York Times, Vogue*, and Universal Music. Today he is an educator and consultant who focuses on developing innovative business models and modes of working for photographers and for online education through his Picturing the Body #picbod (www.picbod.covmedia. co.uk) and Photography and Narrative #phonar (www. phonar.covmedia.co.uk) classes at Coventry University in the United Kingdom, which have been featured in *Wired* magazine.[45] In recognition of this work, in 2009 he was named a Fellow in the Royal Society for the encouragement of Arts, Manufactures, and Commerce (RSA) and made a National Teaching Fellow in 2013.

Today photography is as much about ones and zeros as it is the artifact of the photograph. The artifact is fixed in time and it looks backwards, it has a provenance, but the digital image is unhitched from time and space and it looks out.

NOTES

1 6 + is an art collective that invites women artists from different cultural backgrounds to work together. www.6plus.org/mission.html [accessed 8-31-13].

2 http://www.pacifica.org/ [accessed 8-18-31].

3 "Gombrich believes art is made by means of a trial-and-error process of schema and corrections: "Making comes before matching." Artists do not "match" reality first; they start out ... by constructing ... schema which are gradually modified ... until they "match" the impression that is desired." Juliet Graver Istrabadi, "Ernst Gombrich," in *Key Writers on Art: The Twentieth Century,* ed. Chris Murray (London: Routledge Key Guides, 2003), pp. 137–8.

4 Defined generally as an emerging new field created by the convergence of computer graphics, computer vision, and photography where its role is to overcome the limitations of the traditional camera by using computational techniques to produce a richer, more vivid, perhaps more perceptually meaningful representation of our visual world. http://en.wikipedia.org/wiki/Computational_photography [accessed 8-12-13].

5 Roger Ballen is an American-born photographer who has been living in South Africa since 1970. http://www.gagosian.com/artists/roger-ballen [accessed 7-28-13].

6 Les Rencontres d'Arles is an annual world-famous photo festival held each July in Arles, France. http://www.rencontres-arles.com/A11/Home [accessed 08-02-13].

7 Steven Benson produced a photo essay in 1999 travelling the 400 miles of the Yangtze River valley, documenting the way life was before the building of the dam destroyed cities, towns, and villages when the reservoir filled in 2003.

8 British English for flashlight.

9 http://www.theglobalmail.org/ [accessed 08-31-13].

10 "Is Photography Over? "was a two-day symposium on the current state of photography held in April 2010 by the San Francisco Museum of Fine Art. It featured an esteemed panel that included, among others, Vince Aletti, Trevor Paglin, Charlotte Cotton, Philip-Lorca diCorcia, and Peter Galessi. http://www.sfmoma.org/about/research_projects/research_projects_photography_over [accessed 8-15-13].

11 *Heart of Darkness* is an iconic novel by Joseph Conrad about a river steamboat transporting ivory down the Congo River in Central Africa. It addresses themes of savagery, civilization, colonialism, imperialism, and racism. en.wikipedia.org/wiki/Heart_of_Darkness [accessed 6-21-13].

12 Erasmus, established in 1987, is the European Union's flagship "mobility" program in education, with more than two million students from across Europe participating in its study abroad programs. http://ec.europa.eu/education/lifelong-learning-programme/erasmus_en.htm [accessed 9-9-13].

13 www.zonezero.com/zz/index.php?option=com_content&view=article&id=953%3Aa-reformation-of-the-arts&catid=1%3Apedro-meyers-editorial&lang=en [accessed 08-13-13].

14 Rule by the media: a situation in which media dominates or controls the populace. en.wiktionary.org/wiki/mediacracy [accessed 8-8-13].

15 Charles A. Traub, Steven Heller, and Adam B. Bell, eds., *The Education of a Photographer* (New York: Allworth Press, 2006) pp. 133–9.

16 Bill Gaskins, *Good and Bad Hair* (New Jersey: Rutgers University Press, 1997).

17 Digital Storytelling is an emerging term for a variety of emergent new forms of digital narratives (web-based stories, interactive stories, hypertexts, fan art/fiction, and narrative computer games). It also comes from a grassroots movement that uses new digital tools to help ordinary people tell their own "true stories" in a compelling and emotionally engaging form. These stories usually take the form of a relatively short story (less than eight minutes) and can involve interactivity.

18 $60,000 is an average annual cost of tuition, room and board, and equipment at elite private art and design schools.

19 http://www.ninakatchadourian.com/index.php [accessed 6-23-13].

20 Member of the Most Excellent Order of the British Empire, one of five classes of orders of chivalry established in 1917 by King George V.

21 Author Arthur Ou posits that photography is at "unprecedented historical threshold" because the use of digital cameras and digital postproduction software renders images more computed than taken. www.aperture.org/magazine-2013/photo-edu-toward-a-new-curriculum-by-arthur-ou/ [accessed 06-03-13].

22 Eugène Atget, who died in Paris in 1927, is widely regarded as a pioneer of documentary photography and best known for black and white street scenes of Paris. http://www.moma.org/collection/artist.php?artist_id=229 [accessed 7-7-13].

23 Approximately 12,000 USD.

24 www.byronwolfe.com [accessed 09-02-13].

25 Rephotography refers to the act of repeat photography of the same location, taken years apart. Mark Klett is one of the most well known for rephotography work for his Rephotographic Survey Project, began in 1977,

which focused on precise rephotographs of key locations in the American West taken one hundred years after the original photograph. He partnered with Byron Wolfe for a rephotography project in Yosemite and the Grand Canyon.

26 Byron G. Wolfe, *Everyday: A Yearlong Photo Diary* (San Francisco: Chronicle Books, 2007).

27 http://www.brainyquote.com/quotes/quotes/a/anseladams141288.html [accessed 09-10-13].

28 Computer-generated imagery (CGI) is most commonly used to create 3D computer graphics for special effects in film and video. In a photographic context it is used for rendering still images that combine objects and scenery that exist as computer data with photographic images creating the illusion that the whole scene has been photographed and existed in the physical world. Some imagery plays on this and the makers don't try to hide this "new reality," other imagery is used to pretend. These technologies and concepts are used in advertising, have also been widely used for pop videos for years, but are equally applicable in fine art photography where maybe previously techniques like mere photo manipulation were applied.

29 http://en.wikipedia.org/wiki/I_Am_Sitting_in_a_Room [accessed 7-15-13].

30 The Third View Project builds off of Mark Klett's Rephotographic Survey Project of the 1970s, a collaborative project resulting in a contemporary survey of the American Western landscape.

31 Jacques-Henri Lartigue, Le Grand Prix A. C. F. http://creatsik.dyndns.org/Site_Dictionnaire/GeneratedItems/Pages/Page.php?value2=472 [accessed 8-30-13].

32 Lartigue, Cousin "Bichonnade" in Flight. http://www.hlphotogallery.com/artists/jacques-henri-lartigue/cousin-bichonade-flight-portfolio-jacques-henri-lartigue [accessed 08-30-13].

33 Lartigue, Woman with Fox Fur. http://www.hlphotogallery.com/artists/jacques-henri-lartigue/woman-fox-fur-avenue-des-acacias-portfolio-jacques-henri-lartigue [accessed 08-30-13].

34 Map. 1) A representation, usually on a flat surface, as of the features of an area of the earth or portion of the heavens, showing them in their respective forms, sizes, and relationships according to some convention of representation; 2) A map-like delineation, representation, or reflection of anything.

35 Persons was asked to evaluate the programs at the University of Art and Design in Helsinki, now a division of Aalto University, formed in 2010 as a merger between the Helsinki School of Economics, Helsinki University of Technology, and the University of Art and Design Helsinki.

36 Gallery Taik was established in 1995 in Helsinki as the primary gallery for students from the Helsinki School. It opened its first permanent exhibition space in Berlin in 2003.

37 The Helsinki school "represents an approach, a way of thinking that has evolved out of a process of teaching art at the Aalto University School of Arts, Design and Architecture. http://www.helsinkischool.fi/helsinkischool/index.php?k=8350 [accessed 08-16-13].

38 Bullet time, or time slice, is a special visual effect that refers to a digitally enhanced simulation of variable-speed photography, such as slow motion or time lapse. It is characterized by its extreme transformation of time and space, slowing it down to reveal imperceptible events such as flying bullets.

39 Stephen Shore, *The Nature of Photographs* (New York: Phaidon Press, 2007).

40 Ecole cantonale d'art de Lausanne (ECAL) is a leading art and design university in Renens, Switzerland. www.ecal.ch [accessed 6-21-13].

41 The phrase "1800 graduate photographers" is anecdotal and does not represent a verified statistic.

42 Coventry University is well known for #picbod and #phonar, two hybrid classes that mix traditional on-site education with an online course open to anyone anywhere. See the interview with Jonathan Worth.

43 Joe Strummer, who died in 2002, was a British musician who was the co-founder, lyricist, rhythm guitarist and lead vocalist of the British punk rock band The Clash. http://www.jim-jarmusch.net/miscellanea/author_jim_jarmusch/appraisals/joe_strummer.html [accessed 07-28-13].

44 The site attracted 35,000 unique visitors to the Wordpress site in one ten-week term, far more than numerous other online environments.

45 http://www.wired.com/rawfile/2011/08/free-online-class-shakes-up-photo-education/ [accessed 7-1-13].

CHAPTER TWO
ASSIGNMENTS
CONFIDENTIAL:
EDUCATORS
SHARE

THESE DAYS, photography students don't *need* a formal classroom to learn aesthetics and technique because technical information is available online. A simple Google search of the phrase "photography tutorial" yields sixty-nine million results. The value of a formal photographic education lies in its ability to teach students aesthetics, how to deconstruct an image and to critically and skeptically evaluate a photograph. A photography education teaches students to make images by understanding where to point the camera, how to order visual chaos, and what to include and exclude. To make great photographs, students also need proficiency in other skill sets, including how to rigorously observe a scene; how to translate 4D and 3D into 2D with clarity; how to understand visual aesthetics, such as space, line, form, tonality, color wheels, and palettes, and the photographic aesthetics of perspective, time, vantage point, and light, etc. A good photography education delivers those skill sets. The challenge for educators is how do we guide photography students who are not the most malleable? In fact they are usually just the opposite. They are highly skeptical, stubborn, challenging, and autonomous; they seldom follow instructions and seem intent on doing it their way. Of course that's also what makes them so much fun to teach.

Anyone who has ever stood in front of a classroom of photography students knows that one of the most difficult things we do is design or create an inspiring project or assignment that is open-ended enough to allow for almost infinite interpretation, but structured enough to deliver specific skills or concepts and interesting or unique enough to engage them. The seventy plus assignments in this chapter generously shared by my colleagues do all of that. The assignments are imaginative, complicated, and multidimensional. They range from being skills-based to teaching critique and photo interpretation. Because they are open-ended enough to allow many interpretations, they also can be altered, adapted, combined, and expanded to fit any year level and in a way that will invigorate any syllabus. Some are presented as given to students, others as described by the faculty and interpreted by me with comments from me or the faculty. They have all been edited for continuity.

However, because of the complexity, it was impossible to create simple thematic categories. Even the seemingly obvious assignments titled *Self-Portrait* were so much more than the title suggests. Intent on imposing some order, I created a taxonomy and labeled each assignment with relevant subcategories. The taxonomy, the categories, and the odd interpretations are entirely my own. They were not reviewed or endorsed by the faculty who provided the assignments, and to whom I apologize in advance when they may read this book and think, "Why did she put *that* label on my assignment?"

A few of the images illustrating these assignments were produced by the students in the actual classes, but most of them were created by current photography students (and their friends) from Parsons The New School for Design, the Fashion Institute of Technology, and the Gallatin School of Individualized Study at New York University, all in New York City, and the Arts University Bournemouth in Bournemouth, United Kingdom. The students selected the assignments and took time from their summer breaks to interpret them as written, and then some wrote a short text about their experience.

Beginning B

Intermediate I

Advanced A

Categories

Composition CP

Conceptual C

Constructed Reality CR

Critique CQ

Curating CT

Digital Imaging DI

Documentary D

Editing ED

Editorial E

Fashion F

Fine Art FA

Group G

Landscape L

Lighting LT

Narrative N

Performance PF

Photo History PH

Portraiture P

Reportage R

Self Portraiture SP

Still Life SL

Video V

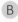

Thirty-Six Strangers

Faculty: Arno Minkkinen
University of Massachusetts in Lowell

AS PRESENTED TO THE STUDENT
▼

Shoot thirty-six exposures, to be printed as a contact sheet, as if each frame were your last and only frame. Ask strangers if you can take their picture with the stipulation that only one image will be taken. Shoot thirty-six three-quarter-length portraits of thirty-six strangers in two hours.

STUDENT RESPONSE
▼

The purpose of this assignment was to shoot one roll of film with thrity-six three-quarter-length portraits of complete strangers in a time span of two hours as if each frame was my last. I asked complete strangers in Williamsburg, Brooklyn if I could take their picture with the stipulation that only one image would be taken and this was the result. As a photographer, I mostly shoot in intimate settings, usually people, places, and things that I am deeply connected with. The idea of going out to ask total strangers to take their picture was an experience that definitely took me out of my comfort zone. The series ended up as portraits of mostly young hipsters and locals closely resembling that of a street-style fashion spread. The assignment was a bit challenging technically because of how quickly each photo-graph had to be taken, and the fact that only one photograph of each stranger could be taken so there are several of these that I took out of focus unintentionally.

LAUREN TAUBENFELD
PARSONS THE NEW SCHOOL FOR DESIGN, NYC

Images courtesy of Lauren Taubenfeld

Archive Assignment

Faculty: Penelope Umbrico
The School of Visual Arts

AS PRESENTED TO THE STUDENT

Make a list of words relative to the subject of your project. Using your words as search terms, search the following three places, in the following order.

1. The New York Public Library picture collection. You may need to translate some of your words if there aren't folders for them. Borrow the images from the library and bring them to class (you can scan them before you return them).

2. Google Image Search. Pull the images (or make screen-grabs) into a digital folder and label it "Google Image Search."

3. An image-sharing website (such as Flickr), or stock photo website (such as Getty Images, Shutterstock)—use only one site. Pull the images (or make screen-grabs) into a digital folder and label it with the name of the site.

You'll have three archives of images (one material folder and two digital folders). Bring all of them to class.

Some questions to consider:

› *Are there any similarities in all the images in overall color?*

› *Are there any similarities in all the images in overall composition?*

› *Are there any similarities or differences in overall color among the different sources?*

› *Are there any similarities or differences in overall composition among the different sources?*

› *Is there a variation in the type of image you found overall?*

› *Is there a variation in the type of image you found between the sources?*

› *Do these similarities or differences tell you something about your subject?*

› *Is there a difference between the sources in terms of how useful they are to your work?*

› *Is there a difference between the sources in terms of what they can tell you about your subject?*

› *Is there a difference between the sources in terms of how you felt searching?*

› *Is there a difference between sources in terms of what you were able to newly discover?*

The Art of Political Discourse

Faculty: Susan Kae Grant
Texas Woman's University

AS PRESENTED TO THE STUDENT

▼

Each student is required to complete a project combining photography and sculpture to create installation style pieces inspired by the theme, "Public Discourse, Cultural Icons, and Civic Engagement: The Art of Political Issues." To create this project, each student will work within the dimensions of a glass display case, three pedestals, or a freestanding floor space of 5 x 5 x 2 feet. Each project must combine both 2D and 3D elements and utilize any photographic process to create a series of three sculptures or an installation with three sculptural elements. Each project must also contain a minimum of five photographic images and utilize at least three sculptural elements. The projects must demonstrate original and advanced experimental techniques that illustrate the content. In addition, each student is required to turn in a typed goals sheet, and during the "show-and-tell" review present a one-minute research presentation on an inspirational photographer and/or theorist related to the chosen theme or technical process.

The Artist Statement

Faculty: Barbara DeGenevieve
School of the Art Institute of Chicago

AS PRESENTED TO THE STUDENT

Work in pairs. Spend time together and get to know each other because you will write each other's artist statements. You will need to know the other person's work, what kind of research she is doing, and what ideas, issues, philosophy, or theoretical positions are important to her. While you are in school, you will undoubtedly write many artist statements of your own if you have not already. But for this assignment, you will be writing an artist statement for someone else. This process lets you step back and listen to the way another artist interprets your work.

Be a Director

Faculty: Terry Towery
Lehman College, City University of New York

AS PRESENTED TO THE STUDENT
▼

You are the director—take charge. Produce three to four images that are not self-portraits. The objective of this assignment is for you to take complete control of the situation you are photographing. Do not to seek out situations to photograph. Create things or events to photograph. Cropping is not allowed. Since you will have complete control of the situation, it will be easy for you to frame within the camera.

Some suggestions (note that these are guidelines and not requirements):

1. The still life: This is a tradition in art reaching back thousands of years. It is not necessarily a plate of food or a bunch of flowers; almost any controlled situation qualifies as a still life. Lighting is critical—remember to bracket.

2. The narrative: In a narrative you should be conscious of the passage of time that is suggested by the series of images. Consider using friends as actors and do a sequence of photographs that tell a story. Narratives are not always inclusive of people; perhaps extend the still-life tradition into narrative. Remember, the story is only as effective as the way you tell it.

3. Non-narrative sequences: These are groups of images, related conceptually or visually, that do not tell a story. Think of visual poetry or music.

4. Visual jokes or puns: These can be humorous, subtle, sarcastic, or playful. Any humorous situation that is staged falls into this category.

STUDENT RESPONSE
▼

My story is about cleansing oneself and finding happiness. My inspiration came from numerous experiences I had over the summer of 2013 that shaped my perspective and make me think more clearly. Finding true happiness is what everyone strives for, and finding it results in a very colorful world. I have had numerous experiences where I got such colorful vibes from certain people and places; I had to find a way to put that into my work. I wanted to try something more edgy.

I had a blast shooting this story! I worked with a phenomenal hair and makeup artist named Tad Greene, some assistants, and a beautiful model. I shot this photo near a waterfall to show human cleansing, which is relevant to why I even began this assignment. Visually, I wanted this image to look psychedelic. I believe I absolutely achieved what I wanted, and am extremely happy with the results!

MELISSA RENEE (BRODIE)
FASHION INSTITUTE OF TECHNOLOGY, NYC

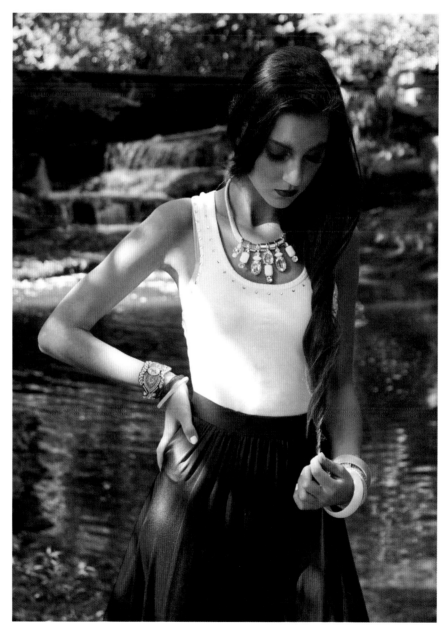

Image courtesy of Melissa Renee Photography

The Big Picture

Colleen Mullins
Photographer and Educator

AS PRESENTED TO THE STUDENT

▼

Shoot twenty-five consecutive images in the camera. These can be film or digital, but if they are digital, the images must still be consecutive. The twenty-five individual images must be printed out as a contact sheet of five rows of five images each that, when printed, form one big picture. You have leeway in how to approach this assignment. It can be meticulously planned and scripted, or it can be shot intuitively, but the grade will be based on the quality and content of the "big picture." Take care in your exposures and watch the angle of light in each frame so that the "big picture," when printed as a contact sheet (digital) or made as a film contact sheet, has the appearance of a single exposure. Try a portrait. How close to subject do you have to be to be successful? Think carefully about the camera's distance to subject and how this affects the scene.

This assignment immediately and concretely teaches students about the challenges of the photographic frame and edges. It teaches what the camera can and cannot do. For example, what is the difference between panning and physically moving the body? How significant are edges of individual frames and point of view? It also presents the possibility of narrative within the context of a single picture. Students are assigned to do two or more, typically, and told that they must take absolutely different tactics in executing them. For example they may choose to do one wide land- or cityscape and one portrait. – **Colleen Mullins**

STUDENT RESPONSE

▼

I expected this assignment to be much easier than it was. I started off doing a portrait without a tripod and very fast, unplanned. It was difficult to line up each shot after shot, which was important to make sure all twenty-five made up one photo. I liked the challenge of it, like I was putting together a puzzle. And it made me really concentrate on how close the camera was to the subject and what lens to use. After realizing that without a tripod it was difficult to make it all come together as one picture, I planned another version using a tripod. However, I used myself as the model, which posed another challenge because I had to get up every time to press the shutter and then make sure I was in the same spot as before. Once again, when put all together not everything lined up. It was fun to try to make one photo out of many and to play with focus and exposure in each individual shot. It was a good exercise.

ELENA MUDD
GALLATIN SCHOOL OF INDIVIDUALIZED STUDIES, NEW YORK UNIVERSITY

Image courtesy of Elena Mudd

A Blind Jury of Contemporary Photography

Faculty: Jim Dow

School of the Museum of Fine Arts and Tufts University

Each student selects and sequences ten images from an artist whose work has been exhibited, published, or completed within the past year. The class as a whole then functions as a blind jury, employing a common judging method: seeing each image for five seconds (or less than a minute for each artist) and then assigning a score of 3, 2, or 1. The "jury" pauses ten seconds between each artist. The scores are tallied and ranked by the cumulative highest scores. After the jury, each student leads the discussion about the artist they selected.

Through this assignment, students confront the fact that they can be intrigued visually by an image when they see it for five seconds because it is a quick read, while other more complex and nuanced images fail completely because they demand a longer viewing. This assignment forces students to confront their own biases, to think critically about how images function and how presentation impacts perception.

Cliché: Unconventional Beauty

Faculty: Steven Skopik
Ithaca College

Image courtesy of Joel Trager

Explain to students that it is a fairly straightforward matter to make an appealing picture of a conventionally beautiful subject. For example, sunsets, stunning landscapes, or cute kid photographs can rely on the built-in positive associations we have towards such things. For this assignment, however, students must attempt to make images of the *ordinary*, even the *ugly*, and use their skills as a photographer to allow the viewer to experience the subjects in a compelling, novel way. Ask students to consider how they might go about transforming what they photograph by using such tools as lighting, framing, composition, depth of field (or lack of it), and shutter speed.

Above all, endeavor to be creative. Take chances and attempt the unexpected! – **Steven Skopik**

assignment continued overleaf →

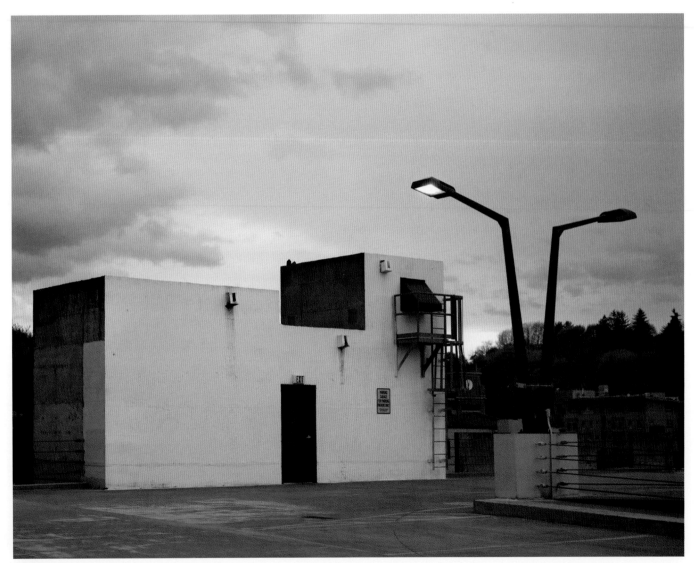

Image courtesy of Daniel Vallencourt

With this assignment I was looking at the idea of unconventional beauty more through the concept of a certain atmosphere or situation rather than a specific object or place. The photographs that I constructed in my mind all contain elements of the everyday monotonous life that is very much associated with unconventional beauty. My aim for these photographs was to represent how, using photography as a tool, the photographer is able to manipulate a scene that is being photographed, whether the situation is staged or "real." By creating and manipulating an atmosphere and mood of light, place, character, and stance in my mind I was able to create photographs that represent an everyday situation, such as sitting on the floor putting a toy together, or taking out the garbage, but change those actions into an idea much more profound: a solitary moment of transformation or self realization that surfaces at any insignificant moment.

SAM GUEST
PARSONS THE NEW SCHOOL FOR DESIGN, NYC

Image courtesy of Sam Guest

Control Your Work

Faculty: Timothy Persons
Aalto University School of Arts, Design and Architecture

The goal of this assignment is to teach students the importance of presentation and controlling their own work. It is presented as a graduate workshop. The students first show their work, including an artist statement that contains their references and influences. When all the work has been presented, the students draw lots to select a colleague's work, which they then must present as their own, based on the written statement and the original arrangement of the work on the wall or in the portfolio.

This workshop always generates the greatest exchange of emotions from both sides of the equation. However, in the end I believe the presenter as well as the presentee both grow from the experience and learn the importance of what a statement should mean and how a portfolio is arranged to achieve the greatest possible effect. Students learn far more from their mistakes than their successes and this exercise enables both students to find new solutions in how to develop and interpret the language of photography through understanding the content of the work at hand. It also presents them with a real example of how important it is to control all the aspects of your portfolio. In other words, would you let your gallerist write your press release? – **Timothy Persons**

Criticism, Interpretation, and Ambiguity

Artist and Educator: Joan Fontcuberta

To illustrate the ambiguity of images, present a photograph to your students, and ask them to write twelve different interpretations.

Some are correct and some are delusional, but the wealth of responses is indicative of photography's equivocating nature. It's like doing a Rorschach test: the projection of our internalized meaning stratifies the ample array of truths. Every photo is a trap set in our consciousness that illustrates the profound epistemological difficulty inherent in the act of seeing. – **Joan Fontcuberta**

Curating: Virtual Exquisite Corpse

Faculty: Sian Bonnell
Falmouth University

This project is a variation of the Surrealist-created Exquisite Corpse technique in which a team of artists works collectively to create a collection of images. The method, which plays on the mystique of "accident," is based on an old parlor word game where a player would write a phrase on a piece of paper, fold the paper to reveal only part of the phrase, and pass it onto the next player for her contribution. Visual artists adapted it for drawing and photography by using images as words, with each participant adding to the visual "sentence" with an image made or selected in response to the previous images. Adapted for the digital age, this virtual Exquisite Corpse relies on a Tumblr blog to post images and responses. Sian Bonnell conceived of using a Tumblr blog in response to a request from graduate students at Central St Martin's College in London, to curate an exhibition of her work. Insurance considerations proved problematic for a traditional exhibition, so Bonnell suggested this virtual Exquisite Corpse project. Students chose one of Bonnell's images as the starting point. Bonnell responded with a new image, followed by student responses, then she responded again until the project ended, ten weeks later. The final project contained more than two hundred images. The Tumblr blog visual "responses" were augmented by conversations via Skype and email. The project culminated in a weekend Master Class where Bonnell and the students met in person to edit and curate a physical exhibition of the blog, which revealed recognizable connections and surprising juxtapositions. The exhibition proved so successful that it was decided they would meet again, continuing the curating experience, but this time to produce a photo book. The end results of this project were three distinct but uniquely different products: the online project, the exhibition, and finally the photo book. This project works well with international students because cultural differences inform the responses and image choices. Students can be based in the same city or participate from different cities or countries.

Image courtesy of Sian Bonnell, Anne Mortensen, Armenoui Kasparian Saraidari, and Fedor Toshchev.

Digital Pinhole

Faculty: Sian Bonnell
Falmouth University

Sian Bonnell assigns students to make a digital pinhole camera because the images have a very soft color reminiscent of early photography. To make a digital pinhole, students can either buy a properly calibrated pinhole online (at pinholesolutions.co.uk) or they can craft one by drilling a quarter-inch hole in a body cap, and then with gaffer's tape attach either a brass shim or some kind of fairly thick foil that has been pricked by a pin to the back of the body cap, which goes on a DSLR camera body.

This project marries the old and new, and it's a great way to show students how photography really works. – **Sian Bonnell**

Edges

Faculty: Jeff Curto
College of DuPage

Assign students to photograph at least twenty different kinds of "edges." Advanced students receive no additional explanation. Beginning students can be given the following prompts: Among many other things, edges can be:

- the edge of an object
- the edge of the frame
- the edge of a cliff
- the edge of a place
- the edge of a moment
- the edge of a season
- the edge of the world.

When Curto first gave this assignment in response to students who asked what to shoot, he was thinking about the edge of the frame, but the student responses were varied and creative so this became a recurring assignment. The open-ended nature allows the students to think in a non-literal manner about the many implications, photographic or otherwise, of the concept of "edge."

STUDENT RESPONSE

As I was in New York, I spent some time looking around the edges of my subway map, as I wanted to find somewhere that had varying degrees of emotional edges and verges, as well as physical edges. I felt as if Coney Island was the end of a subway line and therefore the edge of the city; it would be a great place to use. I went to Coney Island, which has a large fun fair, where people are on the edge of their seats, on the edge of emotion and different feelings, such as anxiety, fear, happiness, and nausea. I decided that instead of photographing the edge of the city (Coney Island beach) I would try and capture an edge of the rides, where people go through these emotions. I was then able to capture the edge of the rides, with people on the edge of emotions, in a place that is at the edge of New York.

KATERINA "KAT" DRURY
ARTS UNIVERSITY BOURNEMOUTH, UNITED KINGDOM

Image courtesy of Katerina Drury

Empowered Portrait

Faculty: Matt Johnston
Coventry University

▼

You should enable an individual to create their own portrait using the skills you have as an able photographer. The subject (and photographer) should think about how they would like to represent themselves and you must support this.

You should not take charge of the photographic conversation but should empower the "subject" to make his or her own pre-visualization and chosen representation a reality. You should not work with someone who has previous photographic experience. Think about how your own thoughts and ideas of a portrait of this subject differ from your partner's.

Ephemeral in Place

Faculty: Sama Alshaibi
University of Arizona

AS PRESENTED TO THE STUDENT

▼

This assignment draws inspiration from the film *Rivers and Tides,* about the artist Andy Goldsworthy. This film foregrounds the way in which art can be a fleeting object, structure, or gesture. Many of Goldsworthy's works are created on site, using materials found in the immediate environment. He often photographs the works and then leaves them behind, so that they often exist for a mere moment before they disintegrate either by the weather or by the environment in some way. For this work you will elect to work in this manner, perhaps in the parks, forests, or gardens of your city, or you could adjust your strategies for the city. Consider also creating an ephemeral work that integrates more urban materials such as the Xerox copy, a performative gesture, sidewalk drawings, or similar. Consider how the materials should/ could be different for this environment. Your ephemeral work should be recorded in the most appropriate form possible such as photographs or video.

Walk One: As a "mode of attention" that guides the walk: en route and at the sites of your choosing, you should walk concentrating on only one sense. At the end of thirty minutes of walking, try to map the MAP (take pictures, sketch, etc.), record sounds, or write a description about them; you can take photographs and record sounds. The conversation about the site—the memory, event, or person—can include descriptions about smells, which are intimately connected to memory. Do this three times, with three different senses, mapping the route.

Walk Two: In *Rivers and Tides,* Goldsworthy pursues a line, his desire to articulate the gesture of the paths and "lines" in the spaces he explores. There are more urban paths of desire, known as "Desire Lines." A desire line is an informal path that pedestrians prefer to take to get from one location to another rather than using a sidewalk or other official route. Desire lines or paths, then, are those well-worn ribbons of dirt that you see cutting across a patch of grass, often with nearby sidewalks—particularly those that offer a less direct route— ignored. In winter, desire lines appear spontaneously as tramped down paths in the snow, seldom perfectly straight. Instead, like a river, they meander this way and that, as if to prove that desire itself isn't linear and (literally, in this case) straightforward. In this exercise, you will explore your environment in search of evidence of desire lines. Map, photograph, video tape, draw, etc. your findings. Observe the surroundings. Can you observe why these "trespassings" happen? You can also interview those who walk/ride on these desire lines. Record your experience in your journal/blog in the form/mapping of your choosing.

assignment continued overleaf →

{Ephemeral in Place ~ assignment continued}

Images courtesy of Rachel Dunlop

STUDENT RESPONSE

I found this project to be the most overwhelming and difficult. For one assignment, I feel as though this project would have to be long term, made up of different steps. I chose to do two separate themes for this project, taking the temporary section of the project and different walks into two separate sets of photos. For the first set, I chose to create a set of photos that showed the wearing away of text at the hand of water on concrete.

To handle the walks, I chose to photograph sand dunes by my home in California. These sand dunes have a no trespassing sign, but are still constantly walked by citizens of my town every day. Throughout this fenced-off area, there are small trails that were created at the hand of citizens, rather than by the sand dunes and area itself. I chose to take both landscape and portrait photos to show the versatility of the area and explain the different walks that I took to explore them.

RACHEL DUNLOP
PARSONS THE NEW SCHOOL FOR DESIGN, NYC

Every Day

Faculty: Mark Klett

Herberger Institute for Design and the Arts
at Arizona State University

Although this is a full semester class, the idea could be adapted by creating a specific duration for the assignment, but still designed to force students to expand their ability to observe and engage the world around them. Most photographers schedule time to photograph and the activity is usually separate from the rest of daily life. The process of making photographs involves coordinating equipment and materials with preparation of thought and action. But what if the camera is always accessible, if the preparation is as simple as reaching inside your pocket for a camera and responding to the moment? Would that change when pictures are made or what we make pictures of? These questions now exist in the realm of practice, not theory.

The goal is to challenge expectations, make sense out of the everyday, and to become aware of what is intangible by transforming experience into awareness. The goal is to rethink the concept of photography, what students choose to photograph and why, and to learn from their work and express this to others. Students must carry a camera with them at all times. Photographs must be made every day, no exceptions. The issues and complications inherent in working everyday will be an important focus. The work involves discipline, a willingness to let go of traditional expectations about the results, an ability to learn from your images, and an open attitude towards your work and the work of your colleagues. This is harder than many students realize, and they must be prepared to invest the effort necessary to sustain their photography over the duration of the assignment. The subject matter for photography every day is wide open. Carrying a camera at all times means that anything encountered may become the subject. The only limits are a student's ability to sort through the world and make photographs of it, the ability to make sense of the results, the limits of the tool itself, and a sense of what is worthy and appropriate to photograph.

Express Yourself

Faculty: Paul Hill

De Montfort University and University of Derby

Photographers are often observers who stalk their quarry. They are outsiders, eager witnesses waiting for that special moment when their expectations have been met. Photographers "take," "capture," "shoot." To encourage students to consider how photography can do more than record the surface reality of things, students are asked to make a series of constructed images in the directorial mode where they become the *victims* rather than the *hunters*. But the images must be *more* than self-portraits; they must express something relevant and important to the student personally, and the final images must communicate that to an audience. The viewer may not get the full story, but they have to be moved, touched, and maybe, irrevocably changed by the work. The images have to resonate with them as well as consciously mirror the intentions of the maker. The images have to communicate aspects of the psychological world of the photographer; for example, their fears, passions, and obsessions, or something recreated from their personal history maybe. The challenge is to make images that *express* those sorts of things, so that the viewer "sees," rather than a photograph of a face, a human figure, or a tree, or whatever is in front of the camera. The object is for the pictures to transcend the informational content— the surface reality.

In constructing these scenarios, the student will learn several skills: how to manipulate lighting, play a role, create environments, and how to release the shutter when they are in front of the camera instead of behind it. With such assignments, things never turn out the way you think they will, so students have to improvise and think on their feet, just like when they do when documenting an event. It's just that the context is different, and they are not outsiders. They are "the event"—and the surface of reality has been penetrated. – **Paul Hill**

assignment continued overleaf →

Keep Her Unnoticed - 17

This image was produced as part of an assignment, Express Yourself, which Paul Hill gives to his graduate students. Maria Falconer had been in an abusive relationship when she was much younger and in this project she 'revisited' that part of her life. Abusive relationships are characterized by fear, violence and low self-esteem and the work uses metaphor to explore some of the issues surrounding domestic violence. Her ex-husband was an alcoholic as well as an abuser, and in this image she wanted to bring those characteristics together and to express photographically what it *felt* like to be a victim.

Image courtesy of Maria Falconer

The Fall of Icarus

This image was produced as part of an assignment, Express Yourself, which Paul Hill gives to his graduate students. When Andy Greaves read that in the United Kingdom older men account for half of all the 6,000 or so suicides each year, with men on low pay or benefits particularly heavily represented, he was shocked and surprised. He himself had reached middle age at this point and was beginning to reflect upon what it was to be a vulnerable male. Men are the 'hunters', the providers and protectors— or so they have frequently been led to believe by their parents and peers. So he wanted his naked body, carefully positioned in a landscape he knew and loved, to express vulnerability and mirror the inner turmoil of the depressed.

Image courtesy of Andy Greaves

Fashion: Constructed Image

Faculty: Heike Löwenstein
University for the Creative Arts

Students are given the following brief: At its most commercially intense, narratives are reduced to a relentless and ubiquitous mass-marketing mirror held up to the consumer. It may (without apology) be a shallow but beautiful pursuit, justified by its own sublime end. Equally, at its most entertaining and inspiring, fashion photography may be pure inspirational narrative and fantastical storytelling. Its theater is writ large upon the pages of venerable fashion journals such as *Vogue*, *Harper's Bazaar,* and more recently, the culturally challenging *Tank, Dazed & Confused*, and *Visionaire*. As a genre, fashion can blur the boundaries of art and sculpture. It envelops portraiture, mimicking and satirizing the secular canons of celebrity. It can speak of the mundane and domestic whilst engaging with the epic and fantastic: regardless, the narrative is a wholly invented artifice, placing and staging the figures into fabricated contexts and environments. Elaborate sets, cohesive styling, sympathetic casting, and

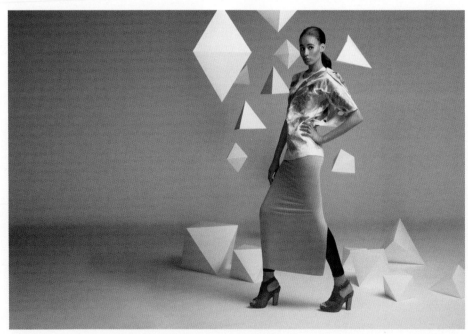

Image courtesty of Agne Bekeraityte, Daniel Paul, Claire Smith, Robert Young

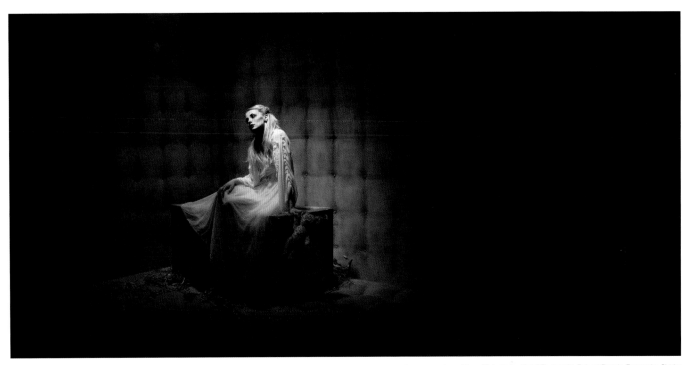

Image courtesy of Leva Gelezinyte, Kamil Raczynski, Robert Roach, Franceska Shirka

evocative lighting designs all help to heighten our emotional responses to the predetermined narratives. Fashion shoots are collaborative offers generated with a range of interrelated art directors, creative artists, set builders, hair and makeup and fashion stylists.

In this project, students work in teams in the UCA Rochester studios to create a series of constructed fashion images, carefully considering how the sequencing can render a particular narrative. By successfully completing this assignment students learn an effective and reflective approach to project management; independently, collaboratively, and as a member of a wider team of sourced talent. Through constructing images, they analyze the nature of photography and increase their understanding of the way in which they and others create and construct meaning using the photographic medium. The project also aims to develop an appreciation of the importance of research, testing, pre-production, and conceptual development prior to a photographic shoot.

Four Corners

Faculty: Arno Minkkinen
University of Massachusetts in Lowell

The inspiration for this assignment comes from Eugene Atget who took many of his street shots in Paris on a slant. This created four different corners immediately.
///////////////////////

AS PRESENTED TO THE STUDENT

Fill a contact sheet with images, each image of which has four different corners. For an example, if the northeast corner of the frame has a cloudy sky, the northwest corner might show the tips of a mountain range in the distance. A deserted farmhouse might anchor the south-west corner and in the southeast, a little girl spinning a hula-hoop. The objective of the assignment is to introduce your eye to the edges of the frame and say goodbye to the center of the image. It also creates an invigorating opportunity for a sense of being there as opposed to selecting merely one thing.

STUDENT RESPONSE

▼

This project brought back the importance of contact sheets. I don't use contact sheets as much anymore because of digital workflow. Now, even when shooting film, it needs to be scanned. Contact sheets are often overlooked or integrated into software like Bridge, Capture, or Lightroom. I rediscovered the contact sheet with this project. It allowed me to slow down and observe the images all together. It becomes obvious when the images don't really work with the others and helps the series become more consistent.

ANDREW WILLIAMS
PARSONS THE NEW SCHOOL FOR DESIGN, NYC

Image courtesy of Andrew Williams

Full Narrative Outcome

Faculty: Andrew Bordwin
Parsons The New School for Design

AS PRESENTED TO THE STUDENT

▼

Write a fully articulated one to two-page narrative involving at least two people and one major turning point in events. Think of this as a scene in a movie or part of a stage drama. Describe the characters in complete detail at the start of your narrative, and fully describe the environment in which the scene is taking place. Describe wardrobe, scenery, background, motivation, outcome, and consequence. You can choose to include conversation or base the scene completely on action. Then create a series of photographs that depict the outcome of this scene, the resolution of all the background that you describe in your narrative. Bring in at least five prints, minimum 8 x 10-inch, of this outcome/scenario, and bring in the printed narrative as well. Remember: the narrative is a device to get you to these final pictures; not every aspect of what you describe in writing need be evident in the pictures. But the pictures cannot have been created without the (largely unseen) details of your narrative. This can be a minor scene, or a major turning point.

This assignment demonstrates to students how the conception of an image does not match the perception of the viewer. When the work is presented, students describe the visual narrative and talk about the narrative triggers, the class responds, and only then does the student read the written narrative. – **Andrew Bordwin**

NARCISO

▼

There once was this young boy who, like any young boy, would get intrigued by the features of his body as he grew; he would look at himself in the mirror to examine them further, discovering his shapes and, through them, the world around him. He looked at every inch that his eye could reach, turning around himself, twisting his arms in all directions, staring intently at the lean, reflective surface for hours on end. So long, so intensely, perhaps, that this particular boy began to enjoy the sight, to admire the looks, and the delicate motion of the light on his skin as he glided seamlessly back and forth, back and forth. He was fascinated, for the first time, by something that emanated from him ever so strangely. It was more delicious than anything he'd ever had, the enticement of such beauty and the power to behold it. After making this inner discovery, the boy couldn't erase it from his mind. He understood its peculiarity, being what made it so precious; thus he decided to embrace it. After all, what could be so dangerous about engaging with oneself in the pleasure of the eyes, in the mere appreciation of innocent beauty? The young boy had come across Narcissus, and fallen under his spell. It was a paradise of pleasure, a kingdom of light, a heavenly feeling of self-completion. He would spend days and nights gliding nude by the mirror-laden walls of his cluttered abode, jumping from one to the other, careful not to blink, not to miss an instant of the spectacle in which the performer and the audience were the same person. He satisfied his sight to the detriment of all his other senses, draining his energies to feed an ever-starving fascination for impalpable superficiality. To the point, eventually, that all other things and people linking the boy to the outer world had lost all their beauty; they reeked with ugliness. He couldn't enjoy anything other than himself—in fact, laying his eyes anywhere else caused him extreme pain; his relations to the world had ended to the benefit of

a relationship with Narcissus, uniquely gifted with the power to take on other people's looks when encountering them. What the boy had realized, after countless destructive hours, was the inaccessibility for himself to attain the object of his desire, which was himself. Paradoxically, he was the owner of it, but he was powerless to change or control it; in fact, it completely mastered him. One day, Narcissus abandoned him, bored of the weakening figure the boy had become from such reckless obsession; he lost all relation and interest towards his life. Slaved by Narcissus, stripped of his innocence and youth, left bare. The man was condemned to live forever depleted, destitute, and ugly, corrupted by the incompatibility of his desires and the inaccessibility of happiness.

AURELIAN NOBECOURT
PARSONS THE NEW SCHOOL FOR DESIGN

Image courtesy of Aurélien Nobécourt

assignment continued overleaf →

Images courtesy of Aurélien Nobécourt

Grab Bag of Words

Faculty: Arno Minkkinen
University of Massachusetts in Lowell

B
I
A
C
FA
G

This is a semester-long assignment that begins with a paper bag filled with twenty single words. A student reaches in and pulls out seven words. Using the words, she formulates a concept and produces three images. The seven words are returned to the bag and passed along to the next student. At the end of the semester all of the work is presented in a group show. The words should change each semester the assignment is given. One word group that Minkkinen has used: church, wishbone, forgiveness, whiskey, perfume, subway, nail file, underpants, gasoline, prairie, desire, revenge, pillow, black, stairway, mercy, hammer, equivocation, tender, and roof.

STUDENT RESPONSE

The idea for this assignment was that I fill a paper bag filled with twenty single words, reach in and pull out seven words. All twenty words were provided and chosen by my professor. Using the words, I was to formulate a concept and produce three images. I was to repeat this same process once more with a separate set of seven words and produce three more images. The two sets of images I produced were based on these words either literally or metaphorically and are up for interpretation.

LAUREN TAUBENFELD
PARSONS THE NEW SCHOOL FOR DESIGN, NYC

To illustrate this assignment Taubenfeld pulled the following seven words: gasoline, black, equivocation, church, mercy, revenge and cold. She produced three images based on concepts derived from those words.

Images courtesy of Lauren Taubenfeld

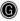

How To Be a Curator

Faculty: Timothy Persons
Aalto University School of Arts, Design and Architecture

This assignment replicates the pop-up exhibition, for which the Helsinki School is well known. Students have to design a specific-sized space based on an idea or theme and then curate an exhibition from the work of a group of eight colleagues, randomly selected. They learn the process of curation: what happens if a work doesn't fit the curator's first idea? How can a curator employ a marginal work as a bridge to bring good ideas together? They learn that sometimes putting two artists together weakens the work of both.

Choices must be made and the art world is no democracy. This exercise also helps the students to envision the totality of a given space in how it moves, sits, and breathes. Learning how to make a work is one thing, giving it the necessary space to find its own voice is another. The most difficult challenge is to teach how to use these various voices of thought to form a harmonious sound. – **Timothy Persons**

Is Photography Over?: An Exquisite Corpse

Faculty: Jim Dow

School of the Museum of Fine Arts and Tufts University

In this non-linear version of a photo history lecture and assignment, students create an exquisite corpse response about how photography has been used historically, by whom and for what, ultimately understanding the parallels between different periods in history. The assignment requires them to watch or review the transcripts from the symposium *Is Photography Over?*, hosted by the San Francisco Museum of Art in April 2010 where for two days, thirteen participants, including critics Vince Aletti, Charlotte Cotton, and Geoff Dyer and artists Philip-Lorca diCorcia, Trevor Paglen, and Walead Beshty debated the title question. Students are then asked to respond with text and/or images to the statement and question:

> *Photography has almost always been in crisis. In the beginning, the terms of this crisis were cast as dichotomies: Is photography science or art? Nature or technology? Representation or truth? This question has intensified and become more complicated over the intervening years. At times, the issues have required a profound rethinking of what photography is, does, and means. This is one of those times. Given the nature of contemporary art practice, the condition of visual culture, the advent of new technologies, and many other factors, what is at stake today in seeing something as a photograph? What is the value of continuing to speak of photography as a specific practice or discipline? Is photography over?*

Dow's response in text and images to their responses begins to form the 307-page PDF of the class exquisite corpse response. A sampling of those responses illustrates this assignment.

...A photograph is the only thing that for a split moment, I can lose all presence of myself. I don't think about hunger. I don't think about the muscles in my legs. I don't even notice my body. Not that I desire to escape these things, but the power beyond photography puts me somewhere else...Perhaps I think photography is so alive because it pains me to look down to write this when there is a great slideshow of images on the screen...

As far as the argument of whether a photograph is science or art goes, I say both. Photography uses technology (science) to produce images. Scientists use photography to communicate their work in visual form. No matter what the intention of the photographer, there are always technological and aesthetic choices involved. I don't feel the need to force "photography" into either category (science or art). I think a huge part of why photography is so fascinating is the fact that it is a bridge between science and art and it is beneficial to both disciplines/practices.

These images were pulled from a PDF produced by Jim Dow, and the students of FAHS 011: A History of Photography Through Ideas, Part II at Tufts University at The School of The Museum of Fine Arts, Spring 2013: Christopher Abrahamsen, Benjamin Aho, David Bavelsky, Meg Bergstrand, Shelby Blavis, Aaron Borque, Alex Buchanan, Mary Catallo, Alex Chu, Faye Chuasukonthip, Emil Cohen, Michael Costello, Angela Counts, Amanda Gagnon, Candy Gander, Emily Garrett, Maude Glendon-Ross, Case Hathaway-Zepeda, Deanna Johnson, Clara Hyun-Young Lee, Christian Meade, Jeanette Miller, Jessica Morgan, Dariush Nejad, Bailey Quinlin, Fay Sanders, Ali Siegele, Stephanie Tabaco, Melissa Timko, James Traggianese, Loi Tran, Bradley Tsalyuk, Jason Wallace, Samuel Waxman, Sarah Weingraub, Lauren Wesley, and Carlos Wyrick.

Landscape and Identity:
Place and Random Place

Faculty: Dornith Doherty
University of North Texas

In a topics class that Doherty teaches students were asked to examine their relationship to place by making work in response to the readings listed below and the work shown in class:

> "Wunderkammer to World Wide Web: Picturing Place in the Post-Photographic Era," by William J. Mitchell, from Picturing Place: Photography and the Geographical Imagination eds. Joan M. Schwartz and James R. Ryan, (London, New York: I. B. Tauris 2003)

> "The Idea of Landscape," by Denis E. Cosgrove, from Social Formation and Symbolic Landscape (Madison: University of Wisconsin Press, 1998)

> "Robert Adams—What We Bought: The New World," by Tod Papageorge from Core Curriculum: Writings on Photography (New York: Aperture Foundation, 2011) (also available on American Suburb X).

ASSIGNMENT ONE: PLACE

In response to the above readings and work shown in class, students examine their relationship to place, starting with a place that relates to their personal narrative, and then through their photographs, express something about their personal history and the landscape by traveling through or remaining stationary on the site. Students were expected to return to the same site several times over the fifteen-week class.

STUDENT RESPONSE

The home, as commonly defined, is an artificial structure on a human plane of existence. This artificial structure must not only be built on this Earth (before the rich start moving to Mars), but must also incorporate the life that already exists here, rather than obliterate it in a fit of cynicism. Even a palace on a hill requires a symbiosis between artifice and naturalness. Furthermore, this concept is imperative to the sustenance of any life on this planet. It is vital, if we wish to stay in such a colorful and exotic paradise full of nourishments for the mind and body. My desires lead me astray from upholding these values; is the palace in symbiosis with the world around it? Perhaps it is only bending the forces of nature to its own will. A home is a balance between desire and sustainability within the self. Find that, and you've found your home.

AUSTIN KLEIN
EUGENE LANG COLLEGE THE NEW SCHOOL FOR LIBERAL ARTS, NYC

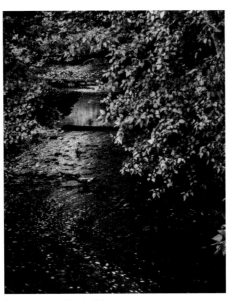

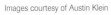
Images courtesy of Austin Klein

assignment continued overleaf →

ASSIGNMENT TWO: RANDOM PLACE

In this assignment, modified from an assignment given by Geoff Winningham when Doherty was an undergraduate, a map is posted on a wall in the classroom and students are asked to throw a dart at the map to select a place at random. The students must travel to the site to photograph together and think about how the meaning of the work changes if the location is chosen at random. How similar or dissimilar is the work produced by a group working at the same place and the same time? What does that say about authorship and the photographic practice?

STUDENT RESPONSE

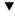

This project was difficult. I chose to throw a dart at Manhattan and ended up landing on Chelsea. It was difficult because of the history of photography in New York. So many photographers made New York City their subject. The toughest part about making the work is not imitating the masters who claimed the city a few generations ago. I kept shooting and trying to get something different but felt that I never captured anything absolutely unique.

ANDREW WILLIAMS
PARSONS THE NEW SCHOOL FOR DESIGN, NYC

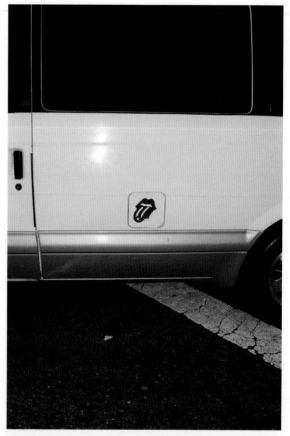

Images courtesy of Andrew Williams

assignment continued overleaf →

{Landscape and Identity ~ assignment continued}

Images courtesy of Katerina Drury

STUDENT RESPONSE

As I was living in New York for a two-month period, I got a map of the area where I was staying and randomly selected a few places to visit and photograph. This area was Brunswick, in Brooklyn. I had no prior knowledge of the areas which I visited, so had no idea what to expect. The Brooklyn area is a very stereotypical vision of America, with mailboxes and stores on most corners. Although it is not too far from the city center, I wanted to capture the stillness that I encountered.

KATERINA "KAT" DRURY
ARTS UNIVERSITY BOURNEMOUTH, UNITED KINGDOM

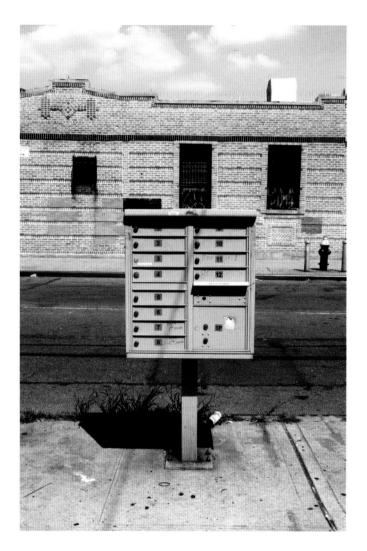

Light

Faculty: Larry Fink
Bard College

This is not one assignment but rather a semester-long course titled
Light. At the beginning, the assignments are designed to teach
lighting fundamentals, such as back-lighting, side-lighting, using one
light source, etc. Even though the underlying subject matter is light,
students are pushed to understand that *how* they express light is their
decision. They are not told what to shoot, only that they need to utilize
light to create the proper ambiance for the subject matter to live and
be expressed more fully. Students are given abstract concepts such as
intimacy, lack of intimacy, physical contact, or a room with a sense of
absence and they must use light to express the concept.

Man Ray

Faculty: Charles Harbutt

Parsons The New School for Design

Harbutt shows a PBS film titled *Man Ray: Prophet of the Avant-Garde.* In it, Man Ray reminds the viewer: "Artists can't hurt you, but a bad doctor or a bad cook, they can kill you." And when asked about his greatest inspiration, he smiles and declares emphatically "Women!" After showing the film, Harbutt assigns students to write a short essay about the quotes that resonate with them and then to take pictures inspired by things Man Ray said.

Manifesto

Faculty: Barbara DeGenevieve

School of the Art Institute of Chicago

Create a three- to five-minute manifesto and perform it for the class. This can be a live performance or a video manifesto. It can be about anything from art to zebras. You can read it or just do it extemporaneously. But remember it's a piece of art, not just a rant or proclamation. Take everything into consideration.

Mapping

Faculty: Joyce Neimanas (Retired)
University of New Mexico

Students are told to look up the definition of the word "map" and then figure out what it means to them. What is a map and what does it mean to use a map? They are encouraged to think creatively about what a map is, or can be, that is, is it a noun or a verb, are they creating a map or using a map? The assignment is to create images based on one's experience of a map or mapping.

The idea of a "map" forces a student to think conceptually about 3D space. – **Joyce Neimanas**
///////////////////////////

STUDENT RESPONSE

Maps are never made without a preconceived activity or purpose. In the necessary transformation from the territory maps block out and disfigure the world. They enhance our perception while making us blind to what has been obscured. Consequently the map occupies the space of a heightened sense of reality and a supreme fiction. I began the assignment from the union of map and territory, conceiving the world as a map of itself. Each new image offered me a new sensation of orientation and direction, ultimately guiding the map itself into completion. I ended up with a map as an aesthetic purpose, at once a compass of city signs and a reflection of visual intuition.

JACK SALAZAR

Image courtesy of Jack Salazar

Measured Space

Faculty: John Willis
Marlboro College

Find a very small, limited space that's measured out. Just by observation try to make as many strong and unique pictures of that space as you can without altering it. Shoot at least thirty-six images. Return a couple of days later and shoot at least thirty-six more images, but this time alter the space, either by bringing things to it, or doing things in it, changing lighting, etc., anything you want. Reflect on how the differences in the space affect your images or your experience of taking the images.

Memory

Faculty: Allen Frame

School of Visual Arts, Pratt Institute and the International Center of Photography

This is an in-class assignment. Students are asked to sketch an important memory from a certain specific time period: before the age of six, between six and twelve, or twelve and eighteen. The quality of the drawing is not important; students can draw stick figures. The image from the memory could have been observed or lived, i.e. the student may be in the image or have observed the image. Besides using time periods, students can draw, and draw from emotional experiences, but to ease into the emotional experiences, students are told to first sketch a neutral subject, such as the weather. The direction to the students would be: sketch a vivid memory of some weather experience you remember. After this neutral subject, students explore more intense experiences such as loneliness, desire, or humiliation, or certain periods in their lives, such as when they were single, or when they were in a committed relationship.

The point behind this exercise, which is about making students aware of their point of view, and asking them to identify personal material that is significant to them, is to tap into the strong point of view that already exists in relation to memory. Being in touch with their point of view helps students bring forth a more authentic voice, tone, and choice of material. The sketches yield a consistency in how a student frames subjects and which themes are important. The type of visualization that occurs in these memories is often more sophisticated than what the students are capable of producing with a camera at that point. These images from memory can suggest the student's potential, what sort of body of work they could create, what sort of visual thinker they are because memory, as it's visualized, is a subjective interpretation of an experience that has been lived, edited, and stored. Memory is a construction and an interpretation, with parallels to the way a student might make or edit photographs. This exercise also allows students to engage in a discussion about personal content that they are authoritative about. I had a student who produced three sketches from a time when he was single and the images mirrored a self-portrait series he had already made of himself as an iconic fantasy of desire. Then he was asked to draw three from a period in which he was in a long-term relationship. They were very different. – **Allen Frame**

Left Behind

"Left Behind" is a series Hugette Ampudia made using appropriated images from Google maps of Mexico City, as she tried to reconstruct the scene of a childhood trauma. The series of photographs retraces the route she may have used to find her way home after being abandoned with no money or phone at the age of 11, in the middle of the city by her mother after they had had an argument. It took her four or five hours to get home. Walking through the city alone at that age was attendant with considerable risks; men would stop to offer her a ride. When she finally arrived home, her parents made no comment. Her father didn't realize until years later what had actually happened.

Image courtesy of Hugette Ampudia

Narrative Project

Faculty: Conrad Tracy
Arts University Bournemouth

AS PRESENTED TO THE STUDENT

▼

Innovative thinking, creativity, and good technique are the foundations of the successful commercial photographer. However, when working within a commercial framework you must be able to channel your creativity into the relevant parameters of the market in which you wish to work. This project allows you the opportunity to concentrate on your own career progression by designing a brief—in the form of a proposal—that allows for individual creative growth, and demonstrates critical commercial awareness.

> ‣ It's not essential for your narrative to be seamless as the chain of events unfold; let there still be questions raised and unanswered, allow loose ends, break the conventions, or perhaps induce a cliffhanger.

> ‣ Intentionally create doubt in the minds of the viewer and let the work be ambiguous. Try and create a nonlinear structure; muddle up the chronological order.

> ‣ The images/work should have clear goals and be believable in their stated context if they are to maintain a sense of credibility. As always, the detail is all-important.

> ‣ Express creativity both in the concept and in the aesthetic outcome.

The theme of the project is simply "Narrative." This can be interpreted in many ways, and can be adapted to any style of photography. You are advised to research narrative within your chosen area of specialism, looking for successful uses of this technique. Keep in mind that "open-ended narrative" is a strategy adopted by the photographer that allows the sequence of images to be read many different ways, often dependent on the cultural context of the viewer, the context in which the series appears, and the target audience of the story, etc. Susan Bright talks about the use of "open narrative" when discussing the work of Gregory Crewdson and discusses the multiplicity of readings that the viewer can make, dependent on their own points of cultural reference. She writes: "The almost claustrophobic calmness of the inhabitants in his tableaux contradicts the activities around them, causing an uncanny tension that we, as viewers, understand and react to like the moment before a catastrophe in a science-fiction film" (Susan Bright, *Art Photography Now*, Thames & Hudson 2005, p. 80).

Bright talks about cinematic signifiers and a recognized structure that is implicitly part of our understanding, part of our "cultural capital." Within film-making, the term *mise en scène,* which literally means to "put in the scene," is used to describe how a director may introduce elements that help to define or suggest things within the frame. It refers to the arrangements and placement of all visual characters in a scene, for either film or stage productions, but is just as relevant a term to use in constructed photography.

There are four key formal elements that you will need to consider that will help you to engage with this process:

1. Setting/location
2. Costume/styling, hair and make up
3. Lighting
4. Staging, which includes movement/poses and acting/casting.

All four of these elements can be applied to your photography and they can help to suggest insight into the larger narrative and offer clues to where the story is headed.

Think about open-ended narrative as giving the photographer almost unlimited opportunities to make work that potentially asks more questions than it answers. The images for this project can be fashion, advertising, editorial/documentary, or portrait related; they may be tied in with a competition brief or a "live" project. The only stipulation is that the images must have a sense of narrative, and must possess a quality and sophistication that is comparable with that of your intended market.

Narrative: Medway Festival

Faculty: Heike Löwenstein
University for the Creative Arts

In the narrative unit, second-year students produce work knowing the outcome will be the Medway Festival, a series of exhibitions based on certain themes identified at the beginning of the term based on certain subject matter that students have identified as of interest to them.

Sample exhibitions in 2013 included:

CLOSE YOUR EYES

An exhibition of work by eight emerging female artists exploring the philosophical notion of absence and presence. Even though the photographers used formats including photography and video installations, each body of work contained a readable absence.

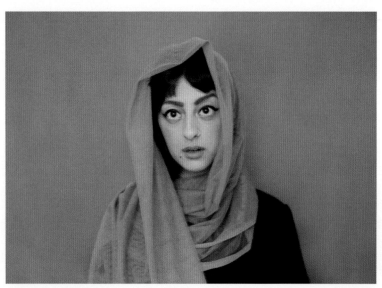

Image courtesy of Sanaa Hamid

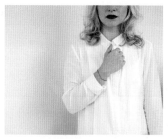

Image courtesy of Ramona Guntert

NOVO ASPECT

An exhibition featuring eight photographers whose work explores the interrelated concepts of change and transition through varied subject matter, including landscapes, cities, human emotion, and mental states, and the way each replenishes, grows, or deteriorates.

Image courtesy of Samantha Shipton

Newtonian Time and the Time of Leibniz and Kant (Immeasurable and Untravelable)

Faculty: Michael Marshall
University of Georgia

AS PRESENTED TO THE STUDENT

▼

For Part I, consider time as a fixed interval, a fundamental quality, Newtonian time. Life as defined by the hands of a clock. Choose a subject matter, then a time interval to visit and photograph that subject. Start immediately. The maximum interval would be every twenty-four hours, minimum could be as little as a few seconds. Three weeks from now you should have at least twenty images for this series, and possibly many, many more. You will compile these images into a short video sequence, adding an appropriate audio track if you would like (something applicable to your subject/concept and not just a favorite song).

For Part II, consider time as Leibniz and Kant do: immeasurable, without sequence, flowing outside of the hands of a clock, life moving more fluidly, as in the poetry of Billy Collins. Sometimes it moves quickly, other times much more slowly. In this version of time, your perception is based on metaphors of visual experience. There is no rigid structure to your subject matter or your time frame. Respond to your daily visual experiences by collecting views in passing and collate these images into a visual poem of metaphors. You will make small digital prints of six to ten of these images, with four inches being the short dimension of each print.

Night Dreams, Day Dreams, and Hypnogogic Hallucinations

Faculty: Susan Kae Grant
Texas Woman's University

Students are required to create a manipulated blurb book inspired by the theme, "Night Dreams, Day Dreams, and Hypnogogic Hallucinations." The purpose of this book is to explore advanced film or digital photography techniques while illustrating a theme. The finished book must be no smaller than 7 x 7 inches and no larger than 13 x 11, and must include a title page with the artist/author's name and a minimum of ten manipulated pages and ten photographic images exploring experimental techniques chosen from the Robert Hirsh book *Photographic Possibilities: The Expressive Use of Equipment, Ideas, Materials, and Processes.* Photographic imagery may be black and white or color and utilize any manipulation process. Manipulation techniques must be original and demonstrate advanced methods utilizing experimental processes that illustrate the content.

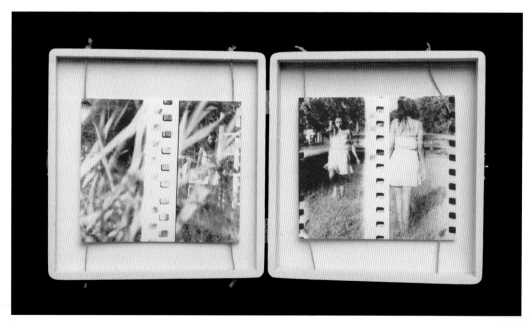

Image courtesy of Sheryl David

Observation

Faculty: Dennis Keeley
Art Center College of Design

Students are given an index card with a rectangular frame and told to go out, look through this "frame," and write or list in a notebook what they see. They write it all down in a notebook and must prioritize the visual arrangement of the scene. They are encouraged to share how and why they think their order of the components might contribute to a thought-provoking image. Students could write about a fictional image, but they aren't told that. They could stay at home and write from their imagination but most of them don't know that.

When we read them aloud in class some of the writing is boring, but what is described really could be an interesting photograph. And sometimes what they write is really interesting and complicated, but in the discussion we find that they might not be able to make a picture that looks like that.

The goal is to make students slow down a bit and think about the process and content of their photographs, instead of taking a lot of pictures or thinking that they will simply pick from a larger quantity of photographs and select the "best" one to show. Photography is a practice. One might think that it begins with looking, but before one begins to look at what might result in a photograph, it is about deeply considering the subject, thoughtfully articulating the contextual influences, and understanding your own curiosity. Anything from a poetic personal longing or even an uninformed enthusiasm can initiate the process and ensure that the activity of making will be more rewarding. **– Dennis Keeley**

Obsession and Intuition: Regarding Beauty

Faculty: Susan Kae Grant
Texas Woman's University

A

N

Each student is required to create a project addressing alternative scale inspired by the theme, "Obsession and Intuition: Regarding Beauty." For this project, each student will choose from color, black and white silver prints, inkjet prints, or manipulated prints (sewing, paint, developer, decay, etc). Each project must consist of a series of three to five sets of prints (eight to nine running feet) appropriate to the chosen theme and consist of diptychs, triptychs, or grids with a minimum size of 11 x 14 inches per print. Techniques must be original and demonstrate advanced methods utilizing experimental techniques that illustrate the content.

On Turning Ten

Faculty: Arno Minkkinen
University of Massachusetts in Lowell

Read the following poem by one-time U.S. Poet Laureate Billy Collins. Then respond with a group of images to what you imagine the poem is about. Try not to illustrate the poem but rather to transform it from verbal to visual.

ON TURNING TEN

The whole idea of it makes me feel
like I'm coming down with something,
something worse than any stomach ache
or the headaches I get from reading in bad light —
a kind of measles of the spirit,
a mumps of the psyche,
a disfiguring chicken pox of the soul.

You tell me it is too early to be looking back,
but that is because you have forgotten
the perfect simplicity of being one
and the beautiful complexity introduced by two.
But I can lie on my bed and remember every digit.
At four I was an Arabian wizard.
I could make myself invisible
by drinking a glass of milk a certain way.
At seven I was a soldier, at nine a prince.

But now I am mostly at the window
watching the late afternoon light.
Back then it never fell so solemnly
against the side of my tree house,
and my bicycle never leaned against the garage
as it does today,
all the dark blue speed drained out of it.

This is the beginning of sadness, I say to myself,
as I walk through the universe in my sneakers.
It is time to say good-bye to my imaginary friends,
time to turn the first big number.

It seems only yesterday I used to believe
there was nothing under my skin but light.
If you cut me I could shine.
But now when I fall upon the sidewalks of life,
I skin my knees. I bleed.

Billy Collins

Images courtesy of Andrew Williams

Order and Disorder

Faculty: Arno Minkkinen
University of Massachusetts in Lowell

Faculty: Arno Minkkinen
University of Massachusetts in Lowell

AS PRESENTED TO THE STUDENT

▼

Rudolph Arnheim's[1] take on order and disorder might be characterized as follows: when we have total order in the world, or on a canvas, we easily fall asleep; when disorder rules the day, we get a headache and reach for the aspirin. But when order exists in the presence of disorder or vice versa, we have a chance to make art. For this assignment, seek to find or construct images wherein the balance between order and disorder leaves such possibilities open. Paul Klee said, "If you want to understand a painting, you need a chair." When we stop moving around, the painting becomes animated. If you sit in front of a Kandinsky composition you'll see order and disorder bounce off each other like fireworks in the night sky.

1 http://academic.evergreen.edu/curricular/emergingorder/seminar/
 Week_7_Entropy_and_Art_Arnheim.pdf (accessed 09-08-13).

Ordinary Made Extraordinary

Faculty: Chris Gauthiér
Utah State University

The goal of this assignment is for students to take an ordinary object and reduce it down to the fundamental elements of design. Students are provided with a choice between several everyday objects chosen by Gauthier. He often uses wood and metal chairs because he likes the basic aesthetic qualities of those objects. To assist the student's appreciation of the object in the round, they are not allowed to remove the object to a new environment or to reposition it; the students must position themselves in order to alter the perspective. They must take one image as reference of the object in its naturally existing space. Then through changing depth of field, shutter speed and aperture, and using varied focal lengths, students produce between thirty-six (film) and fifty (digital) frames of the object, with each image rendering the object increasingly reductive and more design driven. Students submit the reference image and at least five final images.

Passions and Obsessions

Faculty: Steve Skopik
Ithaca College

AS PRESENTED TO THE STUDENT

▼

This assignment is premised on a simple but sometimes elusive proposition—that to sustain the production of an engaging body of work one must pursue the exploration of subject matter that is of deep importance to the image maker. In other words, if you don't care all that much about what you are photographing, your audience is not likely to care either.

For this project select a topic to which you are passionately committed, perhaps even obsessively. This could be virtually anything. Is there an activity beyond photography that you engage in regularly—a sport, a cause, or a pastime? If so, drawing on the technical and formal skills you have acquired this semester, can you think of a way to begin visually representing that activity to convey your commitment and fascination, thus engaging your audience? Is there a situation or relationship that is central to your life that you think might have applicability to others' experience? Or, perhaps your obsession is more along the lines of a fascination or fear. Whatever the case, photograph it. A lot.

As a touchstone, consider some of these photographers: Joel-Peter Witkin explores mortality and the macabre; Emmet Gowin focuses on life, fecundity, and familial relationships; Sebastião Salgado is deeply invested in the plight of the economically oppressed. Despite these images' different work and styles, what they all have in common is an investment in subject matter that deeply affects them.

PechaKucha/Remix

Faculty: Lorie Novak

Tisch School of the Arts, New York University

PechaKucha is a simple presentation format, invented by Tokyo-based architects Astrid Klein and Mark Dytham, that displays twenty digital images, each for twenty seconds. The images advance automatically and the presenter talks along with the images (www.pechakucha.org).

This is a two-part assignment:

PART I: PECHAKUCHA

Using iMovie, Keynote, PowerPoint, or a slideshow program, students create a PechaKucha to introduce themselves and their work to the class. A twenty-second video clip may be substituted for one or two slides. Students can use cut, one-second, or two-second cross-dissolve but no zoom effects. The first slide must contain the student's name. Additional text is optional. Rehearse and bring notes/script to help with your class presentation. The presentations are recorded so that audio can be used for Part II of the assignment.

PART II: REMIX

Students are told to create a one- to three-minute remix focusing on the work or something they care about. The remix must contain approximately half of images from the PechaKucha, some of the recorded audio from the class presentation with the addition of at least two additional audio sources such as fragments of other students' audio recordings or any other audio, any other visuals and effects such as other photos, found images, and audio, media/screen-grabs, video, etc. This assignment can be edited in any video editing software, exported as a .mov or .mp4 format.

The Photographic Cliché

Faculty: Bill Gaskins
Cornell University

I, personally, am very much against, in principle, any art or visual education. It seems to me that education of this kind is potentially very dangerous and is likely to develop certain clichés. – **Alexey Brodovitch**

AS PRESENTED TO THE STUDENT

A cliché is an expression, idea, or element of an artistic work which has been overused to the point of losing its original meaning or effect, "played out," rendering it a stereotype, especially when at some earlier time it was considered meaningful or novel. The term is frequently used in modern culture for an action or idea that is expected or predictable, based on a prior event. It is likely to be used pejoratively. But "clichés" are not always false or inaccurate: 1) a cliché may or may not be true; 2) some are stereotypes, but some are simply truisms and facts; 3) a cliché may sometimes be used in a work of fiction for comedic effect.

In this assignment, using the categories created by Terry Barrett from the book *Criticizing Photographs*, you will collect and present as many photographic clichés within each of these categories as you can and discuss them in class through a presentation using Prezi (www. prezi.com). This is a curatorial project that will require the class to work in five groups of three students each. Prezi is an online program that allows groups of students to create and edit the presentation simultaneously from remote locations. It is very important that your presentation engage your audience of peers as viewers/listeners.

Beyond the photographs in Barrett's categories, I am particularly interested in the photographic clichés commonly produced by photography students, amateurs, and other practitioners of photography. Understanding the range of photographic clichés produced will play an important role in your development in this course and the development of your formal vocabulary in photography. There will be much to learn through this assignment.

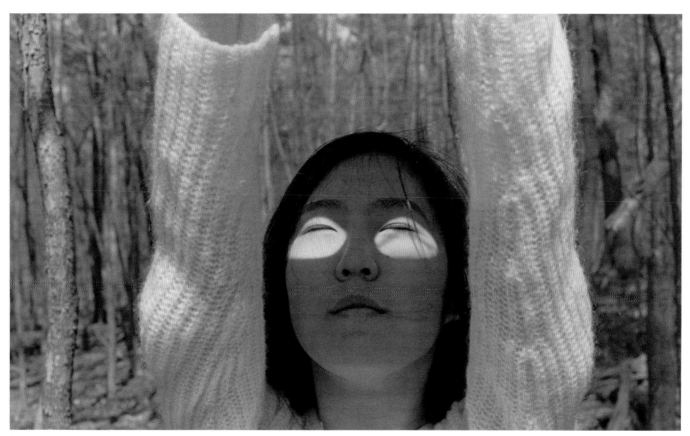

Image courtesy of Valerie Kwee

The Photographic Homage

Faculty: Bill Gaskins
Cornell University

AS PRESENTED TO THE STUDENT

▼

A homage is a show or demonstration of respect or dedication to someone or something, sometimes by simple declaration but often by some more vague and coded artistic or poetic reference. This concept in the arts frequently appears where one artist makes reference to another, such as *Kiss* by Joel Peter-Witkin. Musicians may show respect to musical icons they admire by alluding to their work in the structure of a work or appropriating phrasing of an artist. A homage in rock music often takes the form of an album-length tribute or of a sample of a song in rap music. Visual and audio digital technologies enable contemporary artists to recontextualize both classic and contemporary works in a form of homage.

For this assignment each of you will individually produce work that will be made in homage to a photographer of your choice. You will create one image (or series if applicable) and contact sheet(s). When shooting your homage think about how this person sees, why they see that way, the technical and formal approach they take, and why you chose their work. Note that you are not making a literal copy of the photographs' formal qualities or content of their work. You are expected to translate the conceptual aspects of the work into a statement reflecting your own conceptual, technical, and/or formal questions, experience, or interests. Along with the image you create, create a fictional interview with the photographer you've chosen, including details on their life and career and the conceptual and formal philosophy behind their work and their method of presentation. You will share this with the class along with the image you create. Make one copy of your interview for each student. Cite any resources you use in your research as endnotes.

The Pivotal Edge

Faculty: Arno Minkkinen
University of Massachusetts in Lowell

For this assignment students are asked to make images wherein one edge of the frame becomes the deciding factor in the analysis of the photograph. This focuses student attention on the frame and cropping carefully in the camera because if the edge is a determinative factor, it can't be changed in postproduction.

STUDENT RESPONSE

▼

I found this project to be very intriguing. It was quite the challenge to figure out a way to create interesting images using the edges without flipping them in postproduction. However, it did allow me to consider and try out using visual tricks to make the image look different and interesting based on only what was showing inside the frame.

RACHEL DUNLOP
PARSONS THE NEW SCHOOL FOR DESIGN, NYC

Images courtesy of Rachel Dunlop

Political Photo Montage

Faculty: Rafael Goldchain
Sheridan College

AS PRESENTED TO THE STUDENT

▼

Using a maximum of five photographic images, taken specifically for
this assignment, construct an image that communicates your position
on a "political" issue or scenario of your choice. Think of this image
as being made for a political poster that must communicate a single
idea strongly. There should be no ambiguity and the image ought to
be read and understood in a few seconds. The images you utilize may
be of a single object or of different objects or locations, but when put
together construct a single unified image. It is important to remember
that making artworks with digital technology requires prior planning of
the layout and camera techniques in order to obtain a good fit. Provide
a written statement and sketches produced in advance of the shoot.

Portraiture and Performance

Faculty: Jean Brundrit
Michaelis School of Fine Art

AS PRESENTED TO THE STUDENT

▼

In this project you are going to make two portraits that are conceptualized together to read as one artwork. The portraits could be slightly or substantially different from each other but must be of the same person. This person will be assigned to you. Consider all aspects of the performance in these portraits. Photograph with at least one technical assistant (a member of your group). Conceptually, the project should explore the theme in a rigorous way and the photographs you produce should reveal understanding of the issues of performance, construction, and direction in photography, using methodologies that make reference to contemporary art production. Keep in mind the ethics of photographing people and make sure your images evidence a good understanding of studio and natural lighting. As reference, review Rembrandt's self-portraits, portraits by Egon Schiele, and photographs by Santu Mofekeng, Zanele Muhili, Pieter Hugo, Cornelius August, August Sander, Weegee, Richard Avedon, Sally Mann, and Rineke Dijkstre.

The Possibilities of Collaboration

Amy Stein
Photographer and Educator

Based on the success of a collaborative project that Stein completed with photographer Stacy Arezou Mehrfa, titled *Tall Poppy Syndrome,* she created this assignment. Students are told: Work with another student. Create a series of ten images. The subject and approach are up to you, but the images must be collaborative.

Review the work of Tribble and Mancenido, Soth and Gosage, Gilbert and George, to begin a dialogue about the nature of collaboration.

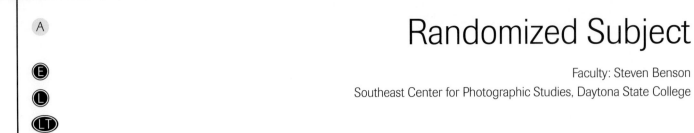

Randomized Subject

Faculty: Steven Benson
Southeast Center for Photographic Studies, Daytona State College

Keeping in mind that his program is "applied" in nature, Steven Benson created an assignment built around the idea that, in a professional practice, there is no way to know what the next phone call might require. He writes a few dozen subjects on pieces of paper, places them in a box, and students select their assignment without looking. The element of chance is in line with some aspects of a classical photographic aesthetic. The subject areas are one or two words and open to numerous possible interpretations, such as money, religion, love, spicy food, politics, violence, fashion, dreams, the environment, or fear. Students have one week to work with conceptual, technical, and logistical issues. They can interpret the subject as they wish. The goal is to create an illustrative photograph that reflects something about the student's perceptual system while at the same time causing the viewer to consider the broader issues at hand.

Image courtesy of Luke Earls

Image courtesy of Christina Storozkova

assignment continued overleaf →

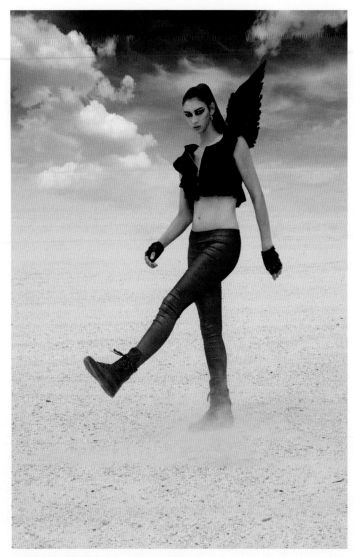

Image courtesy of Erin Gordon

Image courtesy of Jason Weingart

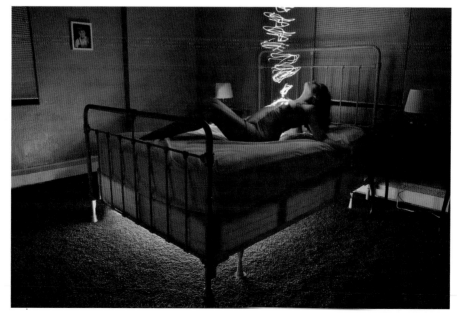

Image courtesy of Danielle Taufer

Re-Do

Faculty: Barbara DeGenevieve
School of the Art Institute of Chicago

AS PRESENTED TO THE STUDENT

▼

1. Using all the accumulated knowledge of your research and all the critiques you've had, choose one piece of work you've made since you started school that, after critique, you wish you had made differently. Remake it.

2. Remake/recreate/re-enact a work you wish you had made by an artist who has been influential to your practice.

3. Make work for a hypothetical exhibition using these as themes:
 Pink
 Full Disclosure
 Exploding Plastic Inevitable
 Disrupt and Step Back
 Teenage Rebel in Chicago

Restriction and Freedom

Faculty: Wang Chuan
Central Academy for Fine Arts

This assignment arises from a class designed to improve students' comprehensive ability by working on small projects in collaboration with someone from another field such as fashion, jewelry, visual communication, etc. The students are required to collaborate with their partners instead of simply serving them. That means the photography students have to find the entry point of their work and offer something special. In one collaboration, the photography student worked with a jewelry design student and placed the jewelry into an archaeological discovery context by making a series of old newspaper headlines, documents, travel tickets. Instead of simply shooting the jewelry, she combined storytelling, shooting, and reshooting, editing,

postproduction and graphic design together to create the feeling of the past. The outcome was unique and surpassed the conventional presentation of jewelry. It brought the viewers into a past age, with a slightly mysterious and very Chinese narrative. Another team of a photographer and graphic designer explored the rumor of a pending salt shortage in the aftermath of the earthquake in Japan in 2011. They conducted surveys, interviews, on-location shooting, and postproduction techniques to create a design that played on the traditional couplet but instead replacing all the Chinese characters with the Chinese character that means salt.

assignment continued overleaf →

{Restriction and Freedom ~ assignment continued}

Images courtesy of Yang Chen

3

4

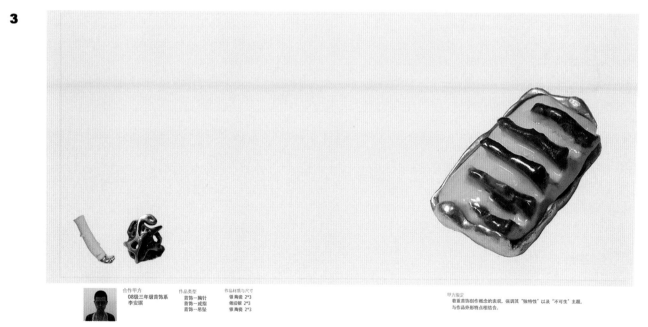

Images courtesy of Leng Wen

Scavenger Hunt

Faculty: Terry Towery
Lehman College, City University of New York

AS PRESENTED TO THE STUDENT

The purpose of this assignment is to help you begin to see creatively by giving you the basic tools of the photographic language of expression. The assignment centers on the basic technical operations of the camera. You must do *at least two of each* of these. The assignment must be turned in in an envelope. Remember, do not do the obvious. Put some thought into every image. Ask yourself, "How can I photograph something in such a way that it doesn't look ordinarily?" The subject matter of the pictures is up to you. It is your approach to the problem that will make you stand out. Technique is very important at this stage; it is the alphabet that will become a language.

The requirements of the assignment are as follows:

> *At least two rolls of thirty-six exposures or one hundred digital frames on your card.*

> *A neatly written record of the exposures made on every frame; include shutter speed, f-stop, which part of the assignment you were attempting, and any other relevant settings.*

> *Edit down to at least six images demonstrating the most successful and interesting pictures from these two rolls of film.*

> *In your slide pages or thumb drive you must include all of the following camera techniques:*

1. Everything in the picture in focus (wide depth of field).
2. Everything in the picture out of focus.
3. Sharp focus on the subject, but everything else of focus (shallow depth of field).
4. High camera angle (taken from at least ten feet above subject).
5. Low camera angle (camera placed at ground level).
6. Panning.
7. Stop action (fast shutter speed).
8. Blurred motion (slow shutter speed).
9. High key picture (mostly light-toned, you must bracket by changing aperture).
10. Low key picture (mostly dark-toned, bracket by changing shutter speed).
11. Picture with strong visual focal point of interest.
12. Picture with no visual focal point of interest.
13. Long exposure (more than one second).
14. Picture with a light source inside the frame.
15. Backlit subject (silhouette).
16. Close-up (as close as your lens will allow you to focus).
17. A reflection.

See With Your Ears

Faculty: Niko Luoma

Aalto University School of Arts, Design and Architecture

A

C

FA

V

P

This assignment challenges students to reconsider their senses. It works best in an environment with which students are not familiar because such an environment always challenges the senses. Send students to an exhibit, or any specific site in the city, such as a library or train station, but tell them that they must use their ears, and put their eyes in the background. Give them a specific time frame, from one to three hours, and tell them to walk around the exhibit listening to the ambiance of the site, noting the sound of color, the colors of sound, the resonances, echoes, silences, random conversations, corners, and rhythms. Then "assign" the students to process the experience using any medium: drawing, sculpture, found object, performance, video, photo, but ultimately, the final result has to be a photograph. For example, the initial response could be drawing based on the audio experience of the place or something found on the streets that is photographed for the final piece.

assignment continued overleaf →

Pollock from the series *Weight of Experience*
Image courtesy of Jaana Maijala

Grand Central Station from the series *Weight of Experience*
Image courtesy of Jaana Maijala

STUDENT RESPONSE

Weight of experience: I make drawings in certain places or in certain situations I wish to remember. These drawings are recordings of my surroundings, and also of my feelings. I photograph these drawings. To me, this is the most interesting step because it changes the materiality of the drawing: what used to be pencil on a sheet of a notebook is now an illusion of mass. A line carries weight.

JAANA MAIJALA
HELSINKI SCHOOL

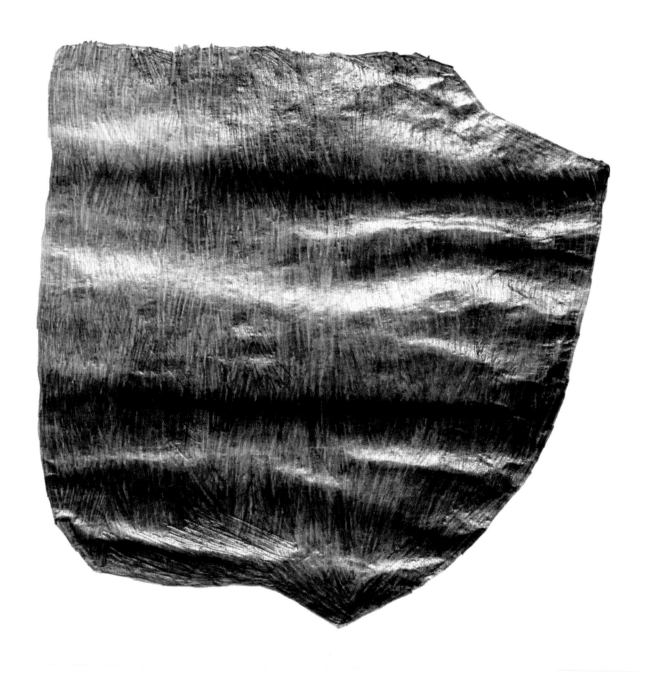

Avenue C from the series *Weight of Experience*

Image courtesy of Jaana Maijala

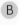

Self-Portrait

Faculty: Matt Johnston
Coventry University

AS PRESENTED TO THE STUDENT

Pre-visualize and produce a self-portrait, using only available light, unrestricted in theme and technique yet still supplying a message to the viewer. You should spend time first understanding what it is you wish to convey before then looking at the composition and mechanics of the image and finally production. Note that while you are required to use only available light you can still shape and adjust this light as you see fit. Streetlights, laptops, computers, and televisions can all be available light. Think about how an audience can be helped to unpack the image and meaning you are aiming to pack up—should it be obvious, subtle, or multi-layered?

STUDENT RESPONSE

Self-portraits are often something that most photographers tend to avoid, since they find comfort in being behind the camera. Lately, I have found myself attracted to taking self-portraits and this assignment helped me fuse both my love for using found light and for helping convey themes using myself. For this project, I forced myself to shoot during the night and found that it can be as enjoyable as shooting during the daytime is. I tried my best to create a theme of mystery and haunting throughout this image, and hope that the light as well as color palette conveyed that.

RACHEL DUNLOP
PARSONS THE NEW SCHOOL FOR DESIGN, NYC

Image courtesy of Rachel Dunlop

Self-Portrait: Signature

Faculty: Charles Harbutt
Parsons The New School for Design

Have students print their names and sign their names and explain that one of those is a literal version of the name and one is symbolic. Reflecting on that, assign students to shoot a literal self-portrait where they must appear in the photograph and a symbolic self-portrait suggesting something they think of themselves as being.

During the critique discuss which version the student prefers: is she more drawn to the metaphorical self-portrait or the literal one? If a student is more drawn to the metaphorical image, encourage the student to continue in that direction. Ask those who like the literal one what they really like about the image, and then build on that for the semester's work.

The whole class gets involved in trying to decipher what's really been done. Unlike a detective story, we know the criminal, but what's the crime? – **Charles Harbutt**
//////////////////////////////

STUDENT RESPONSE
▼

It's strange that I would gravitate towards the self-portrait assignment, when I have such little general interest and experience with photographing myself. Maybe this is what drew me to it—simply the exploration of the unknown. It's perhaps for this reason, among others, that I find there to be more value in discussing the experience than the product, although I'm quite satisfied with the results of this exercise. I started by thinking about the topic the prompt presents: identity, what it is, and what it is to communicate that. It's been a topic of great concern to me for a very long time, and around May of this year, I started getting a true grasp of who I was and, subsequently, what I was made up of—perhaps the most important process a person goes through in her life. Especially for an artist, whose work is a direct product of who she is. I let the development of these images naturally occur. I let myself be drawn to something I found aesthetically and idealistically interesting and pleasing—sunflowers (and this is possibly in some way inspired by van Gogh, one of my favorite artists of all time)—and brought them home (the place where identity coalesces), where I knew there would be light I would want in which to photograph the sunflowers and myself. I determined the most honest process for a project about identity was to study this thing that had captured my interest, and then photograph it, mess around with it, and see what I might be able to capture. In essence, I suppose this project for me was realized by simply letting myself be; and by simply letting myself be, I am simply letting myself be interested in something. Then, I photographed that simple experience.

EMILY HEINZ
PARSONS THE NEW SCHOOL FOR DESIGN, NYC

Images courtesy of Emily Heinz

Self-Portraits

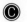

Faculty: Patrick "Pato" Hebert
Tisch School of the Arts, New York University

AS PRESENTED TO THE STUDENT
▼

Create three self-portraits. One print must involve photographing your
own self/body. A second image must address (counter?) a misper-
ception that people have of you. A third image must reveal something
about you that people do not usually see. For images two and three,
you can work with your own person (body, representation). You can
also utilize objects, fashion, context, allusion, constructed narrative,
documentation, text, or any other techniques to create a self-por-
trait. The goal is to create compelling imagery that gets at a richer
understanding of your self.

These three images can be presented as independent, distinct
works; as part of a series; or as part of an integrated whole. The choice
is yours, but please be thoughtful about the relationship between the
three images and how together they can engage and suggest a fuller
sense of who you are and how this is constructed in relationship to
other people and to the context.

STUDENT RESPONSE
▼

The guidelines for the assignment consisted of one print involving
photographing my own self/body. A second image must address a
misperception that people have of me. A third image must reveal some-
thing about you that people do not usually see. I chose to produce
three independent images that I feel are accurate depictions of who
I am, using a still life of photographs, a narrative portrait, and a third
depicting a visual misconception that I have of myself.

LAUREN TAUBENFELD
PARSONS THE NEW SCHOOL FOR DESIGN, NYC

Images courtesy of Lauren Taubenfeld

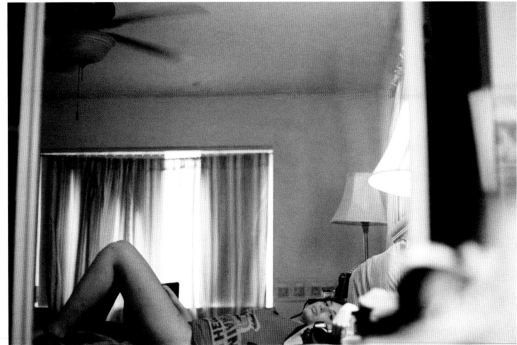

Site: Intervention (The Dart Project)

Faculty: Svea Josephy
Michaelis School of Fine Art, University of Cape Town

Students are required to construct a pinhole camera or use an existing tin pinhole camera. The project aims to explore the conceptual implications of light on a given subject as well as introducing basic principles of photography and photographic printing in chemical-based black and white photographic printing. This is not a digital project. Final submissions must be silver halide prints.

The project requires each student to randomly select a site in the city. Students will do this by throwing a dart at the map of Cape Town in class. Students are then required to photograph the site, using their pinhole cameras.

Photographs of the site should be presented in pairs: a view of the site and the site with an intervention. The last photograph would then either be an additional intervention or an additional view of the site. Or, students can make one photograph of the site and four interventions. This intervention may take the form of altering its appearance by point of reference/viewpoint; different lighting; inserting an object, person, etc. When planning the intervention, think about the historical, political, and social significance of the site, based on research conducted prior to photographing. When photographing, think about the light falling on the subject and how this will work as a tonal gray-scale image; in other words an image made up of black, grays, and white.

The final submission must consist of five perfect 4 x 10-inch negatives and five perfect 4 x 10 positives. The negative should have detail in the light areas as well as in the shadow or dark areas. If it is correctly exposed this will be the case. Your positive will be the best print you can get from your negative. You can never make a perfect print from a technically bad negative.

Something You Have Never Done Before

Faculty: Paul Hill

De Montfort University and University of Derby

Masters students should be challenged to be innovative and to venture out of their comfort zone. There is little point in them repeating what they already know, so to encourage visual development and the acquisition of new skills and experience they should explore a genre, topic, or subject matter *new* to them. For example, one student, who had specialized in photographing celebrities and had never worked on a very personal project, photographed his son grappling with a mysterious illness. Another student who thought of himself as a "people" photographer revisited a black and white reportage project he had done twenty years earlier and made unpopulated "empty" color landscapes. As the work progresses, students share their efforts with fellow students and tutors via seminar presentations, critiques, and tutorials. In order to demonstrate an evolving critical distance to their photography, they also have to write an analysis of the assignment that has the aim of placing their images within a wider critical framework. This helps them to gain knowledge and awareness of new areas of practice, and assists them with the process of locating their work on the contemporary photography "map."

assignment continued overleaf →

{Something You Have Never Done Before ~ assignment continued}

The Field Of Brambles

This image comes from a series produced in Paul Hill's graduate class. The students are encouraged to work in a new mode. Nick Lockett was chief photographer for a major UK commercial TV broadcaster and was an experienced and widely published practitioner. Studying for his MA, he was contemplating making a series of portraits of comedians – so he found himself looking at the horizon photographing distant 'surface' subjects and not addressing what was close up to him and really mattered to him. His teenage son was very ill with M.E. and the condition deeply affected his whole family, and yet it was not photographed. He abandoned the comedians' project and began a series of collaborations with his son that were concerned with his illness. He was more used to photographing celebrities for glossy magazines, and this deeply personal exploration was new to him and way out of his comfort zone. The photographs combined images of his son overlaid with text from school reports, doctor's notes, medicine data sheets, personal diaries, letters and many other sources. The work turned out to be therapeutic and played a part in the boy's recovery.

© 2013 Nick Lockett

The site of the former Mardy Colliery, Rhondda Valley, South Wales, 2008. Opened in 1875 the pit was closed on 21st December 1990. This image comes from a series produced in Paul Hill's graduate class where the students are encouraged to work in a mode that they haven't worked in before. In the mid 1980s photojournalist, Martin Shakeshaft photographed the Miners' Strike in the United Kingdom in black and white. This year long violent dispute changed the country's political map at the time and controversially further enhanced Prime Minister Margaret Thatcher's reputation as the Iron Lady. Twenty years later he re-visited the coalfields to photograph the strike's legacy. Only four pits were left, dramatically changing the landscape, as well as the lives of those who had worked there since leaving school. Shakeshaft had always thought of himself a 'people photographer', but his unpopulated 'empty' color landscapes are perhaps the truest testimony of a momentous period in British history.

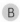
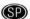

Staging the Self

Faculty: Terry Towery
Lehman College, City University of New York

AS PRESENTED TO THE STUDENT
▼

Produce at least one hundred digital or seventy-two film exposures and seven edited final images. Don't worry about variety in your final images; however, variety must be present on your flash drive or in your contact sheets. I want to see a plethora of ideas explored before you decide on the final images.

The objective of this assignment is for you to begin to consciously express ideas in your photographs. You should make images that convey some aspect of your identity to the viewer, not merely your physical appearance. You should think about clothing, body language, environments, facial expressions, or props. It is permissible to have an assistant release the shutter for you, however it must be your ideas not theirs. Try ideas of your own or combine ideas. The key word is expression. Creativity is important. You know yourself better than you know anything else in the world. Pay attention to your dreams. Don't be afraid to try anything—you don't necessarily have to print it. The technical aspects of the medium are always important. Work to improve exposure and print quality.

If you find yourself at a loss as to what to make images about, here are some suggestions. These are not requirements for the assignment.

1. Explore your personal history: You may want to incorporate other images into your pictures: e.g. snapshots of relatives, lovers, or your childhood. Perhaps collage is an appropriate approach.
2. Absentee self-portrait: Assemble objects that have personal significance and present them in an interesting manner or create environments that portray some aspect of your identity (lighting will be crucial to convey the correct mood).
3. Fantasy: Role-playing has always been an important part of self-portraiture. The lies you tell about yourself can be just as important as the truths. Dress up as your favorite fantasy.
4. Body language: Use your body as an instrument with which to express yourself. Explore facial expressions, gestures, and details of body parts.
5. Photograph yourself in environments that somehow portray part of your psyche.
6. Just let go and be you—there is plenty of room for humor in art.

Research: Anything by Duane Michals, Cindy Sherman, or Nikki S. Lee.

STUDENT RESPONSE

To create self-portraits that portray different aspects of my identity, my first consideration was not actually myself, but my space. By altering my environment and my dominance in the frame I sought to convey a range of subjectivity, where on one end I am depicted in a familiar urban setting, and on the other my presence is disembodied. This subjective access creates psychological complexity, and establishes a relationship between the work and the viewer that mimics my own relationship with many unfamiliar people I encounter (or who encounter me) on any given day: they are either alienated by my presentation, or we share a knowing glance and perhaps a small smile.

HARRY JAMES HANSON
NEW YORK

Image courtesy of Harry James Hanson

assignment continued overleaf →

Images courtesy of Harry James Hanson

Stop and Shoot

Faculty: Arno Minkkinen
University of Massachusetts in Lowell

This assignment was developed during an independent activities period when Minkkinen was teaching at the MIT Creative Photography Laboratory.
//////////

This works best with a large group of students. Students flip a coin to decide the following: 1) in which direction several cars filled with students will head; 2) at what distance intervals the cars will stop; and 3) for how long. Students make photographs at each stop for the pre-determined amount of time. The idea is to make spontaneity and chance a part of the picture-making process. Collaborating with reality is often the best way to make images that are beyond human imagination. This can be adapted to public transportation by having the coin toss determine which direction to take a subway or bus, how many stops to travel and for how long, or if students are traveling on foot, what direction, how long to walk, or how much distance to travel before the students stop and photograph, and for how long.

STUDENT RESPONSE

When I first entered college, I wanted to be a photojournalist. Now, three years later, that dream is long gone, and my projects are meticulously planned down to every last detail. But, I still understand the importance of spontaneity in photography. Chance, the happy accident, the decisive moment—whatever you call it, the unexpected photograph can be the best photograph.

This assignment was all about leaving the photograph up to the odds of a coin flip, letting go of control, and embracing the unforeseen. I started at a lake house in Locust, Texas, a small town about three hours north of Dallas. Once I got out of the gate, I began flipping a coin to decide where to go. Heads was a left turn; tails meant a right turn. Every three minutes I would flip a coin once more and if it was heads I would stop, get out, and begin photographing.

As I was a stranger in their small town, people's comfort with me and my camera surprised me. Living in New York City, and then working in the-middle-of-nowhere Texas all summer, led to culture shock. Instead of people just passing by me and my camera, every single person who saw me standing at the side of the road stopped to ask if I was okay or needed any help. (How much of this was pure, genuine Southern hospitality and how much of it was due to the fact that I am a woman, and was by myself, remains unknown.) It was strange to hold my camera after weeks of neglecting it while I was working; even stranger was photographing small-town Americana. I was used to taking pictures of cityscapes and the hustle of one of the largest cities in the world. But taking pictures of quiet moments—a family-owned bed and breakfast I stumbled on, a dead-end road, the crisscrossing lines of power poles and barbed wire fences—felt good; it felt natural. They were things I normally never would have stopped to look at for more then a second, things I never would have stopped to photograph, but when I did I found I couldn't put my camera down. Call it serendipity, call it fate, call it luck, whatever you call it, sometimes you just have to do the unexpected and leave it all to chance.

CARSEN RUSSELL
PARSONS THE NEW SCHOOL FOR DESIGN, NYC

Image courtesy of Carsen Russell

assignment continued overleaf →

{Stop and Shoot ~ assignment continued}

Images courtesy of Carsen Russell

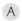
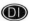

Surreal Portrait

Faculty: Rafael Goldchain
Sheridan College

The purpose of this assignment is to create a contemporary portrait that is *influenced* by historical portrait paintings as well as by surrealism. This does not mean that any particular painting needs to be duplicated or copied, but research of historical and surreal painting is required. Students will need to look at how the main subject in the original was arranged, posed, and lit, and how the background scene was integrated into the image. In historical paintings, many background scenes were landscapes, however subjects were posed in the studios. The integration was done on the canvas from sketches of the scene or from the imagination. Here the integration will be created digitally. This is an opportunity to create a meaningful juxtaposition of subject and background scene, one that makes a statement. Shoot the background scene first and then shoot your portrait subject in the studio under controlled lighting that matches the scene. In Photoshop composite the portrait with the background to create a seamless "surreality." Think of appropriate styling and costume for your subject. Historical clothing is not necessary unless it is part of your idea. Provide a written statement and sketches produced in advance of the shoot.

STUDENT RESPONSE
▼

This was one of my favorite assignments. I had a bunch of fun creating and setting up this surreal portrait. I chose to make the final image look like a digital collage, taking multiple images from the same shoot in order to create the final image. I thought it was an interesting idea to completely control the light on the subject and throw in the background while trying to make them match.

RACHEL DUNLOP
PARSONS THE NEW SCHOOL FOR DESIGN, NYC

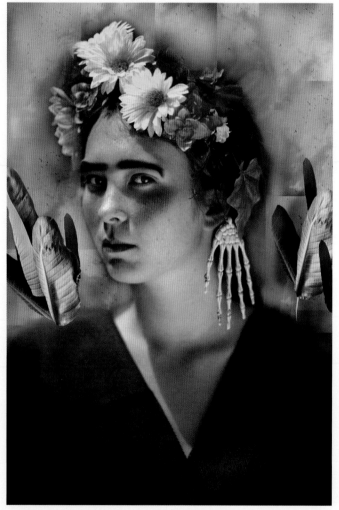

Image courtesy of Rachel Dunlop

Tell Me Something Interesting

Artist: Colleen Mullins
Photographer and Educator

At the beginning of class, say to students: "Tell me something interesting about your week." Tell everyone to take detailed notes but don't tell them why. When everyone has spoken, tell the students that they must choose one of their classmates' stories and illustrate it photographically, trying to push past the literal in the narrative, taking poetic license. The picture story should be no fewer than five images and no more than eight. The idea here is *not* to tell the story in a single image, but to truly think about developing a narrative, telling a story in which each photograph is a page in a book. Consider trying to take two different directions with the same story that are vastly different. In other words, don't get caught up in the first or most easily-made resolution to the problem. There may be no accompanying text with the work. When the work is critiqued, students should not reveal whose story they chose, but the class can comment at the end of the critique. This assignment helps students understand the profound differences between creating pictures that require a caption and pictures that don't because they tell the story. When given the gift of five to seven images, what are the opportunities in creating visual pauses, suspense, and dénouement?

Tell Us, Show Us, Express to Us

Faculty: Barbara DeGenevieve
School of the Art Institute of Chicago

The assignment:

Tell us:
One thing that defines you.
The one thing you love most.
One thing that pisses you off.

Show us:
The best piece you've ever made.
The worst piece you've ever made.
(And tell us the what the difference is between the two.)
A piece by a contemporary/conceptual artist whose work you wish you had made.

Express to us:
Why you make art.
Why you want to be an artist.
What you will do to make this happen.

This assignment is sent to students two weeks before the class begins and they are told to be in class thirty minutes early to load their presentations on the computer. The presentation must be at least three, but less than five minutes. At the five-minute mark students must stop even if they are not finished, so they are advised to practice the presentation in advance. This assignment functions to make students think about their practice as artists and hopefully gives some insight into how they might think of presenting themselves and their ideas. It also gets everyone to speak on the first day (even the extremely shy students), and introduces everyone to each other.
/////////////////////////////

Feel free to use humor, be performative, give a performative lecture with PowerPoint, dress especially for this occasion, do it live or record it all as a video, record it with video and have a live performative component, or find another way to do this, but it must be thoughtful and prepared.

Do not use clichés, sentimentality (including stories about your childhood), images of you or anyone in a fetal position unless it's to show us the worst piece you've ever made. What I want is to be surprised, to be entertained, to be excited about your ideas, and to be convinced. If I'm bored, you will have to do it over. Be fearless. Have fun with it. Surprise yourselves. Impress the class, your writing fellow, and your teacher.

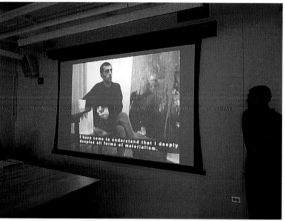

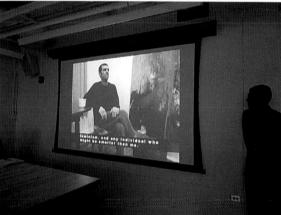

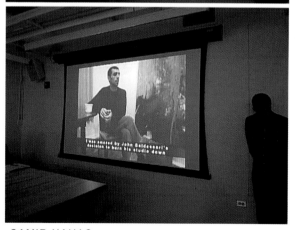

SAMIR NAHAS

Image courtesy of Samir Nahas

Third-Person Talk

Faculty: Barbara DeGenevieve
School of the Art Institute of Chicago

AS PRESENTED TO THE STUDENT

▼

Present a talk about your work as an art historian, curator, critic, or teacher might present research on the work of an artist—therefore you will be talking about yourself in the third person. You can approach it as completely straightforward and true, or you can fictionalize all or part of the story of you as the artist in question. You can show your own work or a combination of your work and work by other artists that you appropriate as your own for this lecture. Find work you wish you had made and show it as if you did. As part of this presentation the historian, curator, or critic presenting your work must talk about the research you engage in as an artist. You've sat through enough art history lectures, artist lectures, and documentaries about artists to understand how this might be constructed. But don't just mimic the typical lecture. Be performative, be serious or use humor, dress for the occasion. You know what "boring" looks and sounds like. Avoid it at all costs.

Three-Foot Square

Faculty: Steven Benson

Southeast Center for Photographic Studies, Daytona State College

B
I
CP
D
L

Make a three-foot square anywhere and without moving from that square, make photographs over a period of hours (or as long as you can remain in the square).

This is an assignment I remember someone talked about years ago. I teach advanced classes and see this exercise best suited to more formative classes, but have always thought it was brilliant. For those of us who might be concerned about the effects of having the ability to make thousands of exposures in an hour I would offer up another possibility as a follow-up assignment by suggesting that students have thirty-six exposures to use during the same time frame and are required to turn in the thirty-six frames as RAW files in the order they were made without editing. – **Steven Benson**

//////////////////////////

Time

Faculty: Steve Skopik
Ithaca College

Based on a lecture that Steve Skopik gives, students are told to think about the component of temporality in still photographs such as historical time, decisive moment time, or metaphorical time, and choose one and make a photograph in which the type of temporality is obvious enough that the class will figure it out when the work is presented.

Beginning students do not think about the idea of time in a still photograph, because they think of it as a frozen moment in time. I survey the different types of temporality in stills to help people understand that all photographs are informed by time. For example, a photograph can evoke a specific historical moment, so I show Robert Frank's photographs, so clearly from the 1950s in America, or Atget photographs of nineteenth-century Paris. I will then ask them: if they took a photograph of the Ithaca college campus in 2010 and wanted it to evoke that historical period, what would the photograph look like? Other photographs have a sense of timelessness. Then we discuss Cartier-Bresson's Decisive Moment, that crystalline moment in which the photographer notices the perfect summation of action and formal revelation. I might talk about time as metaphor, as well. For example, Jock Sturges' Last Days of Summer is not about the last days of summer. It's a metaphor for a time of life, the cusp between childhood and adulthood. In this sense time may be the subject of some photographs. – **Steve Skopik**

STUDENT RESPONSE

While this was an interesting prompt, I struggled a lot to zoom in and focus on themes that would relate back to the current time period. I feel as though this assignment can so easily be interpreted in multiple ways and it might be hard for students to view the present day the same way that one might think of New York City in the 1960s. Either way, in my image, I touched on the themes of technology and the disconnect between the current youth to situate it in the present and so it might define the time when seen years from now.

RACHEL DUNLOP
PARSONS THE NEW SCHOOL FOR DESIGN, NYC

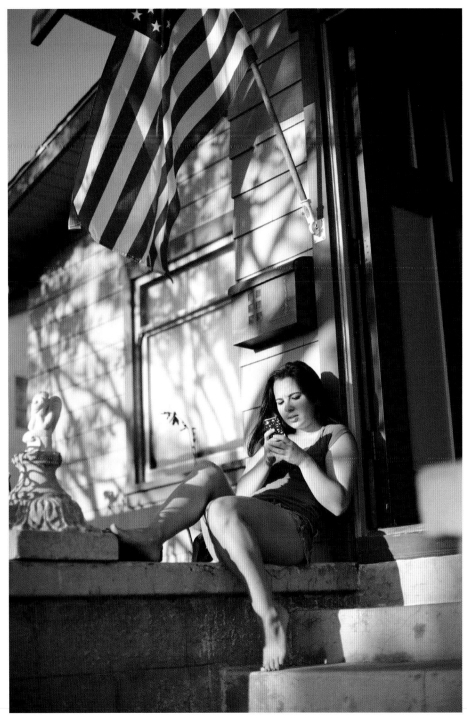

Image courtesy of Rachel Dunlop

Time as a Container

Faculty: Michael Marshall
University of Georgia

In a class titled "Time":

Dear Pat,
You came upon me carving some kind of little figure out of wood and
 you said,
"Why don't you make something for me?"
I asked you what you wanted, and you said, "a box."
"What for?"
"To put things in."
"What things?"
"Whatever you have," you said.
Well, here is your box. Nearly everything I have is in it, and it is not
 full. Pain and excitement are in it, and feeling good or bad and
 evil thoughts and good thoughts – pleasure of design and some
 despair and the indescribable joy of creation.
And on top of these are all the gratitude and love I have for you.
And still the box is not full.

John Steinbeck

This assignment requires you to explore the concept of time as a container. The photograph has often been associated with stopping an instant of time. A photograph can also be an instant of life captured for eternity that will never cease looking back at you. It also serves as a vessel, revealing the events that occur through duration. Consider John Steinbeck's letter above—what pain, excitement, thoughts, joys, despairs, and loves will fill your images? Use the inspiration of Annie Dillard's *Seeing* (Chapter 2 in her book *Pilgrim at Tinker Creek*) to consider not only what you are photographing, but also how you are engaging the world.

Finally, consider how the following artists use the medium of photography to see and contain time: Richard Misrach, Tokihiro Sato, Michael Wesely, Atta Kim, Mark Klett, Christine Lebeck, Hiroshi Sugimoto, and Duane Michaels.

Select from the following options:

1. Consider the conceptual implications of capturing, not a single moment, but a *perceptive* expanse of time and space within one photograph. Reveal a passion for your subject, contained in an expanse of time, in three or more beautifully printed images. Your negative will serve as a container of a continuum of spaces over durations of time. With this approach, you will complete three exhibition-quality prints at least 11 x 14 inches. Consider all of the technical implications of long exposures and compensate appropriately so that your final prints have full detail in shadows and highlights, with a rich tonal scale throughout.

For this assignment Jack Salazar chose to create an alternate depiction of time that compared the visceral and conceptual schemata that organize our perception. He juxtaposed the methods of timekeeping notations, metaphysical limits, mathematical concepts, and the suggestion of the arrow of time through entropic ruin and decay.

Image courtesy of Jack Salazar

With the goal of finely printed photographs in mind, select a camera and film combination that will give you the quality you desire. You will need to take into consideration any reciprocity failure that may occur in your exposure depending upon your film choice. Large areas with no detail are not acceptable so be selective in your choice of lighting and precise in your exposures to get good shadow detail. You may also need to adjust your development to avoid blocking up your highlights.

2. Consider the conceptual implications of revealing change over expansive time through the approach of rephotography. Your negative will serve as a second reference to a time and space previously captured so the time lap between images extends into years. Since we don't have years to wait, you will appropriate another image taken at least ten years earlier. Find at least three images that are related in some way, and recreate those images with as much exactitude as possible. Consider camera location, time of day, etc. Reveal an evolution of time through pairs of images. Copy and print small versions of each of your historic images. Then make at least three exhibition-quality prints, at least 11 x 14 inches in size, of your rephotographs.

3. Consider a sequence of images as a narrative over time … the glances of Annie Dillard walking through the woods, or the collective of passions and despair as collected in the box of Steinbeck. Construct at least three sequences of images (made up of two to six images each) that reveal a narrative experience over time. Reveal an evolution of time through three or more sequences of exhibition-quality prints, with each frame of the sequence at least 8 x 10 inches in size.

4. Create or discover another way of capturing and revealing a duration of time through printed photographic images.

Untitled Film Still

Faculty: Svea Josephy

Michaelis School of Fine Art, University of Cape Town

For this project, which must be shot using medium-format film, scanned and then postproduced digitally, students are required to produce a film still (in color or black and white) from a film that does not exist. The images must demonstrates a knowledge of cinema lighting, angles, dramatization, etc. Students decide on a topic, a genre, a narrative, and the process in consultation with faculty and then formulate a credible film still. Accuracy in terms of period, costume, and lighting is important.

Image courtesy of Ashley Walters

This project aims to consolidate technical skills previously learned, and add the skills of lighting (studio/daylight/strobe, etc.), studio photography, digital photography, image manipulation, medium-format photography and printing, advanced color shooting, and large-format printing techniques.

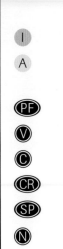

Who Am I, Really?

Faculty: Barbara DeGenevieve
School of the Art Institute of Chicago

This assignment is based on a Freudian construct, and although Freud has fallen out of favor, De Genevieve uses his theories to emphasize the extremes, and aspects of the psyche that might play into the argument. This is a time-based piece and must be either video or performance. It cannot be shorter than five minutes or longer than seven. The student must play all parts. Other than that there are no rules.

AS PRESENTED TO THE STUDENT

▼

Create a work in which you have a dialogue/argument/fight with yourself about your work. This is a constructed reality piece in which you play all the parts. A place to start to think about how you unconsciously/semi-consciously function and therefore often sabotage yourself is with Freud's psychoanalytical model of the various aspects of the psyche: the id, the ego, and super-ego. (Do basic research on Freud's ideas if you haven't been exposed to them in other classes.) The images could show: the super-ego argues/battles it out with the id or the ego argues/battles it out with the id, or the ego argues/battles it out with the superego. Think about the controlled you and uncontrollable you; the good you and the nasty you; the moral/ethical you and the calculating, hyper-critical you; and the overly civilized and the primitive uncivilized.

In other words, consider two or three distinct parts of your "self." The argument is about your work.

STUDENT RESPONSE

▼

The assignment "Who Am I, Really?" and Freud's psychoanalytical model of psyche made me think about my own conscious and unconscious mind. I asked myself what are my own battles between id, ego, and super ego, which I presented in the series of photographic collages, composed of simple still lives. As a perfectionist from nature, I find myself struggling almost all the time between my resolutions, temptations, should-dos, and should-nots. The images I created reflect the small, personal battles going on in my head:

> ❯ *The heart represents the fight between heart and mind, especially in relationships with other people.*

> ❯ *The collage of donut and orange is the symbol of temptation. Should I eat a sweet cookie, which will please my senses, or shall go with an apple, which is good for my health?*

> ❯ *A similar battle is presented on the collage consisting of cigarettes and roses—why is it so hard to resist a cigarette when I am so obsessed with a healthy lifestyle?*

> ❯ *The collage of angel and bulb is a representation of the sweet haze of childhood dreams and the harsh light of adult reality.*

In general, this photographic assignment has been a very interesting and personal experience for me. I discovered not only new photographic techniques, but also a few hidden truths about myself, which unconsciously I was trying to hold back.

OLGA KEDZIERSKA
ARTS UNIVERSITY BOURNEMOUTH, UNITED KINGDOM

Image courtesy of Olga Kedzierska

Who Are You?

Faculty: Charles Harbutt
Parsons The New School for Design

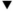

When Charles Harbutt was in journalism school, he and his classmates played the game of 5Ws. They would ask someone the "who, what, where, when, and why" questions and then after the person answered, say again, "Okay, now that we have the name rank and serial number over with, who *are* you?" They would go through all five questions again and again say, "Okay, but who are *you*?" They would ask the person the same question five times, stressing different aspects of the "who are you?" question.

In this assignment, students verbally engage in the same exercise in class, but then are assigned to go out and answer the questions with photographs. Harbutt uses the photographs as a template for judging the rest of the semester's work. Is the new work a continuation or a departure from the Who Are You assignment?

STUDENT RESPONSE

▼

I am a storyteller; an indulger; a lover of fables, fantasies, philosophies, and histories. I am a stager and I present in a lifelike fashion. I act out or direct a moment you can ingest. Will you digest? I am a critical thinker, and when I am asked who it is that I am, I peer directly at myself with tender eyes and a patient curiosity. Where I am, is in a fantasy, searching for reality. In transporting inspiration from Caravaggio's *Narcissus* to photographic form, I have successfully realized myth under my own direction. The story is now one of self-examination and lovingly critical reflection in a real world, not painted, but photographed. The uniqueness and specificity of my mirror image is the only beauty that obsesses me; in this moment I am not concerned with sexual appeal, unlike our dear old friend Narcissus. It is only with theatrics and the camera's record that I am able to assert these postulations and adapt the immortality of ancient folklore to my contemporary necessity. *A Real Narcissus* is manifested.

AUSTIN KLEIN
EUGENE LANG COLLEGE THE NEW SCHOOL FOR LIBERAL ARTS, NYC

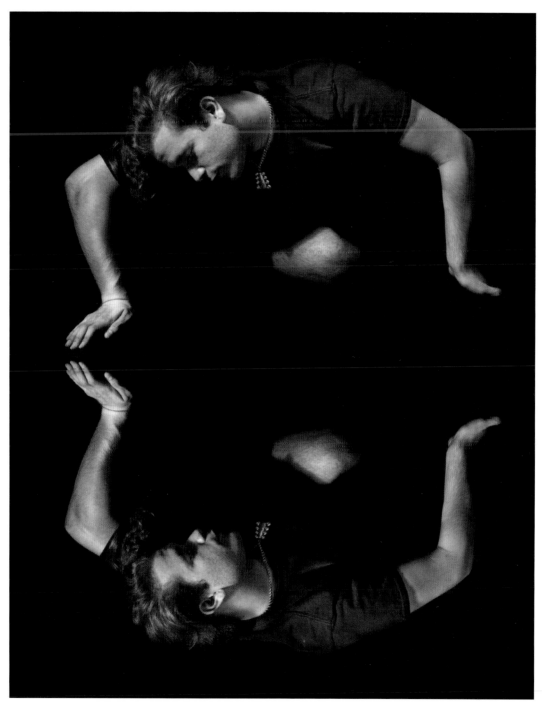

Image courtesy of Austin Klein

The Year 2072

Faculty: Barbara DeGenevieve
School of the Art Institute of Chicago

Artists are multifaceted; you are being educated to be a thinker, a solver of problems, an analytical observer of the world and your environment, a life-long learner. With this education, you will continue to have an artistic practice for the rest of your life—it may continue in the studio, but more importantly it will be integrated as part of your being and will exist in the choices of things and ideas with which you engage. You may or may not make "art" objects for the rest of your life, but an education in the arts, the way it makes you ask questions and the way it makes you look at the world, is as valuable as when it produces actual success in the art world. Think about being a good artist, but also think about being a generous, productive citizen of the world and what that might look like. By the time you're eighty years old, what will you have given to the world?

For this assignment project your career as an artist/designer/scholar/entrepreneur sixty years into the future. The *New York Times* is gathering information about you, and one of their best writers has the task of interviewing you and your friends about your life and work in anticipation of your death. This is standard with famous people so the paper can be ready with an obituary on the occasion of their death. Create a three-page paper that takes the form of a Q&A interview that chronicles the exploits, successes, detours, great accomplishments and tragedies, and the one thing you would most like to be remembered as having done in your life, whether or not that thing relates to you being an artist. Please consider that success is not synonymous with wealth, so an outrageous and juvenile story about how rich you had become is not acceptable. There should be one image that is used to illustrate the essay/interview from your time as an undergrad student that will show to the readers the budding artistic genius you were even sixty years ago.

Zen and the Art of Archery

Faculty: Type A (Adam Ames and Andrew Bordwin)
Parsons The New School for Design

Type A assigns *Zen and the Art of Archery*, written by Eugen Herrigel, to students and asks them to think about how the book relates to photography. This book, published in 1948, involves theories about motor learning and control applicable to almost any sport or physical activity. It is assigned several weeks into the class, because its relationship to photography is oblique and students need to trust the faculty. The discussion that ensues after students have read the book includes an explanation of how the central concept is what the Japanese call "mu shin," which roughly translates as "mind of no-mind." Mu shin is a state of mind where one makes work or performs without thinking and that state is as applicable for photography as it is for archery.

If you only think of the target you will not shoot straight. You will make more interesting photographs if you can achieve the state where the camera and your thinking process become fluid. – **Andrew Bordwin**

Teaching: Tips, Strategies, Ideas to Ponder

Joyce Neimanas created four categories of subject matter for all photographs: beasts (anything living), flora, light, constructed objects. She asks people if there are others.

Finding Out What Students Really Know

Faculty: Joyce Neimanas (Retired)
University of New Mexico

To ascertain technical knowledge, create a true or false test where all of the answers are true. Don't tell the students that. Give the test but tell students not to put their names on their papers. Shuffle the papers and pass them back to the class. Ask if anyone has a paper with a question marked "False." Explain why it isn't false or ask other students to explain the answer. All the false answers reveal the basic information that students don't understand. Then, let the students take the papers home for reference.

Editing and Selection

Faculty: Catherine Opie
University of California

Students who shoot digitally or with an iPhone have a hard time selecting images, which is why when they bring the images from their devices and make prints, the image doesn't hold our attention. I spend a lot of time talking about that. I tell students to clear out a wall in their house to pin up their images, and keep looking at those images for at least a month and when something tells them that they have to keep looking at a particular image, then maybe the image is actually doing something. You can't live with an image if it's only on a digital device. I also ask them to print out contact sheets, put them in a binder and then mark it like we used to mark contact sheets in the film days, so that they can get used to looking at images together on a page, rather than just editing them as individual images on a computer. I also sometimes limit how much they can shoot in the field. First, they can't delete images and I will say instead of shooting two thousand photographs because you have the camera for that day, try to limit it to sixty photographs, and rather than moving in and out with a zoom, change lenses. Look at your edges, stop thinking about the center, what does the edge do?

Image courtesy of Lauren Taubenfeld

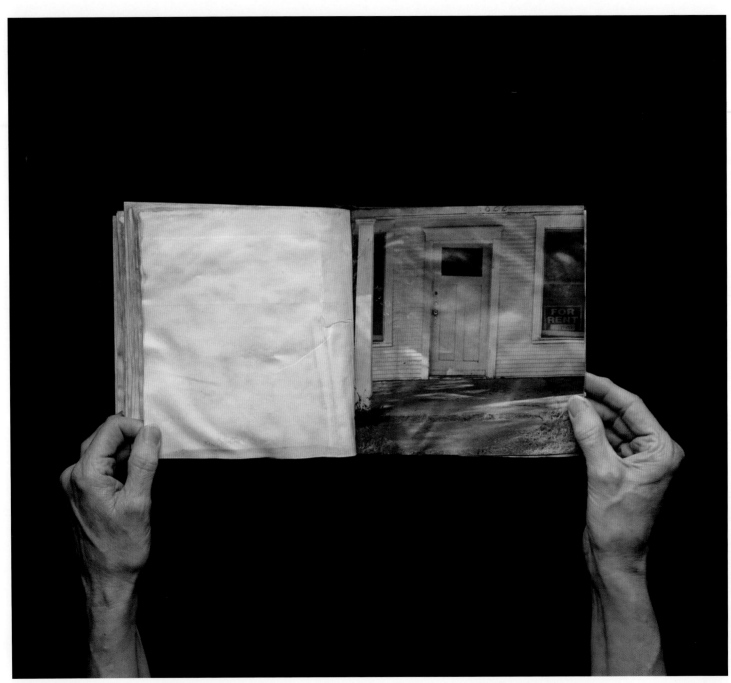

From the assignment Night Dreams, Day Dreams,
and Hypnogogic Hallucinations
Image courtesy of Erica Williams

Resources

This resource section is not comprehensive. Such a list would be impossible to compile. This is simply a partial list of some of my more recent favorite books, blogs, and websites that provide engaging reading when I am trying to avoid doing something else, or provide substantive information for my students. I can only confirm that all of the digital links worked at the time this manuscript was submitted.

WEBSITES AND BLOGS

www.1000wordsmag.com Online magazine on contemporary art photography in the United Kingdom and beyond. Content includes well-curated exhibitions, essays and book reviews

www.burnmagazine.com Edited and curated by award-winning Magnum photographer, David Allen Harvey, Burn is an online "evolving journal for emerging photographers" that publishes new stories or images at least two times a week.

www.cambridgeincolour.com Tutorials in photo concepts, equipment, editing, post processing, color management, printing, and technique, and a heavily populated forum discussing everything from equipment to competitions.

cphmag.com *Conscientious Photography Magazine*, founded by author, photographer and photo educator, Jörg Colberg, is dedicated to contemporary fine-art photography. It offers profiles of photographers, in-depth interviews, book reviews, and general articles about photography and related issues, including how to write about photography.

currentphotographer.com Founded and edited by designer and photographer, Trevor Current, this website provides information and resources, including photography industry news, tips, tools, techniques, tutorials and reviews for beginners through professionals.

www.diyphotography.net Feed of contemporary articles on photography and equipment, reviews of equipment, photography tips and tutorials, DIY tutorials and cheap alternatives to expensive photography equipment, and tips on purchasing gear such as lenses, bodies, rigs, and cranes.

dvafoto An eclectic blog by photographers Matt Lutton and M. Scott Brauer who publish interviews, articles and photographs on a range of topics from law to photo contest entry dates to Jörg Colberg's wonderful essay on how to write about photography. exposurecompensation.com: This very eclectic blog by Miguel Garcia-Guzman features writings about contemporary fine art photography by emerging and established photographers.

blog.fotomuseum.ch This blog explores photography's role as the seminal visual medium today—as art, as a communication and information tool in the context of social media or photojournalism, and as a form of scientific or legal evidence. Theorists, critics, educators, enthusiasts, users and photographers conduct the discourse. *Still Searching,* written by guest bloggers is moderated by the Fotomuseum Winterthur (Zurich) and located on its website.

www.imagingdna.com Imaging DNA is a blog about ideas, images and insights about the image, populated mainly by photography educators. Its features include interviews with educators, essays by photographers (many of whom are teachers), webinars on teaching, and a forum directed by educators.

www.instagramersgallery.com Instagramers Gallery is a new, open, and free on line gallery created by Phil Gonzalez, (@philgonzalez) and designer and social innovator Jorge Martinez, for photographers to display and exchange Instagram images with people from all over the world without having to create a profile, add friends or follow anyone.

lens.blogs.nytimes.com Lens is the photography blog of the New York Times, authored by James Estrin. It has become the authoritative voice, showcasing New York Times photographers, as well as highlighting the best of photojournalism and documentary

www.lensculture.com Edited by author and designer, Jim Casper, Lens Culture is an authoritative resource for contemporary photography. It frequently features emerging photographers working in diverse points of view: documentary, fine art, nature, photojournalism, activism, street photography, sports, fashion, poetic, personal, abstract and human. The LensCulture International Exposure Awards, now in their fifth year, are granted yearly to discover, reward, and promote talented, new, emerging and established photographers and multimedia creators from around the world.

pcuts.net This new zine, Papercuts edited by Marc Feustal and Dan Abbe, parses the relationship between images and culture and "taking the tension between these two forms as a starting point." @p cuts.

politicstheoryphotography. blogspot.com This blog engagingly titled *(Notes On) Politics, Theory and Photography,* is written by political theorist and professor James Johnson. It is as its masthead states a collection of essays about visual culture that is "alert to the power of images for good and evil."

petapixel.com The goal of this blog is to "inform, educate, and inspire in all things photography-related." It features equipment reviews, tutorials and an "inspiration" tab that includes images and videos accompanied by tips and advice from the photographer.

www.photoattorney.com This website from Carolyn E. Wright, Esq., author of *Photographer's Legal Guide,* focuses on copyright news, contracts and business forms that photographers need.

www.picturesocial.com A website created to allow photographers to display and critique photos (unlimited free photo storage), blog about their experiences, ask and answer questions, discuss camera equipment and more. While some of the content is more amateur, there is substantive discussion and critique if the viewer digs into the site.

photocritic.org Not to be confused with A.D. Coleman's Photocritic International, this photography blog by Haje Jan Kamps, who calls himself a "gadget geek" and "photography nut" and Daniela Bowker covers all things photography, from articles telling you how to do it better, to coverage of new products entering the market, and essays about photography.

www.ai-ao.com/publications/ pro-photo-daily Edited by photo insider, David Schonauer, this daily blog compiles the leading photo stories from leading sources, ranging from copyright news to exhibitions to tech news and reviews.

resourcemagonline.com This quarterly publication, edited by Aurelie Jezequel and tech editor Adam Sherwin, is a comprehensive "photo, video and lifestyle platform" that mixes interesting photographs (and features on established and emerging photographers) with articles about the photography industry, tech news, equipment reviews and marketing techniques.

www.stuckincustoms This blog, rated the number one travel blog on the internet features work by travel photographer and HDR expert Trey Ratcliffe, as well as some of the best (and mostly free) technical tutorials on HDR and HDR photography, as well as photography tips, equipment and software reviews, videos and apps.

www.teachingphoto.com This website authored by A.D. Coleman, a critic, historian, curator and educator, includes articles on photo history, criticism, theory, media studies and visual culture. Coleman was honored at the 51st annual conference of the Society for Photographic Education (SPE) with the Insight Award, given annually to recognize individual achievements of significant distinction in photography education. Coleman's well-known blog, Photocritic International, is hosted on Nearbycafe.com. As Coleman is both irreverent and outspoken, his blog is always interesting and often provocative.

www.thisweekinphoto.com Weekly news updates about photography, reviews of apps, sites, and equipment, internship opportunities, tips and tricks, and interviews with photographers.

tv.adobe.com This is an excellent resource for learning adobe products and techniques.

unitednationsofphotography Founded by Grant Scott and Sean Samuels, this website is a place "where the informed, passionate and inquisitive meet.." It features an engaging twitter feed @UNofPhoto, eBooks, essays, interviews and general news about the photography industry.

vervephoto.wordpress.com Created by photographer and photo editor, Geoffrey Hiller, this blog features photographs and interviews by and with contemporary image-makers. It also lists photo blogs to follow, multimedia sites to peruse and contests to enter.

BOOKS

A Field Guide to Getting Lost
Rebecca Solnit, Penguin Books
(New York, NY 2006)

Core Curriculum: Writings on Photography
Tod Papageorge, Aperture
(New York, NY 2011)

Genius of Photography
Gerry Badger, Quadrille Publishing Ltd.
(London, England 2007)

The Nature of Photographs
Stephen Shore, Phaidon Press
(London, 2011)

How Learning Works: Seven Research-Based Principles for Smart Teaching
Susan A. Ambrose, Michael W. Bridges, Michele DiPietro, Marsha C. Lovett and Marie K. Norman. John Wiley & Sons
(San Francisco, CA, 2010)

Photography Degree Zero: Reflections on Roland Barthes's Camera Lucida
Geoffrey Batchin, The MIT Press
(Cambridge, MA, 2011)

Teaching Photography, Notes Assembled
Philip Perkis, OB Press and RIT Cary Graphic Arts Press
(Rochester, NY, 2005)

Words Not Spent Today Buy Smaller Images Tomorrow: Essays on the Past and Future of Photography
David Levi Strauss, Aperture
(New York, NY 2014)

From the assignment Express Yourself

Index

optimum environment for 63

in political science departments 35

prepare portfolio of work 85–6

proliferation of 52

psychology of being an artist/physically creating art 00–1

strategy 8, 14, 85–6

structure of 104–5

students as active learners 102

take risks/learn from mistakes 16

taking responsibility for projects 48

taking/editing 70

teaching "artists" or "photographers" 119

theory should not lead your work 16

twenty-first century education 11–12, 27, 72–3

updating 26

using camera to realize conceptual ideas 99

video 9, 25, 30, 45

visual intelligence 18

visual literacy 104

technical skills 13–14, 18
 importance of teaching 56, 58, 130–1
 lighting 14
 recognizing a great story/narrative intelligence to tell a story 14

technique/core competencies 17, 18, 31–2, 53, 65, 72, 81, 105, 127, 130–1

technology
 acceptance of 25
 challenges 27, 32
 confusing skill with visual literacy 40
 dilemma with the "other part" 22
 expanding range of 26
 history of 25
 impact/influence of 14, 42, 45, 51, 52, 63, 107–8

importance of 69

obsolescence of 25

postproduction software 76

spread of 56

Texas Women's University, Denton (Texas) 141, 193, 195

Three Gorges Dam (China) 15

Tisch School of the Arts, New York University (NYC) 201, 224

Toth, Carl 15

Towery, Terry 113–14, 142, 216, 230

Tracy, Conrad 115–17, 188

Trager, Joel 147

Type A (Adam Ames & Andrew Bordwin) 118–19, 255

U

Umbrico, Penelope 120–1, 140

Unconventional Beauty assignment 147–9

Universitat Pompeu Fabra (Barcelona) 33

University of Arizona, Tucson (Arizona) 8, 157

University of Boulder (Colorado) 8

University for the Creative Arts, Rochester (England) 164, 190

University of Derby, Derby (England) 161

University of Georgia, Athens (GA) 192, 246

University of Mary Washington 46

University of Massachusetts in Lowell 138, 166, 172, 196, 198, 205, 234

University of New Mexico, Albuquerque (New Mexico) 184, 256

University of North Texas, Denton (Texas) 176

Utah State University, Logan (Utah) 199

V

Vallencourt, Daniel 148

Verdú, Vicente 33

video 9, 25, 30, 32, 45, 51, 82–3, 110–11, 114, 120–1

view camera 14, 105

Vimeo 20

W

Wall, Jeff 31, 104

Wang Chuan 122–5, 213

Weegee 207

Weingart, Jason 211

Wen, Leng 215

Wesely, Michael 246

Weston, Edward 22

Williams, Andrew 166, 178, 197

Willis, John 126–8, 185

Winogrand, Garry 104

Witkin, Joel-Peter 200

Wolfe, Byron 70

World Press Photo report 19

Worth, Jonathan 129–31

Y

YouTube 47

Z

ZoneZero website 22